'TRUST THE PROCESS,

AN ARTIST'S GUIDE TO LETTING GO

SHAUN MCNIFF

SHAMBHALA
Boston & London
1998

Shambhala Publications, Inc.
Horticultural Hall
300 Massachusetts Avenue
Boston, Massachusetts 02115
http://www.shambhala.com

© *1998 by Shaun McNiff*

9 8 7 6 5 4 3

Printed in the United States of America

♾ *This edition is printed on acid-free paper that meets the*
American National Standards Institute Z39.48 Standard.
Distributed in the United States by Random House, Inc.,
and in Canada by Random House of Canada Ltd

Library of Congress Cataloging-in-Publication Data

McNiff, Shaun.
Trust the process: an artist's guide to letting go /
Shaun McNiff.—1st ed.
p. cm.
ISBN 1-57062-357-0 *(alk. paper)*
1. *Creative ability—Psychological aspects.*
2. *Self-actualization (Psychology)* 3. *Artists—*
Psychology. I. *Title.*
N71.M35 1998 97-40182
701'.15—DC21 CIP

For every thing there is a season,
and a time for every purpose under heaven.

—ECCLESIASTES 3:1

CONTENTS

ACKNOWLEDGMENTS

I AM GRATEFUL FOR THE SUPPORT and insightful dialogue offered by Kendra Crossen Burroughs at Shambhala, my editor of many years. Kendra has been my closest advisor through every phase of this project. The "process" of creating with her has been one of the most rewarding parts of bringing the book to life.

Linda Klein gave an early reading of the manuscript and our discussions ignited many ideas about creation that found their way into the text. Bob Evans is another of my art idea collaborators and I thank him for "license to create" which emerged from one of our conversations.

My children Liam, Kelsey, Elyse, and Avery have been my mentors on childhood imagination.

And thanks to the students, colleagues, and studio workshop participants who have trusted me in the different roles I continue to play as a keeper of the process which never fails to teach us all.

Trust the Process

LICENSE
TO CREATE

A person's license to create is irrevocable, and it opens to every corner of daily life. But it is always hard to see that doubt, fear, and indirectness are eternal aspects of the creative path.

WE ARE LIVING IN AN ERA WHEN people hunger for personal relationships with the creative spirit. This desire has generated industries of creative consultation, therapy, teaching, and self-help, all offering support and guidance on how to make the spirits of creation more accessible.

As we begin to express ourselves in movement, painting, creative writing, performance, and other media, there is an almost universal sense of, "I didn't know I could do this. I never realized what I have inside me."

Those of us involved in offering opportunities for creative expression to others observe how success involves giving ourselves permission to create. There is a pervasive sense in our culture that creative expression is restricted to an anointed group.

From children's art we see that everyone carries an inherent license to create. Somehow, through the course of school experience, this freedom is restricted for the majority of people as the identification of "talent" tends to overshadow universal participation. There are many

forces at work in the repression of creation, and I do not want to speculate here on all the possible causes. I simply want to declare that a person's license to create is irrevocable and it opens to every corner of daily life. The ways of creation are as natural as breathing and walking. We live within the process of creation just as much as it exists within us.

The discipline of creation is a mix of surrender and initiative. We let go of inhibitions, which breed rigidity, and we cultivate responsiveness to what is taking shape in the immediate situation. The creative person, like the energy of creation, is always moving. There is an understanding that the process must keep changing.

I have written this book as a guide that is different from the more conventional strategy of laying out a series of steps or developmental stages—the one, two, three, four of creative fulfillment. The elements of creation work together in endless combinations.

I cannot augur the creative spirit's labyrinthine ways. As a creator, I know that the process doesn't work that way. It is more unpredictable, complex, perverse, subtle, and intimately associated with the idiosyncratic landscapes of the personal imagination. Creation thrives on inspiration and affirmation rather than direction. When approached through explanation, the creative spirits fly away beyond our grasp.

Travelers through the process of creation also realize that the truly essential spirits are experienced "on the way." Once we arrive, the pleasures are usually attached to reflections on how we got there. And if there is a feeling of satisfaction, it is likely to be ephemeral, since the creative spirit longs to get onto the road again, to create anew.

I hope to convey an unlimited sense of the "ways" of the creative spirit. I practice many different disciplines—painting, writing, movement, drumming, and performance—and each one invariably leads to another. This is a text dedicated to like-minded travelers who admire all of the different spiritual disciplines but can never stay in one place and be one thing alone.

Although creativity has regimental and formal aspects, its deep and transformative movements are more circuitous. Training in creativity

requires the ability to relax in periods of uncertainty and to trust that the creative intelligence will find its way. The education of imagination involves giving up what I call "ego" control. It requires an inclination to step into the unknown as well as the ability to persist when there is no end in sight. The ways of creation are often paradoxical. When you think there is nothing going on, something comes to you, and when you want something desperately, it's never there. Imagination thrives on the turning of tables, and its most successful products are often contrary to initial intentions.

Experience with the creative process reveals that results "happen" through an orchestration of dynamic forces moving in a given situation. For example, when I begin a painting, I try to empty myself of preconceptions, and I move in a way that corresponds to the feelings of the moment. The images of the painting emanate from the motions and energies of the specific time and place.

I can never know in advance what will appear, because I discover what is going on inside me through the process of painting. Like a beginner, I feel surprise and wonder as the picture takes shape. In this respect I always strive to be a novice, a person who is experiencing creation for the "first time." Even the most repetitious rituals and patterns of expression can be viewed anew within the unique context of the moment.

We can define the process of creation as a force and a direction that take shape over a period of time. "Process" suggests a series of actions, changes, and fluctuations. There is an incremental quality to process, and creative results are often achieved by making connections between previously unrelated areas.

Although order, regulation, and planning have important roles in the making of art, the total process of creation is permeated by hidden turns, elusive searches, and subtle appearances. Messages may be cryptic as well as overt; complex and very simple. The process is a route; sometimes it is tangled and at other times it opens to us with the directness, speed, and pleasure of a water slide.

The practice of imagination requires an ongoing interplay between

many different and often contradictory elements. It is a gathering of forces, and the skilled creator knows when to plan and when to check this intelligence at the door. I believe that creativity is an intelligence that is broader than the experience of an individual person acting alone. It is an energy that exists within an environment, and as an artist I strive to collaborate with it. The notion of "process" suggests a multiplicity of components with independent ways. But the word also carries within itself a sense of unity, a faith that all of our experiences gather together in a creative process that ultimately knows where it needs to go.

In his classic text, *Process and Reality*, Alfred North Whitehead affirmed that the ultimate goal of the creative process is an "enlargement" of imagination for all people. Yet, instead of expanding, most of us tend to confine ourselves to the limitations of habit. In my experience as a teacher I find that the most consistent obstacle to creative discovery is the average person's reluctance to become involved in free experimentation. The enlargement of imagination is a more challenging task than we may realize.

Trust the Process is a book for those who long to expand their perspectives on creation. Most of the time we will not know exactly where we are going, and in the art studio this is a laudable goal. Consequently, descriptions of the creative process are remembrances of things that we have done. When we examine life from this perspective, we see that there is a purpose moving through everything we do. The ideas presented in this book are culled from many years of looking back on the process of people creating in diverse situations.

Those who advocate "process-oriented" approaches to creativity typically discourage paying attention to objects and end results. There is a value to doing things wholeheartedly without being attached to what you do. We have all experienced the excesses of self-criticism, the insensitive judgments of others, or the psychological implication that the works say too much about ourselves. But a one-sided disregard for the objects of expression misses the opportunity to look with hindsight at the things that we have made. In addition to offering suggestions

and hints for expression, this book will help you to look at objects in new ways. The offspring of the creative process are resting places that contain the unity of the different things generating them. Artistic images are guides and sources of illumination. There is a time for making and a time for contemplative looking. The creative process has many phases, and each makes its contributions to the whole.

By focusing on "the basics" that underlie every aspect of creation, I have tried to create a practical guide for beginners as well as experienced artists. The beginner wants to know how to start and keep the process moving, while experienced creators need to regain this same fundamental understanding that is somehow lost and obscured through practice. I strive to give a concrete sense of "how to do it" without telling the reader *what* to do because the depths and mysteries of creation elude containment of any kind. The process of creation can only be described in subtle ways through glimpses of its movements, which are always a step ahead of the reflecting mind.

My descriptions of the creative process draw from my personal experiences as a painter and my twenty-eight years of working as a creative arts therapist where I have focused on helping people who desire to become more involved with the creative spirit. My practice ranges from beginners to prominent artists who have taught me that there are basic principles that apply to every level of creativity. I have integrated the total range of art forms throughout my career, so my examples will refer to performance, creative writing, vocal and musical improvisation, body movement, sculpture, and environmental art as well as painting. My experience shows that these different art forms are always energizing and supporting one another in a creative ecology that extends to every aspect of daily life. Since creative work in the studio is not far removed from what we do at our jobs and in our families and other personal relationships, this book strives to make connections among the full gamut of creative possibilities. *Trust the Process* is a reflection on creative living as well art.

To begin with, I establish a basic framework for artistic practice and offer suggestions as to how the reader can work with various artistic

media. In the following parts of the book, I continue to give ways of exercising the creative spirit with different art forms, but I also expand the scope of practice to daily life.

My lifelong passion has been an integrative practice of creativity that combines all of the arts. I cannot resist the urge to move from painting, to creative writing, to performance art, to the office, and then back to painting again. If the reader can tolerate this broad vision and my incurable desire to see the creative spirit in every corner of existence, then this book may contribute to the enlargement of imagination. I want to make lively connections among things, and it is the *process* of creation that binds it all together.

Since many of the exercises and practical suggestions offered in this book focus on painting and drawing, readers who are not currently involved in the arts might be interested in setting up a workspace in their homes. Many artists prefer painting and drawing on walls rather than easels. Find an open wall in your home and use it as a surface onto which you can fasten canvas and paper. Artists will often attach a four- by eight-foot piece of Homesote board to a wall, paint it white or the color of the wall, and then use it as a work area. An artist friend of mine who is a college dean just installed this type of work area in her office so she can create on the job. The paint-covered surface makes an aesthetic contribution to the room. It says to the visitor, "This is a place of creation."

When working on paper, run masking tape evenly around the edges, covering the painting area by three-eighths to one-half of an inch, or simply tack or staple the paper to the supporting surface. Canvas can be tacked or stapled to the work surface and stretched afterward. I like to work with a large easel in my studio but the average household might not be able to accommodate this type of structure. I place a firm piece of plywood on the easel when I want to make a drawing. You might consider using a hollow door as a painting surface in your room. The door can be leaned against a wall, and you can slide it under a bed when you are not working.

Good lighting is one of the most important qualities of an art room.

Try to keep as much open space as possible around your painting and drawing area so that you can experiment with movement exercises described in the book. Keep writing materials and musical instruments nearby so that you can move between media.

If your work room is a multipurpose space, make storage areas and containers for oil sticks, pastels, pencils, inks, paints, brushes, pencils, and other supplies. Close access to water and a sink is always helpful. If you work with oils, ventilation is important. A nearby window is the simplest solution.

Setting up the workspace is a vital part of the creative process, since the environment has a significant impact on expression. A personal place of creation is a grounding influence and a partner through every phase of expression. I envision the studio as a nucleus of creation, a source from which creative experience flows outward to other areas of life and the place to which it returns again. I maintain my artistic workspace as a sanctuary, a place at home where creative expression is nourished and regenerated.

Start by setting up your space.

1

UNPREDICTABLE
MAGIC

There have been so many times when I have given up, only to go at it again the next day, or the next year, and over the full course of a life all of the moments appear so purposeful or even necessary.

THE WELLSPRING
OF MOVEMENT

*We have grown so accustomed to the idea of the
solitary and willful creator that we find it difficult
to see the deeper ecology of creation.*

Experienced creators understand
that a person's mental outlook has as much to do with the quality of
expression as technical skill. The way we view situations is the basis for
their creative transformation.

When asked to define what is a work of art, Pablo Picasso was re-
ported to have replied, "What is not?"

There is a tradition within the arts that perceives every aspect of
experience as an element of the creative process. Although many of
history's greatest artists have identified with this vision, it has been
opposed by those who advocate "art for art's sake" and others who
favor strict or "pure" specialization. While aligning myself with the
integration of art and life, I have never seen an opposition between this
idea and restricted practice. Art has room for both perspectives and
many more.

The classical pianist who spends hours practicing every day in order
to deliver a perfect performance is engaged with an "aspect" of the art
experience. There are many more aspects of creation, as suggested by
James Joyce in *Ulysses* when he writes: "Any object, intensely regarded,

may be a gate of access to the incorruptible eon of the gods." Joyce affirms that creation is limited only by our consciousness.

While embracing the creative expressions of world-class musicians and dancers, we can also celebrate the creative spirit as manifested in the most ordinary aspects of daily life.

Since creation and art are "ideas," let's take these concepts to their limits and see what magic they can bring into our lives. I appreciate the wonders of the concert hall and the museum, but I'm equally interested in how the creative spirit manifests itself in the office, on the bus, or in the kitchen, as it expands our sense of aesthetic practice.

By looking more imaginatively at what you do every day, you will see that you are already a creator.

Our society puts us into boxes, and we do the same to ourselves. We tell ourselves, for example, "I'm a business person, so I'll leave art to the artists." But it doesn't have to be this way. There are other ways of looking at the creative process that are more in sync with how it actually works.

This narrow labeling is encouraged whenever I ask someone, "What do you do?" There is an assumption that we do one thing alone and not many different things that affect one another. I should consider saying to a person that I meet for the first time, "What are the different things that you do?"

We might ask ourselves, "Where is the creative spirit most active in my life? Where is it most inactive? What do I do every day that can become a basis for creative expression?"

I will suggest many methods of creation that build subtly on what already exists and what you already do. Rather than starting you off in completely foreign environments with novel exercises, I want to help you creatively engage what you presently have. The essential technique is a commitment to perceiving and acting in new ways.

I will encourage you to look and re-look, sift and probe, upend and reverse, twist and turn, because ultimately, as the classical adage advises, the process of creation is "in the eye of the beholder."

But as useful as these and other techniques can be, I have found

that there is an absolutely fundamental principle of operation for both beginning and experienced creators. It is such a commonplace saying within the creative arts that until recently I have been reluctant to utter the three words for fear of being trite: "Trust the process." Whenever I find myself in a difficult situation, the principle is reaffirmed. Actually, the more hopeless my problem seems, the more I learn to trust the process.

There have been so many times when I have given up, only to go at it again the next day, or the next year, and over the full course of a life all of the moments appear so purposeful or even necessary. The difficulties are always the most important ingredients in the total picture of a creative experience.

Improvisation is one of the basic principles of process-oriented creation. Working for the first time in any art medium, we tend to think that the result has to be known before we start. I remember my early experiments with art when I assumed that the finished composition was first conceived in the mind and then executed in paint. The same misconceptions apply to creative expressions in other media such as words, movement, and sound. We don't realize that the experienced dancer or painter might begin by simply moving and making gestures with art materials. One movement leads to another. We are apt to be more familiar with this improvisational dynamic in group movement and music. Creative sparks fly from person to person. The same thing applies to the interplay among the different elements of an individual's expression in painting, drawing, and creative writing.

As I look back at my experiences with lecturing, it has always been the unexpected happenings that have produced the most gratifying results. I prepare by establishing a simple framework of what I want to do, but I always leave room for what is generated by the event. The creative process blends structure with chance.

I do the same thing when I am painting. After establishing a rough and overall form, I let the unique qualities of unplanned gestures and color combinations emerge through the process of painting.

It seems that whenever I really want to do well, I am more likely to

contradict these basic principles of creation. If it is an especially important event, I am apt to plan too much. As I deliver the performance, I realize that I am following a script. There is no magic unless unplanned expressions arrive to infuse the performance with a spontaneous vitality that can never be preconceived. After many of my best performances, the notes I made in advance may have little relation to what took place. In a curious way I have to plan and make notes before I begin, but these preparations have to be let go as the performance begins. The ritual of preparation gets the creative process moving and it supplies ingredients that feed the event.

I do not want to belittle the importance of ideas as guiding forces within the creative process. I asked an eleven-year-old how she begins to make a picture. She replied, "I always get an idea. First I look around at my surroundings and then I think of my favorite things. I think of colors and I look at other people's drawings to get ideas. I start with the main subject in the center and I spread out."

I asked, "When you make designs, how do you begin?"

She replied, "I start with one shape and I go on from there with other shapes and borders."

I asked, "When the design is finished, what does it look like?'

She replied, "Most of the time, it doesn't look like what I had in mind."

"Why not?"

"Because I had other thoughts while I was making it," she answered.

Then I asked, "What about the pictures you make of your favorite things?"

She said, "I always mess up and it doesn't come out the way I wanted it. Then I add new details and it becomes something like what I originally thought of."

"Were the mistakes important?" I asked.

"Sometimes, but at other times they ruin the picture."

Ideas are the seeds of creative imagination. They are mental images that stimulate us to bring them into the physical world. But in order to take material form, the idea must go through a process that produces

an amalgamation between the purely mental image and the physical action of creation. Sometimes the end result closely approximates the original idea, and often the final outcome bears little resemblance to the starting point. As suggested by this young girl, we discover things along the way, even when we are trying to render a preconceived idea. The things that we do in service of an idea generate new ideas, and the process goes on and on. And sometimes we fail and have to start again. The act of creating is a partnership between ideas and the physical qualities of art making. One thing leads to another.

When we create from mental images, there must be flexibility and an openness to the new influences delivered through the process of creation.

There are many creative artists and scientists whose work is an execution of ideas that are first shaped in the imagination. Musicians describe how they hear compositions in their dreams or reverie and transcribe them afterward. Writers often engage characters and scenes in their imaginations before expressing them in print. There are endless methods and personal styles of creating. But even the most exact representation of a mental image by an artist with consummate technical skills will inevitably involve new contributions to the work through the process of creation.

I frequently encounter people who quickly grow frustrated and angry because their expressions do not look like their ideas. Creative problem solving is a process of give and take. I have an idea that I want to execute, and I must adapt to what the materials of expression are capable of doing and what I can do with them.

What we call an "idea" may be a mental image or shadowy sense of something that we want to do in an artwork. The original stimulus incites the creative act, which I experience as a building process. I was recently working with a seven-year-old girl in a creative writing exercise. She had drawn a picture of an Egyptian mummy that we used as the source for creative writing. In her first piece of writing the girl offered an explanatory account of what mummies are, why they were created, and so forth.

I encouraged her to write another piece, focused on how the mummy itself felt and how the people in its life felt about it. The mummy became a one-year-old infant who had died. In writing her story, I observed how the girl began with the image of her drawing, which generated the image of the infant, which generated image after image within her ensuing story. Images birth one another. Moving from literal explanation to personifying the image opened the doors to the imagination. The girl stayed within the creative process and its ways of moving. Explanation, something we all do, takes us away from the wellspring.

Trusting the process and accessing the energies of creative movement is a discipline. I liken it to the practice of sitting meditation. It is not simply a matter of surrendering to circumstances and external forces. The creative process requires the active participation of the artist over a period of time. People beginning to commit themselves to creativity have to realize that important results are not always immediate. Just as the meditator practices staying with the object of meditation no matter what thoughts, sensations, or other distractions arise, the artist learns how to stay connected to the image being constructed and the process of creation, assimilating whatever occurs into the creative act.

In my studio workshops on the creative process I tell people that if they simply begin to paint and continue moving from one picture to the next, a series of pictures will emerge. The images emanate from the personal cooking that each of us does throughout the process of creation. It is difficult for the beginner to believe that an inexperienced painter is capable of making a body of work through which each picture builds subtly on the ones made before it. But when we look at a sequence of pictures, it is remarkable how what might have first looked like an insignificant and unsuccessful composition was the substructure for what was to follow. A simple squiggle or series of lines can be the start of pleasing patterns and personal symbols that unfold from humble beginnings. Because of these thematic connections among pictures,

I discourage throwing artworks away when working on a series. What first seemed irrelevant reveals the germination of future paintings.

Looking at a series of pictures enables us to view the emergence of imagery over time. We are given an alternative to judging a stand-alone picture. This perspective is just as useful in looking at our lives over an extended period of time. The bad performance or painful event might in the long run play a pivotal role in the overall effort. Hindsight is the primary viewpoint on process.

I repeatedly see people in my studios who make wonderfully expressive gestures in their first paintings and even though I encourage them to keep working with them in subsequent pictures, they revert to stiff and controlled compositions with little artistic imagination. As they grow frustrated and dissatisfied with these rigid images, the participants reconsider my suggestion to continue with the original gesture that occurred naturally and outside the scope of their mental controls.

When I see fresh and spontaneous expressions emerging from beginners' paintings, I draw it to their attention and encourage them to stay with the gestures in subsequent pictures. I suggest the repetition of a gesture and I describe how we can never do the same picture twice. Repetition encourages reverie and letting go. As I paint the same gesture over and over, it changes as I use new colors and experiment with different sizes. I amplify and diminish, all the while striving to keep the gestures alive.

A first-grade teacher told me that she and her colleagues can never really explain how an individual child learns to read. The teachers work systematically through carefully considered instructional methods, but when the child begins to read, it is always experienced as a magical moment, a time when all of the elements contributing to the process are somehow integrated. This is yet another description of how the creative process works. Whether it involves learning how to read, playing the piano, riding a bike, or writing a graduate school thesis, there is usually a decisive moment or turning point within an overall process which can only be described as magical. It is an instant when all of the frustration, seemingly futile efforts, and tedious drills play their

respective parts in a collective creation. This is what I describe as the "complex" of creativity, a condition that feels as though the individual person acts together with many other forces. A varied series of events and motions carry us over a new threshold, and we can never exactly describe how it happened.

The same thing applies to the repetition of an original series of gestures. As the artist makes them over and over, new qualities emerge from the familiar basis of expression. What might appear to some to be a monotonous drill becomes the springboard for new levels of expressive integration. Repetition provides the basis for new combinations of gestures and flights of imagination. After extended periods of playing with familiar gestures, complete compositions will emerge spontaneously. It is like a child learning to read: the process cannot be explained according to a linear sequence of acts. It occurs magically but upon the foundation of focused exercise and preparation. All of the pieces, the good and the bad, play vital roles in the creative act. However, when we reflect back upon these enchanted moments of creation, we are apt to look more upon the specific turning points and less upon the all-encompassing collection of movements that generate a cumulative effect.

Each of us finds our personal basis for exercising creative expression. What works for me may not apply to you, and discoveries made in oil painting may not translate to wood sculpture. The magic of expression emerges from the individual crucibles of personal experimentation. Hours, days, weeks, and sometimes months and years of frustrating work may be generating a realignment of elements, which gather together at a decisive moment, or in a fertile period, to generate a succession of new creations. Creativity is fed by the difficult course of events as well as by the instants of epiphany that we commonly associate with successful expression.

An experienced art teacher observed, "The biggest problem for adults and children is that everyone wants quick results. They don't realize that you have to work at it. They have to spend time at it and be patient. It's a commitment."

The process of art can be likened to a long-term relationship in which we grow to understand and accept what we like and dislike. Almost every aspect of our experience has its disturbing qualities that ultimately shape the course of the creative process if we stay open to their formative influences. What I don't like about my art is as helpful to my ongoing desire to express myself as those qualities that do appeal to me.

I have also grown to appreciate the creative role of what may first appear to be routine gestures. These familiar motions and forms are always connected to our individual and natural ways of expressing ourselves. Just as the child described how she always begins her pictures with ideas about her favorite things, we can begin to exercise creative expression with favorite gestures that we use over and over again. When I first watched films of Picasso painting and drawing, I was struck by his fluid lines and graceful body movement. He used every part of his body to achieve a total expression. The gestures on paper and canvas extended from his stance and lower body motions as much as his hand and arm. We don't realize how the expressiveness of our paintings and drawings correspond completely to the way in which we move our bodies. Art is close to dance, and our paintings will benefit as we expand our abilities to move with materials. In order to paint effectively I need to commit myself to exercise with brushes, pencils, oil sticks, and other implements of expression. Each device, like a new dance partner, calls for a different sensitivity.

I tend to like large and bold swirls and sweeping motions. As I repeat them over and over again, they elicit complementary gestures in new directions and with different colors. The interactions among movements begin to make shapes and an overall composition. If I don't use these gestures as the framework for a finished painting, my exercise with them is internalized and I feel increasingly comfortable and secure in making these movements. If I make a drawing of a human figure or a landscape, I move with the same spontaneity that characterized my exercise, and the resulting pictures show a unique mixture of my expressive gesture and the subject matter I am painting.

In my painting studios I observe how people benefit by first "warming up" the creative process through free body movement. They stretch their bodies and explore a wide range of gestures without being concerned with what they look like. Movement exercises help us to draw on the total expression of the body. As you move, become aware of the forces generated by your lower body. Imagine yourself painting freely on a large canvas, and feel how much your feet and legs give to your gestures. One of the most crippling inhibitions to artistic expression is the blockage of the full spectrum of the body's expressive faculties, which support one another in an interdependent way.

Trusting the process is based on the realization that creation is a complex interaction of many elements that collectively shape the future. We have grown so accustomed to the creation myth of an individual intelligence acting alone that we find it difficult to see the deeper ecology of creation. I paint together with the expressive movements and gestures that I have adopted through years of practice. And when I succeed in my expression, it is because the movements within myself and those within my environment work together to generate an offspring that carries the traces of our collaboration.

In the real world of creation there are many solitary moments of illumination, but the creator is always a participant in a field of action. Creation is a complex interplay. I can never move in isolation from the contributing forces of the immediate environment.

In previous epochs it was assumed that individual actions were manifestations of a collective creation. The artisans and artists who constructed the Gothic cathedrals and the anonymous artists of tribal culture contributed to a more comprehensive purpose than individual expression.

I believe that this same collective purpose is manifested in the actions of individual artists when we work in unison with our environments. I experience a *participation mystique* when I am in sync with my surroundings. Today we describe these peak moments as being "in the zone." It is a time when the "chemistry" is right. Everything fits. The process carries us as we work together with it. All of the time we have

spent exercising our creative expression results in the ability to move without self-consciousness. We respond instinctively and spontaneously to the mood of the moment, which is comprised of many contributing factors from the environment and from within ourselves.

We've all experienced moments of synchronicity when all of the pieces of our experience fall together in magical ways. The person who you have not seen for years calls you on the telephone the moment you are writing something about him in your story; the missing tool mysteriously appears in your studio just as you need it. These moments demonstrate how experience and creation do not always move according to linear causation. C. G. Jung observed that events and relationships often take shape according to "acasual" patterns. If we persist in our creative efforts, surprising resolutions will appear when they are least expected. The creative discipline involves the ability to keep the field of activity open and responsive to what arrives.

These moments of ease are preceded by unavoidable periods of Sisyphean labor during which I confront an all-too-familiar sense of despair and worthlessness, feelings that on better days I see as "part of the process." Creativity cannot flourish and reach its deepest potential without the participation of its demons as well as its angels.

The "process" has an intelligence that can be trusted, and the gift of creation is the ability to work with it. Envisioning the basis of creation as spontaneous movement suggests that the most fundamental discipline involves keeping the channels for expression open and responsive to what is moving within us and within our environments.

STEPPING INTO
THE UNKNOWN

If we are able to stay with a situation,
it will carry us to a new place.

MY BELIEF IN THE INTELLIGENCE OF the creative process has been affirmed by people who struggle in workshop groups where they are given opportunities to express themselves in the arts. Sometimes, people who are invited to express themselves freely will react with feelings of paralysis, fear, and intimidation. Memories of embarrassment and failure wrap them in what one woman described as a "cocoon." The past traumas are often self-inflicted and not the fault of parents, teachers, or institutions. Even the best teachers of creativity encounter a common resistance to self-expression in their classes. The cocoon is spun partly from fears of self-disclosure. We all know intuitively that our spontaneous creative expressions elude the habitual monitoring of our inner censors, revealing things to others that are outside our conscious control. If we allowed our simple essence or our ungroomed emotions to show, we might look foolish, vulnerable, or unattractive. There is also the assumption that creative expression is only for the talented few and that our creation is a waste of time since it will never compare to what the "masters" do.

The typical person says, "I can't do that."

Or, "This is ridiculous, a waste of time. I have more important things that I could be doing today."

It is intriguing how schoolteachers participating together in my creative arts workshops are often the most resistant to free and imaginative expression. Teachers are known for demanding clear directions and immediate applications because school is almost totally focused on training the literal mind.

There are many things that we teach in school that involve the mastery of sequential skills that build upon one another. Most of the educational system is established on the assumption that learning follows a logical and predictable pattern of acquiring knowledge. Educators are actually required to produce lesson plans and structure their classes around measurable outcomes. We then test the student at various intervals to determine whether or not they are performing within acceptable standards. Many people teach art in this way. They show the student how to draw a head by starting with an oval and then mathematically locate the placements of eyes, nose, ears, and mouth. This approach to teaching is technical and it has its place within the training of artists. Structure and openness are partners in every creation.

But there is very little emphasis within our educational systems on the education of the *imagination*, which requires sustained encounters with uncertainty. My experiences in working with teachers illustrate the benefits of acquiring the aptitude to embrace the unknown—what John Keats called "negative capability."

In my training groups with teachers I repeatedly observe that their initial resistance ultimately leads to rewarding experiences with creative unfolding. There are typically a series of difficult phases that the groups of teachers must pass through in understanding that the creative process is not something to be contained in lesson plans.

When I work with teachers in an extended creative arts workshop, there is a classic resistance that appears at the beginning. The doubt can be heard in their silence: "What's the purpose of this? What's it got to do with my classroom? What am I doing here?"

Someone inevitably protests and questions the validity of what is happening. I experience fear and sense how easily everything can fall

apart. Others join the protest, and the community divides. The group flounders.

I have learned that I must let "the process" follow its course. As frustration builds, someone as a rule challenges my ability and people in the group begin to confront one another. Others withdraw into themselves. It is always hard to see that doubt, fear, and indirectness are eternal aspects of the creative path.

When everything seems hopeless and going nowhere, I observe that the group as a whole is enacting how the process of creation works its way through an individual person. Strong feelings start to focus energy. People become keenly involved in spite of themselves. The process arouses emotion and draws everything into itself.

A new direction flows from the dissolution. There is a feeling of hope and transformation.

If we are able to stay with a situation, it will carry us to a new place. The "process" knows where it needs to go and if it is exclusively directed or controlled by any one person, we miss the opportunity to learn this lesson. There is a group mind or collective intelligence working in every situation and if we can trust it, and sincerely support its natural movement, it will astound us with its ability to use whatever we give it.

The psychologist Carl Rogers used to say that given the proper support and safety, every group will progress through conflict to a state of change and resolution. But in order for the process to become transformative, there must be a prevailing atmosphere of respect and empathy for the participants. These attitudes provide the essential environment that people need in order to risk new expressions, whether in the art studio, the classroom, the office, or the family.

Trust in the process assumes that there is a force that moves within a group, an individual, or a situation that is distinctly "other" and not subject to control. "It" finds the way through problems and complex interactions among people and as well as through conflicting forces within ourselves. Although outside the reach of explanatory definition,

this force is well known to any person familiar with the situations I am describing. It is the primary carrier of creation.

Training people to work with the creative process begins with their personal immersion in it. How can we guide others in a territory we do not know ourselves?

In training graduate students to work with the arts in therapy and education, I encourage an ongoing personal engagement with creative expression. The graduate students experiment with creative expression and personally experience the processes that they encourage in others. Repeatedly I observe how the most pervasive outcome of these extended involvements with the depths of creative expression is a faith in the process. The more intensely the students struggle, the more deeply they discover how the process will ultimately carry them to a new place. As D. H. Lawrence suggested, the soul is perfect in its movement and its ability to minister to itself. We are needed as active participants, but we have to learn how to act forcefully while simultaneously stepping aside so that the process has the freedom to do its work.

What Carl Rogers said about groups also applies to an individual person's experimentation with the arts. If we work in a safe and supportive environment with what Rogers described as "unconditional positive regard" for our expression, the process of creation will ultimately proceed to a stable and meaningful outcome. The most threatening element is the lack of confidence that people have when the process becomes difficult and tense. They don't realize that the conflict and uneasiness that they are experiencing are necessary and "part of the process." Transformation occurs when we lose our way and find a new way to return.

In my personal experience as a teacher, it was the student who fought and struggled the most in her research into the workings of the creative process who produced the most memorable and convincing study of how the creative spirit moves through our lives. The depth and wisdom of her findings were shaped through the authority of her experience. The student taught also me to trust the process, because I

was the constant target of her frustration. When things were going badly, I was the object of her fury. It was very difficult, and I privately wondered whether I was doing the right thing. She needed someone to fight against, someone who would hold firm amid all the turmoil. What distinguished this student's work from the more conventional nay-sayers and complainers was the way she stayed with the process. She gave it the opportunity to transform itself.

In the education of imagination we invariably confront the way in which people have been conditioned to expect certainties in learning situations. There is an expectation that something concrete will be delivered by the teacher to the learner.

In training teachers from every conceivable discipline to engage all of the arts and integrate them into their different work situations, I have observed that they generally come with the following assumptions: "Tell me exactly how to do it and how I can use this in my classroom." They are oriented toward the individual technique, not the process that runs through every method and continuously generates imaginative ways of doing things. Within the creative process, variations and unusual perspectives are encouraged. A group of us might work for a period of time in the same room and with the same materials and end up in vastly different places. There is no one "correct" way of proceeding, and this aspect of creativity goes contrary to many ingrained ideas about instruction.

Personal immersion in the creative process helps teachers establish empathy with what their students are experiencing. In my work I am constantly involving experienced teachers in art experiences for the first time, and they repeatedly say, "Now I understand what the children are feeling."

The teachers describe how there is a pattern to the way they face every new art experience with resistance and fear. They feel an equally consistent thrill and satisfaction after completing each new phase of the work. Whether it is dance, storytelling, musical improvisation, painting, mime, or poetry, the same forces of creation move through

the experience, affirming that there is something essential that cannot be taught when we focus only on specialized technical instruction.

Trusting the process is based on a belief that something valuable will emerge when we step into the unknown. There are elements of surrender and letting go which have more to do with flexibility and the ability to change direction, than with defeat and annihilation. The ego is willing to relinquish its plans and expectations in order to receive an unanticipated result. Experienced creators are able to step aside and relax in order to advance. They work with the process, stimulating it with a forceful initiative or a subtle nudge, but always respectful of what takes shape outside the sphere of a person's control.

The most rudimentary exercise for those wishing to experiment with stepping into the unknown, involves painting, drawing, moving, writing, or making sounds without any goal in mind. If you begin to work exclusively for the sake of expressing yourself, you have begun to practice "negative capability."

In my experience with this type of creative discovery, everything depends upon the degree to which I can perceive what I do with "unconditional positive regard." When the teachers in my studio group began to have a positive feeling for their free expressions with paint, everything began to change. The simplest gestures, color combinations, and repetitious patterns of lines and shapes became fascinating. As with meditation, any object intensely contemplated can be an opening to reverie. Everything depends upon the quality of attention that we can apply to our perceptions. The humblest expressions can be sources of insight and wonder.

Negative and fearful experiences can really test our capacity for positive reflection. In art therapy, healing often occurs when we begin to make paintings and performances that engage the sources of our discontents. When I enact my angst and fears in an artwork, they become my partners in creation, and my relationship to them is transformed.

One of my graduate students decided to conduct a research project on the area of her expression that she feared the most. She was working

in body-oriented therapy, and she had difficulty letting herself collapse in falling exercises. She practiced falling in her classes and made connections between her inability to let go and her difficulties in falling asleep and falling in love. She explored links between the physical ability to fall and letting herself open to simple experiences of daily life. The outcome of her master's thesis was a sophisticated psychotherapeutic method that used falling exercises to treat psychic states of fear and the inability to let go in different activities of daily life. The project began by addressing a fear that needed attention. The final result of the research was completely uncertain. The student simply focused on a theme that was troubling her. By falling into the unknown, she arrived at a new place in her life and work.

When we are constantly keeping ourselves from falling and shielding ourselves from experiences, we exert tremendous energy in controlling our environments and defending ourselves from imagined threats. Falling becomes a release, an immersion in the process of life. Trusting the process brings a realization that miscues, mistakes, and failures make important contributions to the creative process.

In scientific research the world's most advanced researchers spend years conducting experiments that "don't work" in order to eliminate possible explanations for the problems they are exploring. When something doesn't function, it contributes to our understanding of what does. The same thing applies to the arts. Failed expressions close some doors and open others. It all goes together.

When we stand back and look at any creative enterprise, we typically see slips and failings throughout the process. We can do the same thing with our lives. Examine any major success that you have experienced, and try to remember the difficult moments and blunders. Mastery requires the ability to sustain commitment. There is also a time for quitting, and a sense of timing that we need in order to get out of difficult situations. All of these decisions are "part of the process."

When something is difficult and painful, there is a natural instinct to quit and get as far away from the scene as possible. The ability to extricate ourselves from these situations is an important part of creative

expression. But sensing when to quit is always complemented by a stubborn persistence and an ability to stick to the problem in the face of adversity. The magic of the creative process will never be experienced unless we persist and trust that there is a force working in every situation that we cannot know until we undergo the experience.

Clay is an excellent medium for experimenting with the way shapes emerge from the unknown. When working with clay it is important to have confidence that new forms exist within the block that you break apart and shape with your hands. What appears to be random movement has a purpose in the process of transformation. The existing form has to break down before the new one can emerge. Throughout the process, the clay is a stable partner, always interacting with your eyes and hands. When I work with clay, my involvement is primarily physical and kinesthetic. I push and pull, squeeze and twist. There is always a sense that something is taking shape through the motions, even though I have no idea what it will be. My eyes are allies, but they are less directive than the hands and their movements. The visual sense might call for "more of this" or "less of that," guiding us just as the sense of taste does when we cook.

The most important feature of work with clay is the ability to sustain the motion and the effort. I have to stay with the process while the material is moist and amenable to being freely shaped, and there always seems to be a point when the work reaches a completion that feels like the natural end of a dance or the conclusion of a gesture. The decision to stop is sensed.

The same principles apply to painting with any medium. Materials like oil stay moist longer and enable us to move in and out of the engagement over prolonged periods of time, whereas watercolor, tempera, and inks are tied to specific moments.

Each medium makes its particular contributions to creation. The material is always a primary factor in determining what will be realized in any given situation. In every artistic activity we have to have confidence in the material as well as ourselves. The media constantly give directions, inspirations, and counsel as we interact with them.

I like to work with moist materials. The wetness is a constant source of motion. I seem to need the slipping and sliding that accompany thick and oily substances. Others prefer to create with dry materials. We are so inclined to think about art materials with only end products in mind that we don't take enough time to engage them in a purely physical way.

We create together with our materials and our bodies, not just from our minds. We need to trust their individual contributions to the creative act and realize that they are primary participants in the process. When I move freely from my body and other senses, the materials will respond. I have to keep reminding myself that every gesture is significant and that the materials of expression will always reflect the quality of my engagement with them. When I look at a finished painting, I imagine the gestures and feelings of its maker. The more expressive the painting is, the more I feel the presence of the artist who made it. Forceful textures, brushstrokes, and colors stand as a record of the engagement that brought them into being. The same applies to a delicate watercolor or pencil drawing. Each medium generates particular feelings. As I work with these different materials, I try to open myself to their influences. I become like them as I work, never knowing in advance what kind of effect they will have on me during each engagement.

Try working with clay, paints, oil sticks, pencils on paper, and inks with the objective of exploring their material properties. Relax your tendency to think in terms of outcomes. Just give as much quality attention as you can to experiencing the different physical properties of the media. Explore what they do in response to different kinds of movements that you make. Watch how the spontaneity of your gestures corresponds to your ability to feel the medium and what *it* is capable of doing.

Do the same thing with collage materials, pieces of cloth, and found objects. Arrange them in configurations on the basis of how they feel, and don't be too concerned with what they look like. Work with sticks, string, stones, grasses, and other natural materials. If you can surrender

to your sense of touch, you will see that textures produce visual patterns. These art experiences will help you develop confidence in what the materials can do. In my studio workshops I repeatedly see how the simple presence of these varied materials incites the creative imagination. People move from painting to performance art and into the construction of objects and environments within an ongoing process of creative play that responds to the suggestiveness of materials.

Confidence, and what I have described as a positive faith in the outcomes of creative expression, are essential when venturing into the unknown. In order to realize our creative powers, we have to believe that we have the ability to make something significant. As I reflect on this attitude, I realize that I am not really talking about self-confidence. I am describing a commitment to "the process" and its ability to generate worthwhile results. I learn over and over again that the creative process is an intelligence that knows where it has to go. Somehow it always finds the way to the place where I need to be, and it is always a destination that never could have been known by me in advance.

Teaching, as well as my personal art expression, has helped me understand the intelligence of the creative process. I have been one of the primary beneficiaries of the training groups that I have described because I have repeatedly witnessed the way in which the process is a reliable teacher. Throughout my career I have had a deep-seated sense that I must teach creativity in a way that immerses people in the process. It would have been so much easier to avoid uncertainty by giving controlled directions at every turn. When I teach in this experiential way, I travel with my groups into the unknown. Many times I have felt like Dionysus being torn apart by the fury of the maenads because I expose participants to the uncertainties of their individual and collective psyches. But when we stay with the process, its benefits are received as we reach the other shore, and Dionysus is resurrected as well. These journeys into the creative process reenact mythic patterns and truths that have always guided human experience.

As I experience these creative cycles over and over again in my workshop groups and in my personal artistic expression, I have become a

more relaxed and confident guide. My belief in the formative powers of the unknown helps people to trust more and to go more deeply into the creative process. This is the way of the creative spirit, which makes us anew through every encounter.

EMANATION

Anything truly novel and significant comes through
unwatched, unintended, daimonically.

WHEN MY MASTER'S THESIS STU-
dents wanted to be told what to do, how to write a thesis, I'd say,
"Write."

"The thoughts come from the process of expression," I'd say to
them. "Trust me and keep writing."

I have never been able to teach creativity in step-by-step exercises
with common themes. That approach feels like an exercise class, al-
though it no doubt helps many people by giving clear and concrete
procedures.

Perhaps I have never been able to tell another person what to make
or how to make it, because I am ultimately interested in artistic expres-
sions that emerge like images from a dream. For me art has to flow
naturally from the streams of an individual person's experience.

Creation is a process of emanation. Nothing will happen unless we
start working and allow the practice of our particular disciplines to mix
with the streams of ideas and experiences that are constantly moving
through daily life. These currents are never "blocked." Therefore, the
practice of creation involves the ability to tap into them.

An impulse, idea, or sense of something that needs to be done is
often the spark of creation. But nothing happens with a creative work
unless I set to work with a faith that the ultimate form will emerge.

One thing calls for another. The same thing applies to people who start companies and entrepreneurs. There is an initial sense of an opportunity, something that the world needs, and invariably the vision takes shape through the process of implementation. Goethe said: "Begin, and the work will be completed."

We don't necessarily know what the final product will look like, and the surprises offered by the work are one of its most satisfying qualities. The experienced creator is forever intrigued with the unplanned results that emerge from faithful practice. But this is one of the aspects of creative expression that beginners find most difficult to accept. I was just visiting an art class where the teacher was trying to help her students appreciate that what they "want" from a painting is often quite different from what they "get." So much of art education involves an appreciation for what arrives from outside the scope of our preconceptions.

There are many creators who operate systematically, within carefully planned and repetitious rituals of practice. They execute their works in paint, words, music, and movement like engineers. Within the creative process every conceivable way of working has its place. It is important to respect every approach to creativity and to protect the perverse and varied ways of imagining. I might be able to work out a formula or pattern in my personal work habits, but I can't expect it to work for others. This is why the teaching of art has always been based on studio methods where each individual has a personal relationship with the materials and the process.

My way of serving as an agent for whatever wants to come through on a particular day can be terribly frustrating when nothing of value arrives. I envy friends who create more methodically with preexisting forms and ideas. But no matter how far to the right or left of planned activity the creator happens to operate, anything truly novel and significant comes through unwatched, unintended, daimonically.

The creative spirit has a strong feminine aspect, a birthing quality. Things made without this gestation and cooking don't carry the spirits of wondrous individuation and surprise. They look like ready-mades as

contrasted to expressions that go full-term through a person's psychic apparatus. As with birthing, the practice of creation requires a continuous respect for that which takes places autonomously and in its own time. The creator is a necessary participant, but like childbirth the process is not controlled by the person who serves as the agent of delivery.

Creation also has a destructive aspect. The angelic offspring are accompanied by bothersome demons. As Nietzsche declared, the artist must break things apart in order to create anew, and Picasso felt that every major creative act carries a shadow and its share of negativity.

I remember an artist telling me how the process of creating consistently tore him apart. The results of artistic expression may bring relief, joy, and harmony, but the process thrives on tension. Conflict and uncertainty are the forces that carry the artist to new and unfamiliar places.

Creative practice can be viewed as a ritual of preparation, readying the psychic household for unexpected guests and fresh combinations of familiar things. When I teach, I operate as a coach, urging students on and offering support. One of my most important functions is that of listener and viewer. Artistic practice needs a witness, someone to respond and affirm the existence and value of the creation. I offer alternative ways of looking at creations, links to the works of others, leads for further expression, and affirmations when the creator has difficulty appreciating what appears.

Supervising thesis students taught me how the creative process follows a mythic birth cycle that plays itself out in different ways. Year after year I saw how the students struggled, to varying degrees, and ultimately learned how to surrender the controlling ego to the process of creation. If the ego is always in command, there is no room for the truly unusual and new insights to appear. The same thing applies to leadership in organizations. If there is too much control, the different divisions and units don't have the room to innovate. What we see in communities takes place in the individual person. The control factor has to step aside and let the other faculties of creation exercise them-

selves. Mental control cooperates with the muscles, the senses, memories, imaginings, and the process moving through us.

I tell beginning thesis students that they are experts on a particular feature of life, something they know much better than I or any other person in the world. I encourage them to create from the authority of their experience, to examine their lives, and express themselves confidently and continuously over the course of our year together.

I say to them, "Look at your life in terms of your personal expertise."

Every person beginning to work with the creative process needs to respect his or her own special resources for expression. By starting with our strengths we establish a basis from which we can improve.

In what areas do you have special knowledge and skills? Don't limit yourself to lofty standards of authority. Think of expertness as an understanding of experiences that are uniquely yours. Write, move, or make sounds from the basis of these experiences. In this way you begin to create from authority and from a resource that is particular to you. Your expressions will become individuated, in contrast to what happens when people express themselves from stock themes. Have confidence in the unusualness of your experience, and don't feel that you have to create within standard molds. If authority is located exclusively outside yourself, you will have little power and conviction in your expression. When we work from the basis of personal life experience, we tap the source from which creative expression emanates. Otherwise expression will be forced and stereotypic.

If you practice martial arts and you want to experience creative movement and performance, start with your fighting drills and allow yourself to embellish and gradually improvise from the familiar movements. Try softening and slowing down the expressions, and let them suggest new movements outside the scope of your routine training.

The motions we make when painting a wall, holding a baby, typing on a keyboard, moving a computer mouse, or ironing a shirt can become the basis of creative expression. Approach any familiar kinetic pattern as a source for creative imagining. You already know how to

do it, so just continue with the movement in a mindful way and see where it takes you.

Each of us has areas like this within our movement repertoires that can be starting places. Begin with something that you know well and expand upon it. Move rhythmically and according to the accustomed pulse and tempo. When you start with something that is ingrained in your experience, you are able to move and express yourself with little inhibition. If you are able to stay with the movement over a period of time, it will gradually differentiate itself if you surrender to its tendency to emanate into new and vital forms of life. What at first might have been boring becomes fascinating.

As a rule, the process of emanation occurs on its own schedule and not on ours. Creative insights perversely appear when we are occupied with something else. After working on a manuscript all morning, you might be jogging or digging in the garden when a flow of important ideas comes upon you.

Creations are rarely enacted through a series of decisive strokes that follow a strategic plan. It is a process of ongoing accretion and deletion, saving and cutting, with the final form taking shape through this interplay of additions and removals.

People doing creative work for the first time do not realize how one of the most essential skills of the artist can be likened to what carpenters call "fiddling and diddling," moving materials around until they find their place.

Creation gathers and absorbs as much as it initiates. The experienced creator knows the importance of sustained movement and engagement from which new forms emerge. As the creator continues working, the new forms emerge.

In creative writing, I rarely know what I will do before I begin. The thinking happens through the interaction with the medium. The same applies to dance and musical improvisation. In my writing, consecutive drafts refine and ultimately deliver the message of the text, which is formulated by moving things around and helping each piece find its place within the whole. Most of us rely of the "paste and cut" proce-

dure as an essential tool of creation. However, there are those like D. H. Lawrence and Henry Miller who wrote from start to finish with very little editing. They felt that the flow should follow its own course with as little interruption as possible. Too much alteration can create a busy expression with little continuity among its different parts.

Experiment with emanation by continuing your movements with clay and paints. Keep your primary emphasis on the process of moving with the materials by watching how the forms and visual qualities of the media change in relation to your gestures. Creative writing teachers help people to make poems by cutting out words from newspapers and magazines and moving them into different arrangements. The same principle applies to working with paint and clay. We are agents who move and change the materials and help them find a significant relationship to one another.

Expressive qualities always seem to emerge "unwatched," and often we fail to recognize them when they arrive. Without becoming overly critical of your work or too concerned with its visual presentation, try pausing after each new gesture as if you are involved with a meditation. View the pause as a "breather" during which you contemplate what you have just done to the materials. Establish a rhythm to the periods of moving and looking.

The ability to see what is happening to the material is an important feature of the creative process. At times it may be helpful to proceed blindly, but on the whole it's better to have the use of the eyes as allies who enhance rather than inhibit the process of emanation. The key to this type of contemplative looking is the adoption of an attitude of appreciation rather than control. The eyes look and observe. They become partners in the overall movement. Look from the perspective of wonder and discovery, and try not to be too concerned with judging what you do. There is a natural critic in the gesture that responds instinctively to what went before it. Looking in this way at what is emerging in your work will help you to shape the image through the innate qualities of your movement.

Within the visual arts I find that focusing on a series of creations

furthers the process of emanation. Images emerge from one another and build upon their predecessors. One thing grows out of another, and the individual pieces are generated by the overall energy of the series.

A year ago I was cleaning out a closet and found a box full of old business cards printed on attractive beige paper. I always wanted to take the time to make a series of hundreds of small whimsical pictures out of my stream of consciousness, but I never got to it. I gave the cards to my six-year-old daughter and suggested that she use them to make art. A year later I saw her working away on the cards.

She said, "I like to make mini-pictures. It's more fun than making big ones. I don't have to make big details. I can make little things. If I make little things on a big piece of paper they look too small. They don't fit in."

I enjoyed looking at her small pictures on the cards and I liked shuffling through them. There is a sense of fullness to the series and a kinetic dimension when flipping through them all.

I asked, "Why is it more fun to make these small pictures?"

"You can finish them more easily," she replied. "You can keep going without stopping. If I'm making a picture on a huge piece of paper, it takes more time to fill it all in."

I realized that the small surface encouraged fluidity because finishing wasn't so time-consuming. When I make a large painting, the process is characterized by stops and restarts. Sometimes it is difficult to get back into the painting. This is not the case with the tiny works on cards that my daughter was producing.

I asked, "Where do get your ideas for the pictures?"

She said, "I look around at things or there is an idea in my head."

I asked whether making lots of small pictures gave her ideas for new ones.

"Yes," she said. "When I look at a picture for a while, it gives me an idea for another picture. I get ideas from them. When I have a whole pile of little pictures, I can look through them for ideas. When I was looking at a picture I drew of an animal, it gave me ideas for other

animals to draw. If I made a design in a picture, I might make another picture by taking the same shape and making it different."

Emanation is a process of one thing emerging from another, and this quality of creation reinforces the importance of working in a series. Whether you are making large works or small ones, images grow from other images and the process of being produced.

Try making a series of images on small cards. Work with pens and fine markers. As the series takes shape, you will experience a feeling of plenitude that helps to generate confidence. Approach the images as inspiration cards, as seeds and sources for future emanations.

Watch how ideas for pictures emerge from previous pictures. Try to maintain connections from one image to the next. This is the way an artist's style begins emerge. For a beginner it is especially important to create a body of work that will reveal patterns, themes, and interests. The small cards make the creation of a series possible within the busy lives that most people lead. Make them in free moments as a meditation. Carry cards with you during the day in order to sketch out a new image when you have the time.

Try not to make too many "corrections" when creating these cards. Don't allow yourself to get fussy with them. This will inhibit the flow from one image to another. Approach the project with the goal of making many pictures. Establish a new set of criteria for evaluating the work—spontaneity, connectedness, variety, whimsy. Concentrate upon the whole body of work and don't get overly involved in one picture. As the series takes shape, focus on the overall motion and momentum of the work. Feel this force as something within yourself, and use it to amplify some of your favorite cards into larger works.

As you become familiar and comfortable with making a series of images, you will be less likely to get overly attached to what you are making at a particular time. Your overall flow will be able to circumvent difficulties that might otherwise arrest your expression, dampen confidence, and interfere with "unwatched movement." You will always know that there are more pictures yet to come.

MISTAKES AND
DISTORTIONS

*Errors are harbingers of original ideas because
they introduce new directions for expression.*

WHEN ASKED FOR ADVICE ON
painting, Claude Monet told people not to fear mistakes. The discipline of art requires constant experimentation, wherein errors are harbingers of original ideas because they introduce new directions for expression. The mistake is outside the intended course of action, and it may present something we never saw before, something unexpected or contradictory, an accident that can be put to use.

Mistakes break the continuities of intention with slips and distortions. Can you recall creations in your life that grew from errors?

Deviations often generate distinctive qualities. They move us forward and into unexplored terrain. Reflect on the different mistakes you have made in your creative expression, your personal relationships, and your work. There are times when we literally "slip" into new ways of acting. We miss a turn and discover a new landscape.

The mistake is a message that calls for attention. I miss a line in the evening rehearsal for a play because I am preoccupied with something that happened to me during the day. The error tells me that while I am on stage, the production has to be the most important thing in my life. I have to be totally focused and let go of other concerns. As I

practice this process of complete focus, I find that it helps me feel better about what happened that day. I find a way to be detached by becoming involved with something else.

The paint spills and suggests a new composition. Colors mix unintentionally and reveal tones we have never made before. The actor forgets her lines, improvises, and stumbles upon an intriguing new interpretation of the play. Forgetting can open the space of creation for new arrivals.

Improvisation is based upon working with whatever presents itself.

If you view your life as an ongoing invention, mistakes shed their onerous nature. The only serious deficit involves the inability to respond.

Do you recall making errors that arrested and overwhelmed you? Do you obsess about errors when you make them? Do they inhibit your spontaneity?

Are you able to let go of your errors and learn from them? Better yet, are you able to build upon your mistakes with new expressions?

The anger aroused by mistakes can also shape new creations. There have been many times when I felt so fed up with what I was trying to do that I let loose with a new burst of creative energy. Frustration might also lead to the destruction of unproductive ways of expression. Often we need to break down tired patterns before we can create anew. Mistakes encourage me to act more boldly the next time around. The nagging symptoms in an artwork demand a new response. Tight and stiff compositions call out for more spontaneity. Anger is often the agent of change and liberation.

Have there been times in your life when anger got you to act more spontaneously? Were the results positive? Did the emotional outburst enable you to take risks that you would not normally take? Or do you tend to repress or restrain emotions?

Creative expression requires an ability to work with feelings and channel them. Frustration, dissatisfaction, and even a sense of desperation may help you access an eloquence that you never knew existed.

There is also a beneficial sense of humility that accompanies the

making of mistakes. They remind us of our frailties and they deepen appreciation for more enlightened moments. Imagine what you would be like without your mistakes. What kind of person would you be if your errors were never pointed out to you?

Have there been particularly significant mistakes in your life? Is there one in particular that stands out? How did it affect you or others?

I like to work with oil paint because of the way I can go over mistakes or use them as the basis of a new expression. As I cover a failed painting with colors, new shapes and compositions emerge and a new painting is built upon them. You can intentionally use this method of painting by covering a surface with quick-drying colors. Paint anything you like with the realization that you will be eliminating it with another coat of paint. When the surface is dry, use what you have done as an underpainting. In the places where the first and second layers meet, interesting and completely accidental shapes and color combinations are likely to emerge. You can do this exercise with more than two layers. Make sure you work with nontransparent paints on a firm surface that is capable of holding many layers of pigment. This procedure of building paintings on top of paintings offers a new perspective on what we once perceived to be mistakes. Everything can be put to use within the creative process.

Watercolor is a more demanding medium because I cannot paint out a gesture and make it into something else. But I have learned in working with inks and watercolors that what first looked like a mistake might ultimately turn out to be my most important and fresh expression. I might be perceiving something as a mistake because it does not fit my current frame of reference. In these cases I try to relax judgment and look at the expression from different vantage points.

There have been many instances in art or life when something that once appeared to be a mistake turned out to be a major achievement. Time, or a person presenting a different point of view about a situation, may help us see the larger significance of what we have done.

Mistaken moves and slips of intention reveal that creation involves more than single-mindedness. We create together with the world,

and everything ultimately participates. The experienced creator realizes how "mistakes" often suggest the most productive and novel expressions.

The surrealist artists and poets welcomed unintended arrivals. In keeping with Freud's discoveries, they found that "slips" frequently delivered the most significant expressions. In accessing the creations of the unconscious mind, they introduced a revolutionary perspective on the value of "accidents" in art.

In all of these cases expressive merits were tied to spontaneity and surprise. The surrealist writers encouraged automatic writing, in which the conscious mind imitated the dreaming mind. Matisse sometimes painted with instruments attached to long sticks to lessen control. He desired the fresh marks that came from tools that made their own contributions to the gesture. What the highly controlled person might see as a mistake, he saw as a treasure and a new beginning. If we handicap and restrict a routine faculty, a new one will come forward to take its place.

Expressionist painting actually discourages exact likeness. The aesthetic concern is focused on what happens within the canvas as an area that refers to nothing but itself. Picasso steered away from any gesture that did not contain a large measure of distortion. The distorted image is a new entity in its own right, and it does not define itself in reference to something else.

We might not realize that even a photographic likeness involves a certain distortion imposed by the camera and the physical qualities of the print. Every medium leaves traces of itself in the artist's interpretation of subjects. Try making human figures with malleable wire, sticks and twine, aluminum foil, and other pliant materials that make it difficult to achieve an exact likeness. Working with these materials makes it relatively easy to abandon yourself to the expressive qualities of the medium. Approach the figure only as a general guide for the overall composition and let the qualities of the medium shape the outcome.

These exercises are useful for beginners who are so concerned with likenesses that they cannot see how an artwork ultimately expresses

itself through its material nature. When the expression of the materials is our primary concern, we minimize the inhibiting effect of deviating from a "correct" likeness. In the art activities that I have just described, the person who has an ability to shape materials into pleasing configurations may generate more interesting images than the artist who is capable of rendering exact likenesses within traditional media like drawing and painting.

I admire the way Picasso was always shifting media and taking advantage of their natural material expressions. Activities of this kind introduce a new perspective on aesthetic value. We are less concerned with making a reproduction of something that we see or envision in our minds. The focus of artmaking shifts to enhancing the natural expressive qualities of media.

Intentional distortion is a wonderful way of increasing spontaneity. It focuses attention on the unique qualities of the gestures you make. The same applies to exaggerations, inversions, and any other departures from the habitual perspective on experience.

Try making a human face, a body, an animal, an object, or a street scene with the goal of distorting and exaggerating the subject matter. As you continue to paint and draw in this way, you will find yourself making gestures that are uniquely yours. The figures and objects from which you work become stimuli for your creation, and you are freed from any obligation to copy exactly what you see.

I encourage beginning painters to work on large surfaces with their eyes closed. This stimulates them to act more forcefully from the body. We do the same thing when working with clay, an even more tactile medium. The absence of sight encourages other sensitivities, which offer different qualities to the expressive interplay. After beginning a painting with creative movement, we open our eyes and build upon the foundations of pure movement. Beginners find this approach useful because the visual sensibility tends to play a disproportionate role in the censorship process.

After warming up in this way, try to work from nature with the goal of distortion and exaggeration. Look at a landscape, a figure, an object,

or a room but feel free to improvise on their visual characteristics. Use the physical entity before you as a stimulus for spontaneous expression. Your strokes and gestures will be bolder, more decisive, and more individualistic when you let go of the need to make an exact likeness.

When painting in this way, we are always in visual contact with the subject being rendered. Even my most expressive gestures are striving to convey qualities of the subject. I find that it is the tension between the form of the subject and the interpretive gesture that drives my expression.

The idea of mistaken gestures begins to vanish when every movement is viewed as expressive in its own right. We shift our focus from right or wrong to the degree to which the gesture conveys expression.

When a child makes a picture of a house, freely yielding to the impulses of expression and the properties of paint applied to a surface with a large brush, do we view these images of life as mistaken? More likely we enjoy the picture of the house within the context of the fresh and delightfully expressive world of childhood. Imagine having the same appreciation for your own creations.

A more liberal and tolerant vision of mistakes is essential to trusting the process. Although there are many sectors of my life where mistakes are clearly mistakes and unacceptable, the creative process helps me to make use of them in novel ways. The "process" view of creation has room for all of our successes and failures. Each one adds its distinct properties to the overall purpose.

2

IN THE BEGINNING
IS THE ATTITUDE

*The issue of talent is the most effective defense
against expression. It is also a crippling obstacle
when used against you. My experience has repeatedly
proven that any person can express himself or herself
in an authentic and intriguing way with just
about any art form.*

THE MANY WAYS
OF CREATING

*Once we realize that artists are themselves
expressions of every conceivable way of living,
we can begin to appreciate variations of creative types.*

THERE ARE MANY WAYS OF LIVING A
creative life. Picasso is the twentieth-century's embodiment of the
artist who constantly confronts convention, working into the early
hours of the morning, and sleeping while the rest of the world begins
the workday. Georgia O'Keeffe, like Paul Gauguin, exemplifies the
artist who lives a solitary existence in a wild and isolated natural envi-
ronment. The poet Charles Olson wrote through the night and was
known to call on friends in the early hours of the morning. Emily
Dickinson was a hermit in her Amherst home. D. H. Lawrence was an
inveterate traveler.

These extreme lifestyles obscure the way the majority of creative
artists live conventionally. The surrealist painter René Magritte
painted small pictures in his living room. The poet William Carlos
Williams had an active medical practice in Paterson, New Jersey, and
another great modernist poet, Wallace Stevens, was a vice president of
the Hartford Accident and Indemnity Company. Anne Sexton was a
homemaker in a Boston suburb, and Marianne Moore worked at the
Carlisle Indian School in Pennsylvannia and at the Hudson Park
Branch Library in New York City during her formative years as a poet.

The unusual mannerisms of prominent artists tend to obscure the fact that many of history's greatest creators, and the vast majority of people who express themselves creatively each day, live ordinary lives and work at relatively mainstream jobs. It is possible to create at the highest levels of quality while still working in a bank, teaching school, painting houses, or toiling in a factory. I have actually found that these different activities further my creative expression. I seek out new experiences and challenges, and they invariably enrich my art by providing subject matter, emotional energy, and new connections to life.

The problem that I share with many other people is finding the time to create. Once we realize that time is a major issue, we can begin to find ways to manage the interplay. Do I have to be an "artist" twenty-four hours a day, or can I step in and out of different ways of being in the world? The exclusivity that we attach to artistic identity may not necessary.

Each of us can examine whether we are capable of putting aside a designated period each day for expression and artistic reflection. "Full-time" artists often have the same problems finding quality time for their work.

Keeping a sketchbook or poetic journal may be a useful way of exercising the creative spirit every day. I know a photographer who keeps a visual diary by selecting one image for each day of the year.

I described earlier how to use index cards to make miniature drawings during the workday. There is a feeling that the scale of the works fits into the structure of the workday. The pictures can be completed in a few minutes and slipped into a pocket or a desk drawer. My personal artmaking has been enhanced by digital media. Making art on the computer fits into the structure of my daily life. I can make images at home and show them to colleagues at work on the office computer.

Wallace Stevens used to write poems on small pieces of paper as he walked back and forth from the office. He found space for the creative process in his daily life as an insurance executive and indemnity law expert.

I do not see evidence that Stevens tried to integrate the different

aspects of his life. He was able to pass between worlds. His art shows few traces of the insurance industry and vice versa. Wallace Stevens demonstrated how artists can make a living at something other than art in order to dedicate themselves to the imagination and its expressive craft in their personal time. Stevens likened his poetic aspirations to the discipline of a monk. His creative work was private and sacred in an era when the artist was viewed as public and profane. Stevens chafed at the assumption that a person is incapable of living in more than one world or one place. He was trained as a lawyer and he became a successful businessman and poet while his employer, the Hartford, took pride in his literary accomplishments. The company also employed Benjamin Lee Whorf, the influential linguist who made his living as an engineer.

As I reflect on my life, no matter how busy I am, the time is usually there for creation, but I may choose to do other things. Paradoxically, I have experienced my most creative periods when I am busiest. The experiences feed on one another. We've all heard about how students tend to do better in academics when they are involved in sports and other extracurricular activities. The same applies to creation. There is a discipline attached to creative practice, and I have to make space and time for artistic expression each day.

People often ask how I can paint and write seriously when I work full-time as a college dean. I realize that I cannot survive without creative activity. It is a basic need for me, and perhaps I am able to paint and write on a fairly regular basis because I have practiced so extensively over the years. These activities are part of my routine, my way of living, my devotion to the world and my immediate environment.

Just as the religious person makes time for prayer during the day, the creative person makes time for expression. My lifelong experience with art can be likened to meditation and spiritual exercise. Although I set out to be an "artist" as a young person, I have never been satisfied with the practice of art in isolation from people and the ordinary actions of daily life. The heroic and special values that our civilization has attached to art are particularly unsettling to me. I aspire to make

good art and to express myself as well as I possibly can and to connect my expressions to art history and the world traditions of creative expression. My way of practicing art is sometimes closer to spiritual exercise than the methods of traditional art instruction.

When I create a successful painting or drawing, there is a sense of satisfaction. I may want to show the image to another person, but the primary sentiment is a feeling of completeness that takes place between myself and the image and the environment in which it was made. I innately long for this type of successful outcome. If the work is eventually exhibited, appreciated, and recognized by others, this is fine, but as I get older, public or external recognition for my paintings feels increasingly secondary. The primary emphasis is creative exercise and the intrinsic enjoyment of the act. And often the process of creation is unenjoyable, tormenting, and frustrating, just as prayer may open to the difficult and confusing struggles of life.

Can you imagine people feeling that their prayers, spiritual exercises, and meditations must be exhibited in a gallery or commercially published? This simple distinction between spiritual exercise and commercial production describes the most fundamental values of my approach to making art.

Art as spiritual exercise suggests that any person can find a way to make time for the creative act each day. I don't want to encourage an overly sanctified and one-sided tendency to view art exclusively as spiritual activity. Art is a process that allows and encourages endless ways of approach and engagement. I want to keep and respect art's irreverence and incorrectness, which ironically make it, for me, a most attractive and acceptable form of spiritual exercise. I love art's way of disregarding boundaries and conventions, and my personal spiritual sensibilities need this free play with all things.

Picasso might protest mixing art with mainstream living. He felt that the arts should be "discouraged, not encouraged," so that art is forever hungry, contrary, and intent on breaking down barriers. But the master's vision may not be far removed from Wallace Stevens's commitment to the monastic practice of poetry.

I affirm Picasso's perspective as one of the many "ways" of art. The only major threat to the creative process is the imposition of a single and "correct" artist-type on society. Once we realize that artists are themselves expressions of every conceivable way of living, we can begin to appreciate variations of creative types. At an earlier point in my life I embraced the heroic and confrontational mode that Picasso celebrated. But as I continue to work with others in the arts, I have become more intrigued with the extraordinary expressions of ordinary people.

The opportunities available to the creator are as varied as life itself. This way of looking at creation establishes strong bridges with spirituality, especially traditions like Tibetan Buddhism and Native American religion, in which every aspect of the physical world is both an expression of the creative spirit and an opening to its contemplation.

When we begin with the idea that every person has an innate license to create, we confront ingrained assumptions about talent and the identity of the artist. I was recently speaking with a woman who told me that she had no creativity. Of course I disagreed, but her attitude was impermeable. Like the society at large, she had a fixed idea about the creative act, and her negative attitude toward creation was self-fulfilling.

We can have as many different kinds of creators as we have varieties of expression. But for some reason we have established cultural stereotypes about creative people. We have not viewed every conceivable way of living as the basis of a creative life. The way we label people in relation to creativity is one of the strongest inhibitions to broader participation. We are apt to think literally and exclusively about art and artists. We don't view the artist in terms of the creative aspect within every person. We are all expert at something, and the extent to which we do something unusual with this ability is largely a matter of commitment.

I have also observed that groups and communities have a creative potential that can be released under the proper conditions. However, we do the same things to groups that we do to individuals: we

label them and think about them within the context of already fixed concepts.

In my practice of the arts with groups and communities I consistently see that gatherings of people quickly tap into instinctual or tribal rhythmic expressions as soon as they surrender to the process. Voices join together and chant with a timeless pulse that lies dormant in all of us. The same thing happens with body movement. When given safety and support, groups of people using the arts will unearth archetypal rhythms and patterns.

Group improvisations also display orientations toward cacophony, chaos, and endless variations, but it is intriguing how the group will consistently merge with strong rhythmic patterns when given the opportunity. These group improvisations affirm how creative expression is an all-encompassing force that draws people into its sphere. The primary condition for participation is a willingness to become involved. Many times with group improvisations I have observed people sitting off to the sides. They make a conscious decision not to participate. The same thing applies to every other form of artistic activity. Everything depends on the person's attitude, openness, and willingness to become engaged. My experiments with the artistic process consistently show that the creative spirit is accessible to everyone.

But keep in mind that people move and act "freely" when they are allowed to do so according to their personal sense of timing. Some take longer to feel comfortable. Never push and force expression in others or yourself. Learn how to wait with a belief that every person will become involved when the time is right. Invite expression but don't judge people who may be warming-up or preparing themselves on the sidelines. Trust that something significant is always moving inside them.

The issue of talent is the most effective defense against expression. It is also a crippling obstacle when used against you. My experience has repeatedly proven that any person can express himself or herself in an authentic and intriguing way with just about any art form. Of course there are levels of ability and places that highly skilled artists can travel

with a piano or violin that I will never experience. There are aptitudes and gifts that individuals have for particular modes of expression. But these specialized approaches to artistic activity are distinctly different from the universal license to create that I have observed in every person. If we make music for pleasure, we don't have to get caught up in comparing ourselves with musicians who play as their life's work. Even when I have no previous experience with a musical instrument, I can explore its sound-making qualities and invent percussive patterns, as if I am a tribal musician coaxing a variety of sounds from a simple, one-stringed instrument.

Interest and commitment, rather than talent, have been the determining factors in almost everything I have done throughout my life. Talent seems less relevant. I consistently involve myself in new areas and take particular pleasure in achieving results in a medium where I was told as a child that I had no ability. Along with many other people I have been inhibited when singing. I've learned that the voice, like any complex instrument, needs training. We also have to learn our ranges of expression and what our voices can and cannot do. I was never trained in this way as a child. I have a deep voice and was expected to sing along with the tenors who dominated the church choirs and school musicals of my childhood. My grandmother was a voice student at the New England Conservatory and she performed operatic arias, and in my family it was felt that if you couldn't sing like that, why bother? So I focused on painting and dancing as a teenager, areas in which I was declared talented by others.

It is interesting how singing was the only mode of expression where I was never reinforced by others, and it turned out to be my area of greatest creative inhibition as an adult. In just about every other creative pursuit I recall my parents giving reinforcement. I was rarely told that I was doing something wrong, which was the case with my singing.

My experience, along with my conversations with adult artists, reveals that the quality of childhood exposures to creativity has a major impact on expressiveness later in life. On the other hand, I am not advocating early, stressful, advanced training in the arts for children,

who may burn out rather than continue the creative activity through-
out their lives. Prodigies need to exercise and perfect their gifts, but
for the normally creative child, comfortable and supportive exposures
to different modes of creative expression are best.

Year after year I see people in my art studios who have not painted
since the early grades of school. In most cases they were not in schools
or environments that provided ongoing opportunities for artistic ex-
pression. Others may have been discouraged from expressing them-
selves in a particular art form, or they may have simply lost interest or
transferred their attention to other activities. Many of us shifted from
creative expression to sports in our preteen years.

When people return to the art studio for the first time since child-
hood, I repeatedly find that they are able to express themselves with
an innate vitality and originality if the environment and materials are
right.

I cannot overemphasize how important good materials are to expres-
sion. The inexperienced artist rarely understands this and to a large
extent makes bland expressions largely because of the quality of the
media. In my work with musical improvisation I have repeatedly seen
people banging away on poorly constructed or untuned drums. When
exposed to a resonant instrument that vibrates to the slightest touch,
they enter a different world. Too often we lose interest in expressive
activities because of the poor quality of materials. If I am a beginner
playing a bad instrument, I assume that the inferior quality of sound is
my fault.

I remember the standard-issue tins of watercolor paint that we used
in my grammar school. We painted onto highly absorbent paper or on
a thin newsprint that wrinkled when it got wet. The first time I worked
with high-quality watercolors, brushes, and paper, it felt like a different
world. The materials have a great deal to do with the making of the
artist. Today's art supply stores have a wonderful spectrum of media
and colors that were never available to me as a child.

My approach to instruction in the arts has always focused on show-
ing people what the paints can do, the body, the voice, the drum. Once

we have a basic understanding of what the materials are capable of, we can begin to experiment and make our own discoveries.

My most formative experience with the issue of talent came through my work with Norma Canner, who pioneered the practice of creative movement for all people. In her movement groups Norma preferred working with the average person. She felt that they were more open to natural and authentic movements than trained dancers, who are apt to move within circumscribed and stylized patterns that display their virtuosity. For many years I observed Norma working with people from every sector of society. She would set up an environment that enabled them to explore the widest range of movement expressions. Like a Zen master she was eager to engage beginners because their movements were often more natural than experts. When we look upon creative expression as manifesting the broad spectrum of movements displayed by human beings, there is a more inclusive basis for encouraging participation.

When we take Norma's principles of creative movement and apply them to other art forms, we see that idiosyncratic and varied movements have many aesthetic values. We are all too apt to assume that only a particular type of vocal expression, painting, or sculpture has merits.

Approach your painting with the goal of expressing movements that you find natural. Don't think about your picture as a visual artwork. Engage it as a movement experience or kinesthetic image. This way of painting assures that every person has something unique to express.

Years ago I worked with a painter with cerebral palsy. He maximized the use of his particular way of moving as a basis for painting, and the pictures were visually fascinating. What some might perceive as a movement handicap became an advantage, the type of unusual and energetic graphic expression that Matisse explored by painting with long sticks.

When you look at paintings, seek out their energetic qualities. Maybe bias is the basis of every perception, so try to encourage different inclinations in your looking. My example of looking from the per-

spective of energetic forces offers a new way of seeing. Step outside the conventional standards and establish new ones. Look at pictures with an eye for their movement patterns and their vibrations. Keep enlarging your perspectives.

One of the best ways to get past the restrictions of talent is to invert convention. For example, my ineptitude for singing suggests that I should pay more attention to my voice. I remember being delighted by graduate students in the multi-arts graduate program I directed in the 1970s who arrived with extensive training in a particular art form and desired to work with one where they had no experience: the person who had a master of fine arts in painting who wanted to study dance therapy, or the M.F.A. in dance who want to focus on the visual arts. Ultimately dance helped the painter make better pictures, and the visual arts deepened the dancer's movements. In our specialized orientation to the arts, we may forget that creativity is an ecology in which all of the senses enrich one another.

If you have no experience in the arts, you are ripe for every possible opportunity. What aspects of your life seem most antithetical to art? These areas may be most amenable to transformation because their creative potential has been obscured.

Reflect upon people in your life that you and others saw as "creative." Did you view them according to stereotypic standards of creativity? Who are the people in your life that no one saw as creative? Can you apply another standard of creation to their lives and change your impressions of them? Look at your own life and see if you can detect the creative spirit in your prosaic ways.

Artistic illuminations are found in unlikely places because these areas have the potential to turn heads, medicine the soul, and infuse perception with a new vantage point on life. Implausible sources are vivid reminders that the process of creative expression will forever amaze and do its best work where we least expect results.

The presence of the creative spirit depends largely on the way we view life. The dull and mundane actions of daily life may be more artistically fertile than the wild and exuberant flashes of emotion.

Take a few minutes and try to put together your creative profile.

Do you have an identifiable style?

Do you integrate everything in your life into your expressions?

Do you have an advanced understanding of certain expressive ma-
terials—ceramics, metal, wood, fabric, paint, the body, voice?

Do you practice an artistic discipline on a regular basis?

How often do you create?

Do you prefer to work alone or with others?

Is it helpful to push against society, or do you conform and please
others with your expression?

How important is innovation to you?

Are you a completely different person when you create?

Does the creative process help to improve other aspects of your
life, or does it make things more difficult for you?

Do you need to be recognized for your creations? If so, by how
many other people?

Have you previously considered creativity as an alien process?

Do you consider yourself "talented"? Is "talent" necessary in cre-
ative expression?

As you reflect on your interests and personal history, keep in mind
that your future potential for creative expression may have more to do
with how you perceive things and less to do with "talent." If the way
you look at the world becomes more imaginative and resourceful, your
creative actions will fall into line with your vision.

In the beginning is the attitude. Everything else will follow.

THE BLANK PAGE

There is something moving in every situation.

We tend to think that paint-
ings and drawings always start in the mind and the idea is then chan-
neled down through the arm and into the hand and fingers, which
execute the mental image. This way of working in any medium is likely
to generate stiff constructions.

Why not consider that images grow through the interaction among
hands, body, eyes, materials, the painting or drawing surface, and the
mind? Images emanate from gestures, spontaneous marks on the sur-
face, and other leads sent out in advance of the composition that call it
forth. Truly original expressions can never be planned in advance. Sur-
prise rather than predictable results rule the process in which creations
reveal themselves. As creators we try to stay open and receptive to what
is moving through and around us.

A performance artist said to me, "I plan, but what comes through is
much bigger than anything I can plan or even imagine. It's actually
frightening how big it can be. I have to learn how to be flexible and
just be there to let it happen."

Skill in creation has as much to do with responsiveness as initiation.
Successful expression involves the ability to let materials and un-
planned gestures lead the way. We do not have to know where we are
going at the beginning of the creative act. People who control the work
in advance are pushing against the grain of creation, so no wonder

there are feelings of inhibition and emptiness. Creators learn how to cooperate with the forces around them.

Yet structure does help the emergence of expression. Limits can be useful. They further focus and foster improvisation and imagination.

Creation is full of these paradoxical principles. Moving too authoritatively in any one direction is sure to arouse a countertruth.

The same principles I have observed with painting and drawing apply to my experience in teaching creative writing, movement, and performance art. Experienced participants routinely advise beginners not to plan too much in advance. People find that their most inspired creations come when they are "present" and responsive to what emerges naturally from the process. Creation requires attention and complete focus. But most of all it demands that we take the plunge into new territory without knowing what will appear.

I tell my writing students that ideas will come through the process of writing, by moving the hand across a paper or tapping a keyboard. Ideas and insights emerge from engagements with words, phrases, and sentences. The purpose of the work comes from the act of doing it. Thoughts gel from the interplay among unlikely participants. Major insights and learnings come upon us when we least expect them. Nothing will happen unless I begin to write and regularly practice this particular art.

"Get the juices flowing" is a cliché that affirms this truth. I might be feeling apathetic or sluggish, but creation, like any other activity, demands that I get myself out on the road, fully involved, in order to be transformed. This pattern supports my sense that the creative spirit is something that moves from the world to us, and it flourishes when we lose ourselves in whatever we are doing.

This morning I felt little direction. It is a cold winter day but the ground is clear, so I listlessly went into the woods on my mountain bike. The first half-hour of riding was tedious, but as I kept moving, and as my body warmed, everything started to shift. The ride became exhilarating. I experience the same pattern when I am averse to teaching, driving to my office, or visiting friends. Once I get myself fully

focused, the energy of resistance is jujitsued. Maybe this is what Nietzsche had in mind when he extolled the magic of extreme emotions.

Over and over again I see that the force of transformation correlates with the counterforce of resistance. I have learned to accept the periods of frustration and blockage as an unconscious buildup for creation.

After all of my years of painting and writing, I often feel dismay before the empty canvas and the blank page. I know on one level that the absence of form is a great opportunity and that it is a necessary condition of creation. But I often envy artists like Josef Albers and Jackson Pollock who work with consistent formulas. There is always something there for them. They don't have to create something from nothing each time.

The empty space is the great horror and stimulant of creation. But there is also something predictable in the way the fear and apathy encountered at the beginning are accountable for feelings of elation at the end. These intensities of the creative process can stimulate desires for consistency and control, but history affirms that few transformative experiences are generated by regularity.

Emptiness does not necessarily mean vacuity and the total absence of matter. There is something moving in every situation. For the creator, "nothing" is a pregnant space, a capacious silence. The blank page and white canvas can be re-visioned as a material place where creative forces take shape.

If I tell a person what to paint or write, I obstruct the forces moving through that person's life at the particular moment. When we immediately tell people what to do in a studio, we alleviate the anxiety caused by the emptiness, but we also interrupt the gestation of the creative process, which may take time and maybe a certain amount of tension.

Starting to work is always the primary mode of discovery, whether in painting, writing, or any other art form. I don't sit back and wait until an idea appears. The ideas emerge through the movement of painting or writing.

The same thing applies to creative problem solving at home or in the workplace. New ideas don't come out of vacuums, and they don't

necessarily germinate inside people. They grow from an interactive process and tend to always involve putting one thing in a new relationship to something else. And they can arrive in unexpected ways. The blank page symbolizes the way new things emerge from the unknown and fill their given spaces. The empty canvas is a forum ready to create a new life.

Practice and preparation are essential even if the performance is totally improvised. Preparing for artistic expression can be compared to athletes training before an event. I might have a game plan, but once the competition starts, I respond to whatever presents itself. As I prepare to create, I gather together my materials and resources, and this individual process can be likened to actors coming together to create a play. There are many different elements that work together within the most private creative expressions.

When I am teaching performance art, I encourage people to begin with a general sense of where they want to go, but to focus primarily on being present in the particular situation. If the participants can do this, they will find that "the process" will carry them in significant ways that cannot be known in advance. I have learned that if I rigidly stick to my game plan or prepared statements, I can completely miss the opportunity to engage the energy that is present and moving through me and a given space. I always try to leave room for that.

The energy of the event directs us. The really vital material arrives spontaneously. Even if I am working with ideas or materials that I have known for years, they take on a new life when articulated in a way that issues from the forces present in a particular situation.

Stage fright cripples some and liberates those who innately know that the "live" energy of the event will carry them to new places. I find that even after many years of experience with the creative process, stage fright will sometimes arrive unexpectedly. I doubt myself and feel that I have nothing to say. I work at turning the fear into creative fuel, but sometimes it paralyzes me. I look out at an audience and feel separate from them and worthless. In these situations I remember past successes and I try to activate an expressive bravado. I realize that these

emotional ups and downs are part of a preparation process, that the fear and separation are stimulants for connection. The fear makes me focus and concentrate. I have to be careful not to overreact to the stage fright with excessive effort. As the adrenaline surges, I practice slowing down and feeling a quiet confidence. In my first experiences with stage fright as an adolescent, I froze completely and could not perform. But over the years I have accepted fear as part of my warm-up. It plays an important role in stirring creative energy.

What is your experience with stage fright? In what areas do you feel it most intensely? Are there activities where you are relatively fearless? What accounts for the differences?

My most effective way of managing stage fright involves the cultivation of a desire to express myself to other people. When I am able to view the event as a vital moment, as something that I really want to do, then I feel energized and self-assured.

Try approaching the blank page or the empty stage as a place of opportunity and openness for creative expression. It is the blankness or emptiness of a situation that draws things from us.

If you paint, start by moving freely across the surface. Concentrate on your movement and the energy of your gesture. In the beginning don't think about the quality of what you've done or what it looks like. Be more concerned with engaging the space and filling it with your expressions.

As you feel a sense of completion to your movement, pause and look carefully at what you have done. Try to withhold judgment and look carefully at the visual qualities of the expression. Go back into the painting and build on the things that interest you or areas that call out for modification.

You might want to do a series of these spontaneous movements on different pieces of paper or canvases. Study the pictures as a group. Do you see patterns and themes that you would like to develop?

Sometimes focusing on one picture alone freezes spontaneity. There is a sense of being involved in an "all or nothing" effort, which tends to generate forced expressions. When I work with more than one picture,

choices are enhanced. I am less apt to get stuck in a desperate attempt to make a picture successful. The process becomes lighter and more spontaneous when I engage a series of pictures at the same time. I am more involved with the overall movement of my expression. It is less confined.

D. H. Lawrence described how his best writings arrived "un-watched" through the movements of his pen.

The most fundamental cause of artist's block is connected to the inability to simply let go of premeditation. To pre-meditate is to strive to make something before it is made. Creative expression doesn't work this way. Creation is a process that cannot be programmed. It is an immediate meditation focused on discovery and there is always an emphasis on "epiphany," a religious term for that which arrives unan-nounced. This unplanned aspect pervades both creative and spiritual phenomena, and it is the basis for their integration.

In artistic discovery the essence of a situation is "revealed" suddenly, in a flash of recognition. Apperception and memory are vehicles for making connections between different realms of experience. Epiphanic constructions do not proceed according to predictable steps of devel-opment.

The craft of expression is inseparable from the movement from which the forms emerge. Reflex sensibilities may be more essential than intentions as creative expressions take shape in increments with one thing building on another.

Writing and painting are modes of performance. We begin in still-ness and make contact with what moves through us at the moment. If there is a resistance to expression, we acknowledge its presence and try to accept its place in our life at that moment. Relaxing with the resis-tance helps to release its negative hold on expression.

The blank page is an open stage.

Emptiness can be re-visioned as an openness to the forces and op-portunities moving through a particular situation. Repeatedly people in my art studios discover that performance art is the best way of dis-covering how to work with this emptiness. The supportive audience

that practices Carl Rogers's discipline of unconditional positive regard, is critically important. If I am to be completely present in my expression I cannot be thinking about whether or not it will please or offend people in the audience. These thoughts distract me and take me away from complete concentration on what I am doing. Some might say that this method of performing "presence" is egocentric. I disagree because the artists and the audience are dedicating themselves to the particular expressions that emerge through the performance. The artist is a medium for their emergence. The witnessing function of the audience both energizes the performance and creates the safety needed to establish an authentic sense of presence.

I encourage people experimenting with performance art to simplify their expressions as much as possible; to present themselves as images; to avoid excessive movement. If they want to use their voices, I encourage making sounds rather than speaking words. When a complicated performance is planned in advance, there is a sense of moving according to a script rather than being a vehicle for the feelings and expressions that will move through a particular situation.

You can experiment alone with performance art or with one or more witnesses. Doing a performance before one other person can be even more intense than performing in front of a group. There is an intimacy and power of focus aroused by the presence of only one witness, generating a more all-encompassing sense of presence for the performer.

If you experiment with performance art alone, you will discover a similar intensity of focus. The surrounding space becomes your witness. The completely private performance enables you to take risks and cross boundaries that you may not wish to do, or be ready to do, in front of others.

You may experiment with performance in front of a large mirror or a video camera. I have found in videos of private performances an aura of intimacy and concentration that may not be possible in front of a group of people.

The designation of performance time and place are key elements when performing alone or with other people. When I am performing,

the limits of a particular time and place are the containers of the event. They hold the performance and give it structure. I begin and end the performance, which might be as simple as sitting in front of a video camera or a mirror for five minutes together with a clock. I sit still while the clock moves and possibly makes sounds. This type of simplicity and clear imagery further the contemplative process that allows me to be present. If I am busy moving about and doing things, I am less apt to feel the process of presenting myself as an image.

I might make a fifteen-minute performance in which I look at a chair and clock for five minutes with or without a video camera, then sit in the chair for five minutes, and then look at the chair alone for another five minutes. Within this structure the act of placing my body into the chair and removing it become significant moments and acts of passage and transition. The simplest actions are intensified through this type of contemplation. Possibilities are endless.

Performance art becomes a mode of meditation that involves objects and the physical world as co-participants. I contemplate together with my surroundings.

Experimentation with performance art suggests that simple transformations of the body can create significant aesthetic images. Painting the body, dressing in a ritual way, costuming, and other subtle alterations designate shifts in time and place that create the auras of performance.

I have found it helpful to approach performance art as a ritual act. The idea of ritual reinforces simplicity, ordinariness, sanctity, heightened concentration, and the sense that something important is happening. Within a ritual every object and action has a purpose and every person is capable of playing a significant role. It is the rite more than the person doing it that carries significance. This attitude helps us become less self-conscious and more focused on our actions as meaningful expressions.

Any act can become the subject of aesthetic contemplation. In this sense there is no blank page in the world. Every moment and gesture

carries the potential for creation. Blankness and emptiness are atti-
tudes. What matters in aesthetic consciousness is the quality of atten-
tion that we bring to the witnessing of actions performed by others
and ourselves.

Reframing

*What disturbs you the most may have
the most to offer in your creative expression.*

THE MOST FUNDAMENTAL SKILL OF
the creative person is the ability to constantly re-vision the world.
Everything is subject to reconstruction and renewal. The "re" factor
is the basis of resurrecting, reshaping, regenerating, reviving, and reju-
venating. Creative persons live in a state of constant search and explo-
ration.

Creative ways of looking at the world offer endless new twists, inver-
sions, and challenges to the hegemony of any idea. The goal is freedom
of expression rather than destabilization. The creative way of looking
at the world assumes multiple truths and interactions among them.
When one idea is enshrined as an absolute over others, we experience
a rigid fixity which ultimately freezes the flow of creation.

The creative person is comfortable with contradictory truths and
constant changes because there is an underlying faith in an all-envelop-
ing process which embraces paradox and movement. As Walt Whit-
man declared, the individual person contains multitudes.

Health and social well-being are envisioned as a life-affirming inter-
play between the varied elements of the world, and the dominance of
a single position threatens the well-being of the whole. Addictions and
obsessions occur when we lose the healthy interplay, when we don't
respect different ways of looking at the world.

Creative practice requires the ability to change perspectives on a situation. People who are stuck or blocked, are locked into points of view. They keep hammering away at the same tired themes or useless patterns. They rigidly adhere to positions that others won't accept. We tend to act in this way through habit and an inability to welcome alternative ideas.

Experiment with reframing by contemplating your most elementary daily habits. Sit in a different chair at the kitchen table or in the living room. Take a walk in the morning if you always take one at night. Explore different routes to work.

The reframing process is essential to therapeutic transformation. I have found it useful to approach pathological situations with compassion rather than as a technical fixer. Look at the situation from the perspective of desire rather than correctness. What need is being expressed? By reframing the negative circumstance in terms of a positive desire, I am able to identify a life-affirming energy that can hopefully be channeled in a less harmful manner.

What useful role does the psychological illness play in your life? What does the pathology give to you? What longings of the heart are fulfilled by the political positions that repulse you or the place that you find unattractive?

In my work with people I consistently find that the most provocative and useful stimulus for reframing is the declaration that what disturbs you the most may have the most to offer in your creative expression. We can tap into the power of our discontents and use them as sources of transformation. In my perverse way, I look for the greatest weaknesses in my life, in another person's life, or the culture of an organization, with the belief that these areas are most receptive to creative alchemization. There is a power of reversal in extreme conditions that does not exist within the stable center. Symptoms are signs of opportunity, indications that other ways of operating may be needed.

In order to make use of a negative force, I have to accept its presence. I have to get beyond my anger and annoyance about its place in my life in order to do something productive with it. I've got to stop

saying, "Why me?" Acceptance prepares the way for action and transformation.

Contemplate those areas of your life where you most stubbornly resist change. Does your persistence annoy others? Does it serve a productive role in your family, work, or community? Or is your adamance a purely personal idiosyncrasy? Imagine your life without this fixity. Are you afraid to change? Will you lose your identity by experimenting with different ways of looking at the world?

Identify the areas of your life where you are inflexible. Compare these with other domains where you are more pliable. What roles do these different patterns play for you and for others? Do the differences complement one another? Where do they conflict most seriously? Why do you act differently in these situations? Is that productive?

Trace patterns of inflexibility back in time. Are they inherited from your parents and grandparents? Do you see them in your brothers and sisters? In the workplace? In your culture? Is your obduracy connected to a fear of losing something? What are the disadvantages of being in complete control of a situation? How does it affect others?

I have discovered that as I get older, I see more and more of my culture and upbringing in my actions. Even those things from which I distanced myself when I was young are manifesting themselves in my attitudes and mannerisms. For example, I am revisiting religious and political beliefs that I rejected as a young person, with an eye for what is good and useful in them. Most everything in life has many qualities, so I find myself less likely now to make blanket rejections.

When we realize how deeply ingrained certain perspectives are within our histories, we have more appreciation for the difficulties and threats of change. The reframing of old patterns may take great discipline and commitment. I have found that trying to vary something as simple as walking from the parking lot to my office in the morning can require some effort. When I experiment with these adjustments, I realize how extensively my life is structured by habits.

One of the greatest impediments to change is the fear that cherished beliefs may need adjustment. We rigidly hang on in order to protect

our integrity. Rather than looking at ourselves as flexible beings with the ability to entertain contradictory positions, we become overly attached to our ideas and opinions. We don't realize that every attitude expresses a perspective, a way of looking. If I change my vantage point in reference to a particular situation, my view will undergo a corresponding change. We become locked into rigid ideas about ourselves and our expressions and don't realize that in addition to the things we communicate, we ourselves are subject to endless reinterpretation. All we have to do is change our perspectives on ourselves and we will see a distinctly different being.

In order to understand how objects of contemplation change in relation to the perspective of the viewer, place a simple rock in the middle of your lawn or on the floor in a room. Move very slowly around the rock and notice how its appearance changes as you adjust your vantage point. There are many different ways of looking at the same rock. Change the height of your vantage point as you move around the rock. Get down low and as high as possible. Look at it close up and from a distance. Imagine what it would be like to look at the world from different vantage points *inside* the rock. Imagine the rock looking at you. The summary identity of the rock includes all of these views plus the infinitely variable ways of looking at its molecular structures, experiencing it through touch and weight, dropping it on different surfaces and from variable heights to experience sounds made through endless alterations of interactive relationships.

If a simple rock can be known in so many ways, and from so many perspectives, imagine what is possible with ourselves and our expressions. We tend to latch onto singular interpretations of ourselves and everything we do.

I ask myself what role this singularity plays in my life. Does it bring a comforting simplicity and predictability? If so, at what price? How does it obscure complexity and my potential for new ways of being in the world?

How does it restrict the range of my expression?

Try making pictures or sculptures that express your discontents. You

might find the conflict energizing. I have repeatedly seen people make images of their demons, only to get close to them. After living with the images and reflecting on them, the artists sometimes establish affections for what was once offensive. The image-making process turns the negative force into a palpable entity rather than a vague menace. Working with the image brings us into close contact with it. We find that it may enhance our expression. I might be energized by the power of my negative and aggressive image. Rather than envisioning the "negative" image as an oppressive force and perceiving myself as its victim, I create together with it. I become an agent of its expressiveness or it helps me to express myself more forcefully.

Performance art and dramatic improvisation can instantly reframe fears and troubling images. If we enact the disturbing image from a dream or a problem from work, the process always seems to take us into a different way of relating to the situation. We may even find ourselves having sympathy for the monster. Through performance we infuse the problem with our energy and expression. We move out of the passive position of victimization. We stop giving all the power to the other point of view which we perceive as negative.

The process of inverting attitudes is also the basis of many expressive skills. We paint a likeness more effectively through suggesting features than through exacting detail. Forcefulness is often conveyed with an ease of gesture. And we find that we cannot paint darkness without light. What appears antithetical is often the basis of what we seek. If we can step outside an oppositional mind-frame, we will see that expression, like electrical energy, uses positive and negative forces in complementary ways.

Try painting as if you are practicing jujitsu. Use the force attacking you as a source of expressive power. Envision the creative act as a mode of transformation that turns things around and makes something useful from everything it touches.

One of the world's most universal spiritual exercises involves establishing empathy and respect for adversaries and annoyances. In our households we typically make little "shrines" or aesthetic arrange-

ments on tables, shelves, or dresser tops, which honor people and experiences that we treasure. You might experiment with making shrines for things that bother you. Opening the heart to the disturbing situation enables us to invert its energy. I am not suggesting a form of ritual that strives to magically bring about change in another person or situation. I am concerned with transforming the attitudes and feelings of the person who feels afflicted or troubled.

Gather together artifacts, photographs, colors, materials, other things connected to the person or situation that you wish to reframe. I have observed many artists who make cigar containers and other small boxes into sanctuaries. They work with scissors, glue, photographs, magazine images, and varied materials to create aesthetic environments within the boxes. Sometimes they glue boxes inside of boxes and on top of one another to vary and complicate the spaces.

This type of art activity is intimate, and it involves the careful placing of things within an environment. It is nicely adapted to the process of reframing discontents into something new and creative. The act of placing an anxiety or troublesome experience or thought into a creative space that we have made, literally changes its place within our lives. The artistic act will often have a corresponding effect on our overall relationship to the disturbance. The use of boxes may help to keep the disturbance "enclosed" and "framed" as we work on the process of transforming its place within our lives. The glue keeps it in place.

When we use our disturbances as materials of expression we see that everything in life is fuel for the creative process. Creativity puts toxins to good use.

BLOCKS

Start working right now, from this place,
with the feelings you have at the moment.

ONE OF MY GRADUATE STUDENTS
spent months building up to writing her thesis. She was ambitious and serious about her research, but she was not meeting deadlines. The other students were much further along in their work. With only two months left in the academic year, she came to class describing how she spent the entire weekend cleaning her house, something she had never done before. She laughed and talked about how she was preparing the psychic household in anticipation of the "thesis guests" who were scheduled to arrive soon. In the coming weeks she immersed herself in the writing process and finished the work on time. Her most helpful ally was the external deadline.

Each of us has our own unique creative time clock. Some like to work away steadily and neatly from start to finish, while others delay till the last minute and build up energy that essentially blasts them into a tumultuous process of creating. There are also people who plunge into the work at the beginning with large aspirations, and then hit serious obstacles. No matter what your style may be, impediments are an inevitable part of the creative process. It can be helpful to think of the obstacles as a necessary part of the process rather than as hindrances to it. When I started mountain biking in rugged terrain, I was annoyed with the rocks covering the trails, but as I got better at the sport, I welcomed them as important contributors to the ride.

I tend to make a mess while I am creating. There are piles of books everywhere or art materials spread out throughout the studio. The clutter stirs my imagining and it becomes part of my process. The different things are like companions and helpers. They continuously play a role in the work, creating an unconscious energy field of incitements.

Creative blocks usually occur before a project begins or when we arrive at a hiatus before starting the next phase of the work. Since the block results in the inability to get the creative process moving, I find the best medicine for stuckness is action.

Get started. Don't be overly concerned with results. Just realize that quality will emerge from the connections you make during successive phases of the work.

Another common creative block, described earlier, is the belief that compositions and designs always take shape as ideas in the mind, which are then executed through the materials. Therefore, if I do not have an idea, I cannot begin to create. I call this the "control tower" concept of creation, whereby the head takes on a management function with other body parts, such as the arms, hands, and fingers, following directions. I like to counter this block by envisioning the entire body as the initiator of creation. The mind follows the initiatives of all parts of the body and thinks together with them through every phase of creative expression. If my mind is stuck, it is probably connected to the inactivity of its partners. Muscles and other bodily parts can be blocked as well as the mind. All of the expressive modalities are members of a collective, a team that excels through interactive chemistry.

Drumming helps people forget themselves and become immersed in the rhythmic movements of nature. I drum and make other forms of percussive music in my studio groups. The repetitious music furthers trancelike movement. People who at first don't know what to make of the live drumming find themselves seeking it out when it is not there. The key to this supportive music is rhythmic simplicity, which furthers reverie. Without calling attention to itself, the music invigorates and intensifies the relationship between the artist and the image.

Rhythmic music loosens the body and relaxes the muscles, which can inhibit expression when they are tight and tense. Actors routinely prepare their spontaneity through physical exercise, free movement, and vocal improvisation. The same benefits will apply to painting, writing, and conceptual creation where the instrument of the body needs to stay attuned to the work.

The materials of creation can be incitements for expression. Rather than locating the starting point in the mind of the creator, the image can be lodged in the material waiting to be formed, like the sculptor who approaches the stone with the goal of releasing the composition it carries within itself.

Impossible expectations are another major obstacle to expression. People describe the demons of perfectionism and the resulting fears of expression as well as the feeling that nothing is ever right.

Expectations are blindfolds. They come from thinking that we need to be somewhere other than where we are. Start working right now, from the immediate place, with the feelings you have at the moment.

Depression and low self-confidence are the most debilitating blocks. It can be productive, although difficult, to create from these feelings and their dark depths. The process of working may also stimulate changes in your bodily chemistry and your emotional state.

The only way to change the energy is to begin working. It's like going to the office reluctantly and then being transformed and elevated by what happens during the day.

Procrastination is one of the most persistent obstacles to creative expression. I find that something is always cooking when I am thinking about what I should be doing but not doing it. Capable people accept periods of inactivity as a necessary preparation for something new and important. I find that when I compulsively push myself, my expression tends to be forced and contrived. As difficult as it may be for me sometimes, I have to learn how to wait and relax.

But as with any other factor in the creative process, the beneficial aspects of waiting are complemented by the discipline of working on a

regular basis. Waiting has its benefits, but sooner or later I have to get moving or else nothing will emerge.

Doubt is natural and healthy. It keeps us humble, but it needs to be partnered with strong affirming voices. After periods of prolonged self-doubt, I can be catapulted into action by support from others. But on the whole my creative process has involved an ongoing interplay between doubt and confidence.

Don't underestimate frustration and discontent. They are eternal wellsprings for artistic expression. After sustained periods of being stuck, your impatience with the situation might unloose a new phase of creation. You might boldly paint over the picture you have been fussing over for weeks and discover the basis for an original composition in your burst of emotion.

One of the best ways to get beyond creative blocks is to step out of the mind-frame that sees everything beginning and ending with ourselves. If the materials of creation are envisioned as partners, we learn to follow their leads. Since "they" are not blocked, they can help us get started.

Because I am a person who needs to be creating all of the time, I work in many different areas. When one sphere dries up, I shift to another, and over an extended period of time I keep all of them going. This is not something that I consciously plan. The pattern has emerged through the process of living, and it satisfies my creative desires without burdening or expecting too much from any single area.

Creation does not occur exclusively in response to the direct calls of the muse. I do not recommend sitting around and waiting. The experienced creator generally establishes daily time frames for the work. If you practice your art on a daily basis, the discipline of working will offer ways of incorporating the different experiences you have during the day. It is sometimes the most inconsequential occurrence that takes creative expression into important new directions.

Try creating in different media over a period of time. Hopefully, you will find that these changes will help to renew your relationship to your primary forms of creative expression. Keep moving and changing.

What is your past pattern with creative imagery? Do you envision your creations beforehand or do they completely merge through the process of creation? No matter which way you operate, it can be helpful to view both your materials and your preconceived ideas as allies. The same thing applies to images of the imagination which can be approached as partners and guides.

Imagine yourself cooperating with things other than yourself— artistic media, ideas, people at work, and suggestions generated by your environment. When you focus on creative partnership and interplay, you are not alone.

Picasso described how he welcomed visitors to his studio each morning because they recharged his creative energies. The experiences with the guests had an indirect or subtle effect on his expression. Although there were few direct connections to his work, Picasso said that if no one came to see him in the morning, he'd have nothing to work with for the rest of the day.

After attending a conference or after working with a new group of people, I often feel creatively energized. Simple changes in our interpersonal or physical environments can be important inspirations for creation.

People describe that they attend my creative arts therapy studios in order to activate their expression. They need the structure and the overall environment of creating together with other people. The expressions of others activate our own.

I have experienced creativity as a spirit that flies among people and things. It is an influence that I have never felt coming exclusively from within myself. Creative people inspire me to create. If I watch an artist at work, I want to do it myself. Watching activates my desire to participate. It suggests, invites, and shows the way.

You might go and watch an artist friend create or just visit and talk within the other person's creative environment. In addition to receiving an infusion of the creative spirit, you might be of reciprocal value to your host as in the case of Picasso's visitors.

Are there people or places in your life that you visit in order to

receive creative energy and inspiration? Recall instances where watching someone created a desire for participation. Remembering these experiences may rekindle desire.

Creativity is an appetite, and if it is blocked it may be because we have lost appreciation for what exists outside of us. Blocks are commonly caused by becoming immersed in ourselves and in limited experiences. We cease imagining.

Some of our most useful stimuli for creative expression are indirect and subtle. Just as acupuncture to one part of the body treats a problem in a different place, we find that doing something in one area of our life generates an effect in another sphere. Talking with people may generate expression in a painting. Riding in a car might stimulate a poem on a theme that has nothing to do with the car ride.

It is impossible to offer exercises to encourage these effects because the process is circuitous and highly individualized. My experience indicates that a broad range of experiences facilitates expression in every medium. I have also benefited from working in varied media. Paintings are a useful way to prepare for performance art because they generate images and offer focal points for dramatization. When I continue to engage the themes of my expression in performance, I revitalize my paintings, and so forth. One creative act is the stimulus for another. The painting stimulates a story and the story shifts to body movement and vocal improvisation, which inspire yet another series of paintings.

Opening the varied channels of expression expands options and possibilities. This approach lightens the burden of "breaking through" or "overcoming" obstacles. Rather than concentrating all of our attention on the problem and intensifying the resistance, or digging a deeper hole, we step aside, try something else, and see where it takes us.

MOVING BETWEEN
WORLDS

The creative process is an ecology that depends
upon the full spectrum of our resources.

THE BEST WAY TO QUICKLY EXPAND
the scope of creative expression is to actively experiment with different
roles. If we envision ourselves as actors, we can try out new ways of
being in the world. As an artist who does other things in my life, I find
that the essential skill of the creative process involves the ability to
move between "worlds" or different ways of being. Through the
expansion of my role repertoire, I begin to show myself that I am capa-
ble of acting in new ways. I actively seek out challenges to expand my
relations with the world.

The more conventional view of talent keeps us specialized and lim-
ited to a particular sphere of action throughout our lives. If you do
something well as a child, that particular mode is considered to be your
way of creating. In earlier times a childhood gift was channeled into a
career and something that one did throughout one's life. My bias on
creation favors sustained experimentation and learning. I prefer to
change roles, and even if I happen to work with the same creative
modalities throughout my life, the adventures into other areas invari-
ably deepen my skills in the sustained disciplines. This approach to
creation is consistent with the new landscape of the workplace, where

the average person makes many career changes. We can no longer expect to do one thing throughout our lives, and we need a new psychology of the creative process to support these shifts.

An art teacher I know who studied art history in college and art therapy in graduate school still thinks that she should have stayed with the interest in drama she had in high school when she played Dorothy in *The Wizard of Oz*. When she sees friends from college acting in films, she feels anxious about whether she is doing the right thing with her life. She has recently begun to act again in summer theater but still thinks that she might have chosen the wrong career path even though she loves working with children in the art studio. When I look at her life, I see fullness and variety and the realization of my ideal of total expression through the arts. But in our society we continue to perceive ourselves in terms of a single function. We are apt to view ourselves as one thing and nothing else. My friend does many things, and she does all of them well.

We don't realize how often we change roles during a day. We think that we're the same person in every situation and don't realize how we unconsciously play out different aspects of our personalities in response to environmental cues—the screaming maniac who surfaces when cut off on the highway immediately shifts to the kind comforter when a client calls on the car phone. The person who can't stand you in a certain work situation can't believe that you're the same person when you are relaxed and joking.

We've all grown up with the stereotyped pictures of the domineering boss at work who meekly takes orders from the family at home or the drudge at work who is omnipotent at home. I am concerned with a more subtle interplay of roles, like the ability to shift from being a passionate speaker to a quiet and attentive listener in the same meeting; from patient reflection to active motion when working on a project; from leadership to following in collaborative enterprises. This sensitive interplay among roles is required when I paint, write, dance, make music, and perform.

A writer friend used to tell me that single-octave living is boring and

unproductive whereas the creative enterprise is chordal and multifaceted. An integrated way of living involves constant movement from one thing to another. Everything is changing in the world environment, so successful relationships require ongoing attunement. If we approach the most habitual daily activities with the consciousness of an actor, we'll become more aware of these shifting roles and more skillful in their use. The talented actor is the one who can play many distinctly different roles, as contrasted with the actor who works exclusively within a stock type.

Mix the roles you play. Put them into new combinations and infuse the most routine activities with imagination. Voices, gestures, and facial expressions change as we take on different roles. When you try different tones of speech, different vocal rhythms and physical gestures, you discover yourself behaving as a very different person. For example, I notice that when I am insecure, I stiffen up and overexert myself, perhaps speaking louder than usual or talking too much as a way to compensate. I don't do this when I am more relaxed and confident. I am a distinctly different person in each of these roles, and I constantly seek out new roles and challenges when the familiar ones become too easy.

In what areas of your life do you think you are most expert? Try approaching them as a complete beginner. Practice watching and listening as if you knew nothing about that particular role.

Surprise people by taking on new roles in situations where you have been most predictable. Stand up and speak in the meeting or class where you usually sit quietly, or be passive in the group where you are known to talk too much.

Don't expect your first attempts to be perfect. Give yourself time to experiment with the new roles. As a rule you need to feel comfortable in order to perform consistently well.

When conflicts emerge at home or at work, try a different way of responding. If your typical response is to rush in with solutions, sit back and watch. If you are usually passive, offer help and guidance.

Take a risk if you are characteristically on the fence. Trust the process if you always have to be in control.

Is there anything you do in daily life that is so effortless and pleasing that you feel like a dreamer? Do you have skills in this area that have been refined through experience and practice, or does your comfort in the role just come naturally to you?

Think of areas in your life that are more difficult for you. Identify the sources of discomfort. Can you approach these difficult situations as though you are engaged with something effortless? In other words, can you play a different and more graceful role?

Try acting as though you are different characters. Mix up your role repertoire and don't be worried about appearing mad. These exercises assume that all of us are composed of multiple aspects and that the notion of a singular persona is a facade, a false front.

Imagine that each of the characters you play has a distinct job to do or a particular function to play in nourishing the soul within a complex world. The outraged complainer contributes to getting things "right." The compassionate listener helps others feel better about expressing themselves.

Contemplate the different creative types that inhabit your psyche. The solitary dreamer, the energetic team player, the organized planner, the intuitive wanderer, the calm and reflective observer, the enthusiast, the adventurer, the humble listener, the fearful isolationist, the confident participant, the serious caretaker, and the entertainer. Each of has a community of types within ourselves.

We tend to get into trouble when one of these characters takes over. This domination either gets us stuck or causes us to lose sensitivity to the communal interaction. For example, I have a strong predilection toward order and neatness. When my expression is exclusively governed by this tidy aspect, my paintings become fussy and overworked.

The creative process needs varied ingredients. My penchant for order has to step aside and take a break while the more impulsive and spontaneous gestures make their contributions. At the appropriate time my gifts at cleaning up and organizing will have their opportunity

to contribute. Others will have a different interplay going on within their expression, but there will always be an orchestration of different contributors. The capacity to permit and integrate these varied qualities is a distinguishing feature of creative acumen.

When we are dominated by a single aspect of expression, there is a hegemony that hardens into fixed patterns of behavior. This one-sidedness and intolerance of contradiction arises in organizations as well as within our individual lives.

The creative process is an ecology that depends upon the full spectrum of our resources. Effectiveness involves an ability to move among changing scenarios while coordinating the different aspects. I've learned from my work in organizations that the integration of the varied aspects does not necessarily involve control over them. They need to be encouraged and nourished as well as criticized from time to time. Leadership requires the ability to pass among different worlds, attentive to all of them while staying unattached to a single point of view. Composure and personal balance are traits required of leaders who engage these different and often competing worlds. Each one has to be fed and nourished, but the leader cultivates a vision that encompasses all of the contributors to the overall composition. Leadership of complex organizations closely approximates the essential dynamics of the creative process. Domination by a single aspect arrests the interplay of the whole.

Leaders are in special need of exercises that emphasize flexibility, balance, and nonattachment. I read about a Mexican shaman who practices his balance every day by walking across a narrow board. He describes how his healing practice requires him to walk between worlds, and he needs excellent balance for difficult passages. The healer has to be keenly attuned to the immediate situation and yet capable of letting it go in order to engage the next phase of experience.

Try training your physical abilities as a way of perfecting your mental insight and emotional sensitivity. As you perfect balance and endurance in these physical domains, they will influence the wider sphere of your actions.

The ancient principle of similarities is based on the realization that actions in one sphere influence events in corresponding areas. We are once again realizing that everything is connected and that creation requires an ability to move in sync with the interplay.

Imagine yourself as a leader of "a creative organization" that exists within your personal experience. When you take on the role of coordinator of the dynamic interplay, you are less likely to be dominated by a single aspect. You realize that you need all of the different contributors and you avoid attachment to one "department." In our daily lives we easily take on the role of advocating a particular point of view and do not realize how this attachment interrupts the deeper ecology of creation. It is more challenging to establish empathy with all of the participants in a situation.

For example, I watch young art students become so attached to creating a representational likeness that they overlook the movement, textures, spontaneous gestures, and compositional interactions that constitute a successful picture. A one-sided orientation to spontaneous and primal gesture may be equally problematic. A successful picture is always an orchestration of varied elements.

While making spontaneous paintings, give different personalities to your gestures. Let the big and dominant lines or brushes interact with the tiny and sensitive ones. Empathize with each gesture as you make it.

Introduce other expressive roles into your picture—the bold and aggressive one, the shy and hiding one, the playful and joyous character, the serious and calculating type, the quick and jumpy line, the relaxed and steady stroke. Personifying your gestures will add yet another dimension to your improvisations and help you access novel expressions. Imagining your different gestures as "persons" is a poetic way of thinking that is the basis of empathy.

You can also experiment with these character "types" in your vocal improvisations, body movements, drumming exercises, and other forms of creative practice. The range of characters serve you as expres-

sive allies. They help you to forget yourself and to work as though an autonomous force is moving through you.

Don't worry about "losing" yourself as you create. The self-conscious personal identity is only one of many aspects that live within a person. There are many more expressive roles available to us. Artists speak fondly of the poetic madness that possesses them in their most inspired moments. In order to create freely we need to get beyond our self-consciousness and especially beyond the attitude that we have limited gifts of expression.

If you tend toward order in your daily actions, experiment with the expressive chaos and imbalance. If you are generally impulsive in your habitual ways, focus for a while on orderly and calculated movements. Try to access unfamiliar roles. There is tremendous energy in whatever is antithetical to the norm.

In my painting studios I often encourage people to respond to the pictures they make through creative movement and vocal improvisations. Although silent contemplation is always the most natural and primary way of looking at art, we find that bodily expressions enlarge and sharpen perceptions. When we interpret creative expressions with more of the same, and through other expressive modalities, we become immersed in the process and the energy of the artworks. In contrast to these artistic responses, I have observed how verbal explanations tend to distance me from the images. However, a poem, a story, or a dramatic improvisation, just like movement and vocal expression, will heighten the impact of another artwork. Creative responses to artistic expressions and life experiences almost universally draw us closer to them.

As you begin to work with new movements and roles, give them plenty of time and sustained practice. Nothing will sink in and become an ally unless you stay with it and move through all of the predictable "approach and avoidance" phases of a new relationship.

To orchestrate the varied contributors to the creative process, we need what I call the discipline of flexibility. Many people are able to change quickly and move in new directions, but their actions are not

always characterized by self-discipline. We have all experienced what it is like to change abruptly and carelessly, to feel ourselves being tossed about aimlessly and without regard to a studied direction of any kind. I experience this type of change as chaos rather than creativity. Pandemonium has its place within the creative act, but the overall process is ultimately governed by disciplined sensitivity and effective expression. The other antagonist to disciplined flexibility is rigidity and the inability to change.

As I examine my experience with the creative process, I see a clear history of my personal interaction with flexibility and rigidity. I like to think of myself as flexible, but there have been many times when I have been locked into rigid attitudes.

How do we bend and accommodate different points of view without losing our guiding principles?

I have found it most helpful to practice this disciplined flexibility through experimentation with different roles and points of view. When I am practicing flexibility and attunement to different perspectives, I feel more grounded and secure than I do when I am rigidly adhering to something. We tend to exclusively identify morality with rigid adherence: "Thou shalt not," rather than "Try acting in this new and different way." Great visions are always malleable, pragmatic, and open to influences from others.

My inflexibility tends to be most consistently activated by the rigidity of others. I find myself getting caught by the position that I abhor. My response ultimately completes and feeds an oppositional situation.

Theater gives us all the opportunity to experiment with roles and different perspectives on life. The gifted actor is the one who is capable of authentically playing the most detested and despicable characters. The actor cannot succeed without the disciplined flexibility that I am describing. There must be an ability to take on any role and use ourselves as instruments to articulate the position as fully as possible.

We can practice the dramatic discipline within the sphere of our personal likes and dislikes. Who are the people with whom you are in conflict today? In the past? What is it about them that triggers you?

What is it about you that responds to the provocation? Where are you most flexible in your experience? Most rigid? Observe how you become captured and restrained by your antagonism; how it blocks the view of the complete landscape.

Imagine yourself becoming the person or situation that annoys you the most. Let go of your frame of reference and take on the other's. Imagine yourself presenting the case of the person who irritates you. Speak for that person as convincingly as you can. Introduce humor. Imagine the person describing you and your point of view. Do the best you can to relativize yourself and your opinions. Envision them as participants in a larger drama. What roles do they play? How do they feed the situation?

As I practice these exercises, I feel my hardened positions becoming more flexible. I realize how they possess me. I view myself with more humor, and I see how absurd it can be when I get caught in a rigidly fixed position. I see how it interferes with my overall flexibility and effectiveness. I see how powerful and restrictive attitudes can be. When I view myself as an actor, I want to expand my role repertoire. I realize how important it is to be flexible and adaptive.

These obsessions can be likened to what happens when I am painting a picture or writing a story and I become so involved with a particular detail or part that I lose the movement and interaction of the whole This is one of the most common problems with creative work in the arts and life. We simply get caught, stuck in a rigid attitude, invested in its illusory importance, and we stop seeing the more comprehensive movement taking place around us.

Give a place of honor within your life history to those positions that most consistently evoke your inflexibility. Appreciate their purposefulness and the roles they play. Try to be more playful and clever with them. Cultivate a better understanding of what sustains them. As you move freely between their worlds and yours, the boundaries between you may become less distinct. You will begin to see them as aspects of your own experience that fuel your life drama. The objective of your

experimentation with them will be a more flexible way of moving in the world.

I find that the best way to practice flexibility with the areas of my life where I am most rigid is an indirect method of training. Expressive fluidity in one area influences other things I do. As I become more elastic in my artistic practice, there may be a corresponding effect upon a problematic area at work.

Head-on attempts at change are often apt to strengthen resistance. As I practice the artistic flexibility exercises that I have described in this section, they have an effect on my more comprehensive behavior. I become more pliant, limber, and capable of acting in new ways. I feel the benefits attached to taking on new positions. I realize how they enlarge my vision and my ability to relate more spontaneously and generously to situations. They show me how limited my habitual attitudes may be.

As we move among these different positions, we appreciate how everything is far more interconnected than we first realized. The creative ecology is subtle and far-reaching, and it requires the ability to pass freely and sensitively between worlds and attitudes.

3

EVERY EXPERIENCE
HAS SOMETHING
TO OFFER

*Everything that we perceive and feel potentially
contributes to the creative vision.*

KARMA OF SIMPLE ACTS

Small, subtle, and improbable gestures
are always major contributors to the creative process,
which is a complex gathering of influences.

WHEN I LISTEN TO PEOPLE DE-
scribe their feelings of powerlessness in relation to the movements of
mass society, I perversely consider the places where everyone has
power. Lasting changes and improvements are made through the cu-
mulative effects of individual actions. Heroic figures grasp the oppor-
tunities of moments and perform in a way that catches the imagination
of a civilization and mobilizes a collective response, but even these
actions ultimately receive their power from the responses of ordinary
people.

I experience the process of making an individual artwork in the same
way. Many simply resign themselves to powerlessness and say, "I can't
do it. I'm not creative." We tend to leave creation to artists who take
on heroic roles in the public consciousness.

I knew a man who wanted to change the world through a people's
cultural revolution that would rise like a tidal wave. He was frustrated
by the lack of attention his books received. "I'm sitting here waiting
for the revolution to begin, but nobody comes."

He was a talented writer who never achieved public acclaim. At the
end of his life he was alone in his house. He couldn't walk upstairs, so
a small bathroom was built next to the library where he spent his days.

Visitors came and sat next to the fire with him as they had done throughout his life. He was known for gracious hospitality and rich conversation. I was one of the close friends who came to visit, and I always left the house transformed, feeling distinctly different than when I arrived. I realized that the revolution was taking place within the walls of the house, through person-to-person dialogue. He affected and changed people through his interactions with them.

I don't see my friend's life as a failure. He influenced me and many others. He was a vital part of his community.

I am less interested in what people profess than what they do. Watch how they live, how they treat people and things, the care they give to the garden and the house, what they do for the community, how they arrange things in their homes and apartments. Maybe there is more creative power in private acts and intimate reflections than sweeping revolutionary movements.

What do you do every day in your home to enhance creativity and imagination? Creation is an aggregate of many small things as well as bold actions.

I envision creative transformation in a microscopic way with simple gestures making vital contributions to the whole. I don't feel that the most lasting changes are made by sweeping and heroic acts. I am more interested in the small and subtle things, the contradictory influences like my friend's writing about world revolution and not realizing that he was changing the world by the way he served coffee and tended the fire.

We think it is only the leaders and major creative personalities that have the power to change the world, and we overlook the powers of caretakers, maintenance workers, and housekeepers. The small and intimate aspects of daily nurturing and care affect the world in ways that we do not always see.

We feel that home is farthest removed from the centers of power and creative influence, when it may be the opposite. There is an unrealized creative power that exist on the peripheries of our lives and in the small things that we do within our personal environments. Simple actions

may effect the most lasting changes. Within this vision of creation the neighborhood becomes a fertile milieu for creative practice.

Imagine neighborhoods where each house is a museum of domestic creation. The inhabitants can be viewed as curators of the things on display and the presiding soul of the place. We can be more mindful of places and things. We can do more to care for them and the creativity they express. The way we treat the objects of the earth creates the imaginative realm in which we live.

Why is it that the person who does imaginative things every day to fill a domestic environment with creative spirits is not viewed as an artist? Why does art have to be limited to expressions sanctioned by "art world" gatekeepers?

There are more people writing poetry than there are readers of poetry. This is a good sign for the world soul, but expectations need to be adjusted. The stage for poetry has to relocated. If we accept the home and small community gatherings as places for sharing art experiences, creative expression takes on a new potency, in line with its true power to change the world through the aggregate of microscopic acts.

There will always be a need for individual artists to rise to a world stage, the great ones like Shakespeare who challenge us to work with a similar excellence, paragons of creative virtues who inspire us with their gifts, craft, and disciplined practice. This modeling is different from the culture of novelty that pervades so much of the art world, which is on the verge of a necessary transformation. If the celebrated artists of the moment are ultimately insignificant in the broader history of creation, this should teach us that there is a place for every person within the creative process of a civilization.

Throughout the Western world, people are gathering to create together in groups. I met a woman in Houston who dances with a sacred arts group that "prays through sweat." Millions of people are turning to creative writing, painting, dance, pottery, and music as a form of soulwork. There is a sense that spiritual practice needs palpable expres-

sions. One of the driving forces is a pervasive call for creative community.

We can begin to think in terms of communities of creation rather than persist with the notion of individual artists creating alone and generally being condemned to isolation. These communities of creation value the idiosyncrasies of individual expression.

One of the great obstacles to creative expression is the assumption that a few minutes of effort should yield dramatic results. We don't realize that even the greatest artists often advance inch by inch with the different elements gradually finding their place within the whole.

This incremental aspect of art may seem to contradict everything I said earlier about free improvisation and spontaneity and perhaps it does. Creative expression is permeated by contradictory forces and experiences. What works today might be futile tomorrow. The process of creation thrives within an inverted world where everything I say can be turned inside out in relation to the experience of another person. This is why creative types have such a difficult time with rigid orthodoxy and doctrine. The process of creation can never be scripted through central casting or a ministry of correct behavior. Creation is forever individual and it always involves an accumulation of small acts as well as decisive strokes and sweeping integrations.

The many little things that we each do during the process of creation gather in different configurations every time we approach the creative act, and it is impossible for them to crystallize in the same way from one experience to another. We never know whether they are constellating in a way that will move freely and quickly or whether they will get congested and stuck.

Patience is one of the most important qualities of creation, especially for anyone who wants to begin making art. The results cannot be pushed. Everything emerges in its time. Even experienced creators find it difficult to accept that the gestation period of an artwork might be prolonged with few signs of progress. There may not even be indications of inch-by-inch progress. Days, weeks, and months may pass without any signs that the work is moving forward.

Ultimately, we can trust that every purposeful action contributes to the complex ecology of creative gestation operating outside consciousness. Creation cannot be reduced to a linear sequence of causes. Small, subtle and improbable gestures are always major contributors to the creative process which is a complex gathering of influences.

In the beginning of this book I described how repetition can further free expression. Experiment with making artworks that require the repetition of small gestures over extended periods of time. This exercise becomes a restful meditation, and it is gratifying to see how the tiny gesture that appears insignificant when it stands alone contributes an essential part to the total composition. The simplest way to practice this approach to art is to make thousands of small strokes on a surface with a pencil, pen, or paintbrush. Don't be concerned with what you are trying to make. Just allow yourself to become immersed in the strokes and lines for their own sake. You can do the same thing with dots of color. Layer them on top of one another and you will see how small actions contribute to larger expressions. Like meditation, this way of making art takes time and does not yield instant results.

Whenever I make art with these repetitions, it gives me great pleasure, but I rarely take the time to do it. I tend to create with large gestures that immediately begin to shape an overall composition. My usual way of painting can be likened to Japanese brush painting and watercolor painting, where a single stroke of the brush can become a major part of the picture. The process of building a picture from thousands of small strokes is antithetical to my way of creating with large and spontaneous gestures. When I experiment with these repetitions, they always offer a new insight about the process of creation. In my most recent exercises I rediscovered the pleasure that repetition brings. The process of building a picture from thousands of strokes also gives me the opportunity to carefully watch how a composition emerges, as contrasted to the sudden emergence that occurs when I work quickly with large and decisive strokes.

I have a friend who makes paintings that combine different types of expressive gestures. He has a place usually around the edges of the

surface for his repetitious expressions, and then he moves spontane-
ously and boldly within the center. The small, repetitious strokes on
the outside make an enclosure and sanctuary for the dancing move-
ments inside.

Computer graphics utilize these small gestures, which can fill a large
area with a click of the mouse. But don't take shortcuts in the begin-
ning. If you use the computer tools that instantly fill a surface with
thousands of dots and lines, you will miss the benefits of the meditative
process. The computer is a wonderful tool, but you will appreciate it
more and use it more skillfully if its graphic techniques are related to
your own gestures.

Van Gogh and the impressionist painters used small brushstrokes
across the entire surface of the canvas to interpret scenes from nature.
As you experiment with the process of constructing images from small
gestures, you can begin to use this way of working to represent scenes
and objects as the impressionists did. But try in the beginning to stay
with the small marks for their own sake. As you continue to experiment
with them as pure forms and gestures, they will suggest further uses in
your expression.

A similar method can be applied to carving wood, chiseling stone,
or molding clay. Stay with the strict repetition of a single gesture and
watch how the little expressions contribute to an overall effect. This
way of making art analogizes to the spiritual effect of the *mitzvah*, the
performance of good deeds that is the heart of Judaism. Small and
well-intentioned actions ultimately contribute to a greater effect. We
build a positive karma of creation through the little things we do within
a larger process.

Cut spools of malleable wire into small sections of the same size and
twist them together into a construction. Glue beans or colored beads
onto a hard surface. Cut waste paper into small identical sections and
make piles that you then fashion into aesthetic arrangements. The pur-
pose of these creations is to honor the small actions that permeate all
of our lives. As you work, reflect on how the artistic acts that you
perform relate to the small and often overlooked things that you or

other people do within the broader context of life. Keep these works as icons and reminders.

If you feel that you are relatively insignificant in comparison to the heroes and heroines that characterize the public imagination of the arts, liken yourself to one of the small gestures that contribute to the larger impact of an artistic expression. Every one of us has something distinct to offer to the all-encompassing process of creativity.

DISTILLING

*As we contemplate physical forms, we discover
a corresponding structure and focus in our lives.
They help us to see ourselves.*

ALL FORMS OF CREATIVE PERCEP-
tion extract essential features from nature. Artists strive to get to the
heart of life, to the core of matter, and they are known as much for
what they omit from their interpretation of nature as for what they
include. In the creative process, "seeing" is as important as "doing."

Let me demonstrate ways of distilling essential features from the
perception of daily life. Try looking at your environment as a composi-
tion of forms and colors. Find the purely formal relationships and
rhythms within your surroundings. As I do this exercise, I look in a
very different way at the windowpanes in my room, the floorboards,
the fireplace, and the trees in the yard. I start to look at the major
planes of the surrounding landscape as distinct forms and masses of
color. The white snow on the field extends to a wooded hill, and above
is the blue sky. The top of the hill curves and makes a definite shape
when I look at it as an entity unto itself rather than focus on the multi-
tude of trees that cover it. The narrow cove between me and the hills
intersects the landscape with a bold horizontal shape.

Contemplate the spirits and energies conveyed by the structures of
your environment. How do they affect you? Do you see different ex-
pressive qualities whenever you meditate on your home environment?

As I look around the room where I sit, I see rectangles, circles, straight lines, and curves. I have never looked at the room and the familiar objects exclusively in terms of their shapes and lines. Looking in this way helps me to focus on the way the physical space expresses itself and influences me. How do the circles in your environment affect you? How do they contribute to the overall atmosphere of the space? What do the rectangles express? Curved lines?

I continue to look at the room from the perspective of light and dark colors, illumination and shadow. In order to look in this way, I have to focus on certain qualities while not paying attention to others. I begin to see how the different shapes relate to one another, how they contribute to patterns and perceptual movements. Nothing is completely isolated in that there is always a connection to a neighboring shape, and each part that I perceive is ultimately an aspect of an all-encompassing space.

I recently met with a group of college students to discuss artistic ways of looking at the world. The students were not art majors and I wanted to demonstrate how the way we approach perception will strongly affect what we see. I described how Marcel Duchamp took a commercial bottle rack and exhibited it in an art gallery as a work of art. When we remove an everyday artifact from its functional environment and place it in an artistic context, we have an opportunity to view it as a thing unto itself. When I look at the bottle rack in an art gallery I am apt to be attentive to its purely formal qualities. We can also look at everyday objects with imagination as Picasso did when he made an image of a bull from the seat and handlebars of a bicycle.

I drew the students' attention to a four-by-six-foot configuration of translucent glass bricks on the wall of the room. The glass was framed by a wooden molding. The opaque glass bricks were designed to provide illumination together with a degree of privacy. I remarked that these blocks were commonly used during the 1950s and 1960s in the New England construction industry and that they are much more common in places like Florida. One student described how her grandmother's house has glass bricks around the front door and she went on

to say how much she dislikes them. As a New Englander I've never liked the look of the glass bricks in this region, but I find them much more attractive in Florida, where they seem to fit the local architectural aesthetic.

I asked the students to put aside all other previous feelings about the glass bricks and to look at the configuration on the wall as if it were a work of art. I described how an artist might take the same configuration and exhibit it in a museum as a serious artwork. We spent considerable time discussing what we saw when we looked at the configuration of glass bricks—subtle variations in color, different shapes created by the reflections of light, the repetition of qualities within an overall pattern.

The students were dubious of the significance of looking at ordinary things in this way. They were hesitant, and I sensed them saying, "What's this got to do with art? Those are just ugly glass blocks on the wall." But as they continued to reflect on the glass bricks, they were surprised at how much more they began to see in a visual configuration of which they were previously oblivious. I described how the artist or the person who meditates on the physical appearances of the world sees things that others do not see, and that this awareness heightens the experience of life. Sensory awareness also brings satisfaction, enjoyment, and a deeper understanding of what is taking place within a given environment. The results may be purely contemplative or they may help us act more effectively in different life situations.

The distillation of essential shapes and patterns from complicated scenes can be one of the therapeutic qualities of the creative process. In creative arts therapy we also encourage the poetic process of making metaphoric connections between the physical features of artworks and personal experiences. When we make analogies between artistic expressions and our lives, the images help us see patterns and themes. They give us a physical structure or template to hold over our lives. The visual configuration offers a basis for comparison. It elicits stories from us. As we look at the physical structure, it activates thoughts and

memories. The perceptual form evokes a corresponding sense of structure within otherwise undifferentiated life experiences.

In creative arts therapy images are perceived as guides and helpers. We follow their leads and adopt their purposefulness. Poets similarly work with the interplay between perceptions of the physical world and emotional experience. In the poetic process physical things are personified. People and things correspond to one another. In poetry and creative arts therapy, there is an assumption that there are many mutual influences between physical expressions and human emotions.

Are there essential forms and configurations that permeate your life? Is there a central focal point? Many different focal points?

What colors do you associate with the different phases of your life? Is there a color that pervades every period of your life? One friend who has made several pilgrimages to India has formed a strong attachment to the combination of red and green that is popular there. Not only does it remind her of her spiritual journey, but she also says it has released her from the exclusively Western association of red and green with the Christmas season.

Look at your life in terms of illumination and shadow. What stands in the light? In the darkness? Do the same thing with circular configurations. Are there aspects of your life that have followed a circular path? What experiences do you locate in the center of your life circle? On the circumference? Completely outside?

Are there straight lines that run through your life? Consistent and unwavering conditions and commitments?

How about zigzags? I have many of them in my history. Ups and downs. Ins and outs. Radical shifts and returns to old commitments.

There are also many broken lines in my life experience. Large spaces between things. These gaps and intervals are significant. Like the spaces between figures and forms in a painting, the gaps contribute to the composition. Try reversing your perception of the gaps by viewing them as shapes. What is happening within the gaps? What do they express? What do they contribute?

As we contemplate physical forms, they help us to see ourselves.

Are there formless qualities of your life? Experiences that cannot be identified with physical structures of any kind?

It might help to apply the principle of simplification and distillation to a recent event in your life. As you reflect on the experience, think of yourself as an artist who must omit aspects of the scene in order to focus on a particular message. Imagine yourself "cutting to the quick." Paint out irrelevant or bothersome details. Delete anything that interferes with the primary sense that the scene wishes to convey.

Elimination is essential to concentration. When you can't find the way through a situation, it might be better to reflect on what is already presenting itself. As you choose what to omit, you indirectly select what to keep.

There can be a tremendous pleasure attached to deleting and throwing out materials that obstruct the flow of what you are trying to express. We tend to hang on to bothersome things, trying to make them fit into our lives like parts of a painting or a story that just don't belong. Keeping these things obscures the essential message we are trying to convey. Moving along can be as simple as designating the unworkable sections and hitting the delete button on your keyboard.

Negativity is an important aspect of creation. Zen Buddhism finds the way to spiritual fulfillment through imperfections. In describing the "marrow of Zen," Shunryo Suzuki said, "Those who find great difficulties in practicing Zen will find more meaning in it."

Experienced artists as well as beginners continuously experience difficulties in getting to the core of the creative spirit. There is no blueprint or map. Even success presents its particular obstacles to accessing the "marrow" of creative expression. Once a style of expression is ingrained, it has a tendency to become a superficial formula. There comes a time when I have to let go of a successful theme or way of working and intentionally immerse myself in uncertainty. The loss of the creative spirit is an eternal condition for regaining it in a new way.

Getting to the core involves a realization that we are in a process that is much bigger than ourselves and that all we can do is make contributions and connections between things, one day at a time, one

instant to the next. Trying too hard to find the essence tends to keep us on the periphery. The most vital expressions emerge when we are most relaxed, when we simply immerse ourselves in the immediate environment and trust that something significant will appear.

Eliminating things from a composition is one of the best ways to get to the essential statement. Yet there is probably nothing that is more difficult for the experienced artist as well as the beginner. We become attached to whatever appears in our creations. My thesis students find it excruciating to throw anything out. I have the same trouble myself when I am working with a manuscript. Experience helps, but there is always the nagging fear that I might be tossing the best part. We all know how what is despised today can be adored tomorrow.

Getting to the core through elimination goes counter to the human instinct to save and hoard. We grow attached to whatever enters our environment and accommodate to its presence. The perennial garden has been my best teacher on the process of elimination. If I don't regularly thin the plants, the roots will choke one another. They get too thick and cluttered. The same thing happens to a painting or drawing. The forms need breathing space and light in order to be seen.

We never know for sure whether we may have painted over a future masterpiece or trashed the best page in the manuscript but the process of creating requires taking these risks. The measure for making deletions in art is the determination of whether it feels right or not, whether the composition "works," and whether we like it. There are few laws and the procedure tends to operate according to personal taste.

I approach the making of deletions with the realization that they are a necessity. I cannot get to the core unless I eliminate the clutter and distractions that obstruct concentration on the essential message. There are phases in the making of a painting or the writing of a book that resemble cleaning out the barn, the attic, or a cluttered closet in order to gain a renewed sense of spaciousness, and a better use of the environment.

Edward Hopper is one of the best economizers in twentieth-century

painting. He takes you right to the core of a scene. Georgia O'Keeffe does the same thing with her flowers and spaces. But even in the highly complex paintings that we see in galleries and museums, their creation probably involved many eliminations.

"Rubbing out" and "painting over" are essential techniques for every artist. Practice these skills by covering a surface randomly with oil pastels, which are one of the most receptive media to being covered by other colors. Eliminate sections of the picture by randomly covering them with different colors. Notice how much easier it is to go from light to dark. Use your finger to rub out areas and create different kinds of atmospheric effects through the merging of colors.

As you work in this way, try to think very little about what the overall composition looks like. Let the total expression emerge from your actions. Keep experimenting with the process of elimination and realize how each deletion simultaneously adds something new. As every door closes, a new one opens. There is an ebb and flow to the process.

Your objective in this exercise is to experience how covering and eliminating create new shapes and compositions. I like to scribble over sections of oil pastel drawings with soft ebony pencils. The black lines take on an intriguing new life in relation to the colors of the pastels, which are similarly enriched through contrast with the lines. Try to think exclusively about what the materials are doing and very little about the end product. This type of experimentation will add significantly to your repertoire of expressive gestures and ultimately help you to produce more satisfying pictures. But for the moment immerse yourself in discovering what the materials do.

Some people might prefer to look at the process of getting to the core of an expression from the positive perspective of construction, while others prefer elimination. "Erasing" is a technique that reaches back into our childhood experiences. Try covering a heavy-quality paper surface with charcoal or with marks from a soft pencil that you spread with your fingers. Make an image by erasing areas.

Gesso is a multidimensional painting medium. It is used to prime canvas or any other painting surface, and you can use it to paint over

sections of a picture. Cover a canvas, board, or paper with paint in a random fashion. Use different colors or limit yourself to two or three. Randomly cover parts of the surface with Gesso and watch for the shapes that emerge in the colored areas as well as the new white forms created by the Gesso.

Another expressive gesture that is based on elimination and addition is "building" the surface of the painting, as I described earlier. As you apply colors on top of one another, you "build" the image.

Many artists prepare surfaces with thick mediums and then add sand and other substances to enhance texture. Try working in this way as a purely sensual experience, like a child playing at the beach. You will discover how different surface qualities affect the appearance of an image.

Attach layers of paper on a Masonite or plywood surface with glue. Add scrapes of cloth and other materials that will adhere and vary the appearance of the surface. Keep pasting the materials on top of one another with the goal of making a sculptural relief. Cover the surface with gesso or a latex primer from the hardware store. As you work, you will experience how every addition eliminates what went before. The forward-moving process of expression requires deletion. Think of your previous gestures as contributions to building the image.

In the artistic process and in daily life, it is always challenging to eliminate and let go. Today's foreground becomes tomorrow's background.

Whenever we abstract an essence from a life situation or perception, we simplify, select, and delete. Edward Hopper's paintings offer vivid illustrations of this process. The artist sees configurations of shapes and colors in nature, and he conveys these perceptions in his paintings by elimination as well as through positive presentation.

Look at your surrounding environment with the goal of abstracting essential elements. In order to do this, you have to look beyond details and discover structural underpinnings. Drawing and painting from nature require the ability to distill fundamental forms and to let others go.

Drawing from memory helps the process of distillation because we do not retain everything. Forgetting plays an important role in extracting the marrow from a situation.

Look carefully at a figure, object, or scene and then turn away to sketch it from memory. Don't worry about getting the structure right. Your sketches are interpretations that distill qualities.

Be forgiving when you look at your memory sketches in relation to their subjects. Don't worry about exactness. As you practice this exercise, you will find yourself looking differently at things before you sketch them. Your perceptions will begin to extract essential structures from the surrounding environment. Sketching will help you to look more thoroughly and to see more.

You can practice these memory exercises by simply looking at a scene and then closing your eyes and remembering essential qualities. As you do this exercise over and over again, observe how your memory images select certain qualities and overlook others.

Oftentimes we miss the subtle shadows and reflections of light in a scene when we are looking for dominant features. Practice looking at the shapes created by light and shadows.

Learn to see what exists outside consciousness. Sit in a sunny room and seek our subtle qualities that you normally do not see. Look for the sharp lines and shapes created by the interplay between light and shadow. Reflect upon the wavy reflections on glass surfaces, the patterns created on wood by light and shadow, the spaces between objects, the images reflected on hard and shiny planes.

The experience of an essence may be enhanced by a proliferation of things. One state gives rise to the other. Complicated and dense configurations, packed with details, may be more helpful to your meditation on essential elements than minimalistic scenes. The many choices offered to your senses in every situation require concentration and an intensification of your relationship with a particular quality of the environment. What I am describing as distillation is nothing more than a heightened and focused relationship between ourselves and something that was previously unseen.

GATHERING AND
ARRANGING THINGS

*If you are convinced that you have no artistic
abilities, start gathering things. Keep them and
arrange them into aesthetic configurations, and you
will find that the things will initiate you into the
world of design and creative expression.*

W HENEVER I SEE PAINTS AND
other art supplies, I feel inspired to do something with them, but I have
worked with many people who find them intimidating at first. If we
focus the creative process on the home and its artifacts, we can all ex-
press ourselves with materials and things that have personal significance.

One of my graduate students makes objects and framed construc-
tions with personal objects that contain her personal and family his-
tory. She takes doilies made by her grandmother, charms from her
childhood bracelet, ribbons connected to special events and memories,
a match cover from a cousin's wedding, a snapshot, and uses them to
construct a composition that is visually pleasing. It also generates an
intensely intimate and sacred aura. The constructions are mounted on
velvet and other fine materials and elegantly framed. The high-quality
construction of the frame enhances the sanctity of the contents. The
works look like treasuries of memory, enshrinements of the past and
the family.

An artist friend, Dana Salvo, has been taking photographs for years of home altars made by women in the United States and Mexico. During religious feasts the shrines are constructed with arrangements of flowers and different religious artifacts. Personal objects and photos of family members are also woven into the displays. They give the shrines a distinctly individual and artistic appearance, as contrasted to displays made in churches and other public places. The personal memorabilia make the shrines a living extension of the household. Photographs of deceased relatives are often included, and they deepen the spiritual sense of the shrine. Loss awakens intimacy. The use of photographs or simple objects connected to a beloved person infuses the creation with emotion.

These home altars elegantly display the interplay between distillation and proliferation that I described in the previous section. The viewer experiences a vastness conveyed by the arrangement of numerous objects. Yet there is a sense of order, as with a large bookshelf covering an entire wall. The gathering of diverse things is itself an expression of unification. The pieces come together in an overall sense of ritual and aesthetic purpose. Anyone can create an equally wondrous and impactful artwork. The only requirement is a willingness to commit the household space and the time for collecting the objects and constructing the display. As a way of preparing to make artworks from arrangements of materials and artifacts, take some time to contemplate what is already going on in your personal spaces at home or at work.

Sit in any room in your house or apartment and observe the things you see. What do the objects say about you and your past?

Look at the objects in the room, the space itself, the way things are placed in relation to one another. Ask yourself what your sense of beauty and intimacy wants in this room.

If the room is sparsely furnished, clear and open, or if it is full and densely furnished, what desire does the arrangement express? Looking from the perspective of longing can help you see your living space in fresh and stimulating ways.

Look at your house or apartment as a museum. How does it reflect

your personal interests and family? Where are the most sacred places in your home?

Every home, even the most secular one, has shrines that were constructed without any sacred intentions. They are often gathering places for artifacts, stones, photos, and objects connected to loved ones or memories. Walk through your home and identify your shrines. What do they give to you? What spirits do they convey?

Have you created healing or magical spaces in your home? I have a friend who built a stone throne for his wife in a secluded corner of their garden. Do you place things in particular places in order to influence the energy flow of the house? Do you make votive shrines expressing a desire or sense of gratitude? Have you ever made a talisman?

Set up a worktable and prepare a hard surface to receive an arrangement of your personal things. Masonite or thin plywood can be covered with fabric, burlap, or paint. You might want to make a collage with textured papers and pieces of cloth.

Gather together memorabilia that you would like to enshrine in an artwork and try out different arrangements on the surface. Overlap things and make patterns with them. Think about the visual qualities of the arrangement together with the personal and symbolic significance.

I keep most of my "memory objects" in a dresser drawer in my bedroom and rarely look at them. Making an aesthetic display can further appreciation for these artifacts. If the arrangement is flat, you will be able to frame it with a glass cover. If the display is more three-dimensional, you might construct a display box with a glass cover that can be hung on a wall.

As with the design of rooms, you might want to experiment with different styles ranging from dense gathering to open spaces. The individual objects will convey different expressions in relation to the types of environments you construct.

Many people arrange displays of small objects in the sectioned wooden containers that printers once used to organize blocks of type. Each small thing or tiny selection of things has its place within an

individual section of the display. The visual impact of these artworks is usually pleasing and intriguing. The structure of the container generates a comprehensive sense of order for the plethora of things within it. Simple organizing devices like this make it easy to create aesthetic and evocative arrangements.

I have also seen many fascinating home arrangements on simple tables, shelves, and radiator covers where diverse collections of things seem to gather without any particular organizational scheme. Refrigerators will similarly display fascinating visual configurations and arrays of family memorabilia and symbols.

Some people are more apt to keep their collections of things in private places. A friend has an extensive display of personally significant objects in a basement room. I have made personal shrines in office closets and other personal places. Not everything that we make is intended for public presentation.

I am most apt to make arrangements of things in my office environments. The things fill the workplace with imagination and a sense of personal presence. I find that most people have some type of creative display going on in their workplaces, and often I will consciously visit offices as though I am going on a gallery tour. The things collected and arranged in offices give a sense of intimacy and connection to work. In factories people similarly place personal artifacts and symbols of their machines. We still carry out the most ancient ways of using artifacts and talismans to establish a sense of our presence in and connection to the world.

Consider expanding your experimentation with object constructions to include impersonal things and found objects. As you select and gather things, keep them, touch them, look at them, and work with them, you will find yourself bonding to these objects. Creative activity builds intimate connections with things that previously had no significance for you.

Further your compassion for the physical world by working with things that you would normally despise—plastics, Styrofoam, junk, and commercial materials that are mass-produced. Look at them with aes-

thetic fascination and their place in the world will be transformed. Get involved with their visual and tactile qualities. As you look at them over time and commit yourself to caring for them, they will become participants in intimate expression.

I have an artist friend who makes surfaces from industrial tackboards. She gathers junk and assorted objects, new and old, and she nails, glues, and sews things into patterns. I envy her methods because I would love to spend more time collecting and putting old and assorted things to a new and creative use.

These arrangements of objects have archaic ties to the shamanic use of power objects and familiar spirits. Gather together grasses, sticks, stones, flowers, and other materials from nature and make object arrangements with them. Tie and weave them together in bundles and hang them from a pole. Make patterns and designs on flat surfaces.

These art forms are truly for every person. Whenever we gather together things that have significance to us, we feel an immediate spiritual and aesthetic sense. The pressure to make something from nothing that we may feel before a blank page is absent, as the substances already exist; the creative process entails simply putting them into new configurations and relationships.

If you are convinced that you have no artistic abilities, start gathering things. Keep them and arrange them into aesthetic configurations. You will find that the things will initiate you into the world of design and creative expression. Stay with the process and it will expand. Every object expresses itself in some way, and we can begin our creative work by simply paying close attention to them.

You might expand your gathering activities by constructing environmental artworks in your yard. I have artist friends who go into fields, woods, and marshes and work together with the things that grow there to make environmental artworks.

I see my gardens as environmental constructions and creative spaces where I gather many different kinds of flowers and forms of plant life. The garden is my most satisfying creative work, perhaps because it is ephemeral. It comes and goes, and it offers me my most direct links

with the creative forces of nature. In the garden I create together with nature and its movements, which take place without my direct involvement. The garden displays itself to me. It creates while I am away, and it stands as a reminder of how every creation is a collaboration with forces outside myself.

PLAY AND ORNAMENTATION

The creative imagination requires a certain abandon and disregard for results, which often paradoxically generates the most useful outcomes.

A FRIEND WHO TEACHES ART TOLD me how she helps her students to put aside their intention to "make something." She described how she wants them to be in a *relationship* to the materials they are using. "They will paint better," she said, "if they're *in* the paint." Otherwise, she said, "they're at the end of the process."

Immersion "in the paint" can be likened to play. In a playful exploration of artistic expression, I trust that one gesture will generate another and another and then another. The overall process can be viewed as ongoing, without a single finishing point. Samuel Beckett once said, "I have never in my life been on my way anywhere, but simply on my way." This goal-free state of inquiry is well known to the imaginative artist, scientist, and meditation practitioner, but it tends to be the most difficult aspect of the creative process to convey to the beginner.

Although the pure process of artistic and imaginative play is a relatively carefree and relaxed condition, I don't want to give the impression that access to this realm is always easy and without conflict. Most of us encounter many distractions and doubts when trying the enter

the relaxed state of expressive play. We keep forgetting that truly creative results happen by grace rather than effort and planning.

Being "present" during the process of creation is one of the most essential skills of the artist. Some of us try too hard, push too forcefully, and expect too much. Others are reluctant to risk opening themselves to the unknown. And there are those who are forever distracted, focusing their thoughts on places other than their immediate surroundings and engagements. Playful experimentation with art materials is an antidote to all of these maladies. Play requires an attunement to things other than ourselves and it is characterized by a pure commitment to the immediate process of creation. When we disparage play as nonproductive and wasteful, we are viewing it from the perspective of end results.

When playing with art materials and expressive possibilities, the most fundamental advice is, "Withhold your desires for outcomes." You don't want to be at "the end" of the process when you are just beginning or in the thick of it. You have to be where you are as completely as possible. Free play is the best way to achieve this state of committed presence because there is no expectation beyond the activity pursued for its own sake. In keeping with the pop adage, "Wherever you go, there you are."

Although play is often described as aimless, I observe how there is always a purposefulness inherent in any sincere activity. Random play paradoxically builds and constructs a particular type of artistic configuration.

If you are a serious person who cannot take the time for whimsical activities, you can approach play as one of the most earnest ways of being involved with the creative process. The primary obstacle to serious play is a person's inability to take play seriously. As the philosopher Hans-Georg Gadamer said, "Only seriousness in play makes the play wholly play."

For the adult and older child, play can be viewed as a "discipline" because we have typically grown far afield of this way of relating to the world. "Competent" play requires the ability to forget oneself.

Start by ridding yourself of the idea that play is subjective and ego-centric. It is actually the opposite. Play requires immersion in "other-ness." I get out of myself when I play and I enter an imaginative realm that is a distinctly different state of being.

When a group of people play together, the overall effect of the experience depends upon the extent to which each participant is able to be totally committed and open to the collective activity. In groups we become infused with the overall energy of the communal effort. Groups are able to carry us along, and this also accounts for their negative influences on people.

I recently participated in a series of creative arts therapy workshops with a large group of people. The leaders engaged us in different art activities and interspersed comments about the therapeutic purpose of what we were doing and how it could be applied to work with patients. I observed how my experience in the workshops had very little to do with the psychological and clinical explanations of the leaders and much more to do with the effects of working and playing together with others. The impact of the workshop was directly related to the extent to which I committed myself to the exercises that I did with the group. We could have done just about anything together and there probably would have been a similar result. Group play is transformative when we commit ourselves to collective creation.

Successful play engrosses the player. There is a feeling of ease and relaxation. If we are able to let go and subordinate ourselves to this state of being, it will invariably effect us. The medicines and spirits of play are like those of meditation, and the benefits are proportionate to the degree to which we are able to lose ourselves in play. I might feel stressed and preoccupied before an extended play session and I leave feeling relaxed, fluid, and focused. Adults may have as much to gain from play therapy as children, but we invariably seek out problem-solving and analytic therapies. We see the latter as serious and useful. Immersion in the state of play works more directly on both the body and mind. It is a very potent and valuable medicine.

If I am able to play with art materials, I act with a relatively low level

of self-consciousness, and I surrender to pursuing the activity for its own sake. I might make a series of lines or shapes across a sheet or paper and then make other shapes that relate to them. I do the same thing with colors and lines, continuously building upon the ones that went before them. In the play with materials, our plans or expectations never get ahead of the process of responding to what is before us. This pure immediacy of expression distinguishes doodling and playing with materials from art projects oriented toward a particular type of end project.

Artistic expression probably originated in the urge to decorate and make ornamental markings on bodies and everyday objects. Ornamentation exercises are one of the most universally accessible ways of beginning to practice creative expression, since every person knows what it is like to doodle and playfully build shapes from other shapes.

The making of mandalas utilizes artistic urges for play and ornamentation. Children naturally make mandala configurations by drawing circles and then dividing them into quarters. The mandala, or magic circle, generally involves some combination of circular shapes and fourfold division. The structure gives a sense of order and a template that is capable of holding and supporting highly differentiated embellishments within a simple overall form. The symmetrical sections of the mandala encourage repetition and a trancelike approach to artmaking. Because of these qualities the creation of mandalas has been widely used in art therapy and in the practice of meditation.

If you want to spend an extended period of time making a mandala in a highly ornamental and playful way, work with colored pencils or fine-tipped markers. These materials enable you to make elaborate and sharp details. They also require many strokes to cover even a relatively small surface. The abundance of strokes and repetitious motions facilitate meditation and reverie.

Begin by drawing a circle on your painting surface and then divide it into four or more parts. You can let your dividing lines go through the circle and to the edge of the page. Start in the center with a shape of some kind, and build on it by drawing designs out from the center.

You can also include figures and symbols in your design. If you work microscopically, the time element will be extended as well as the meditational elements of the work.

People will sometimes work for weeks on a single mandala configuration. Carl Jung went through a period in his life where he made a mandala every morning as a form of personal therapy and reflection.

Try to draw with a sense of abandon, and don't think too much about how the different forms and colors relate to one another. The overall structure of the mandala will always generate a sense of visual cohesion.

You can also create mandala configurations with three-dimensional materials and collage. Use utility knives to cut paper and magazine photographs into small sections and then glue them onto a firm surface with the goal of making a symmetrical design emanating from the center. Make a pattern around the border of the surface, and your mandala may look like an Oriental tapestry.

I have worked with artists who make mandalas by gluing thousands of colored beads to a solid surface. Others have made their designs with beans, small stones, sticks, colored yarn, strings, ropes, sand, or a combination of many different materials.

After exploring mandalas you might feel a desire for a less structured way of creating ornamental designs. I find that free play with highly ordered configurations inevitably elicits more random designs as a counterexpression. Playful action usually involves an ongoing oscillation from ordering and building to scattering and breaking apart.

Aboriginal art is often characterized by compositions that combine human figures, animals, and other natural things with designs and ornamental configurations. Try making a figure or object and then surround it with spontaneously drawn configurations. Approach the making of these designs and ornaments as though you are doing a free association exercise. Make whatever marks emerge instinctively. Don't hesitate or hold back an urge. Fill the surface with as much activity and elaboration as you can, and don't worry about making pictures that look bizarre.

You might find that personal symbols and your own unique designs will emerge from this free play. When you find something that you like, repeat it in another picture and build upon it. This is how style and personally distinct artistic contents emerge. Play becomes a mode of experimentation and emergence.

For too long people have thought that a fragmented and strange picture is an expression of a corresponding mental state within the artist. Fragmentation and elaborate ornamentation can be perceived simply as aesthetic ways of organizing a pictorial composition.

Many thoroughly sane and well-adjusted people make fragmented and strange artworks. If we worry about what our pictures say about us, playful discovery will be arrested. The creative imagination requires a certain abandon and disregard for results, a condition that, ironically, will often generate the most useful outcomes. The formative forces of chance and accident have to be given an opportunity to shape our expressions.

I have discovered that mixing visual configurations with random writing across a picture generates a particularly fluid form of expression. Maybe there is a child in all of us who wants to write all over a surface.

Graffiti is one of the most liberating forms of expression and artistic play. There is a sense of expressive delight and a shattering of convention when we magnify and exaggerate our habitual repertoire of handwriting gestures. Because graffiti has ties to taboos against expression, I find that taking the liberty to scribble words, phrases, and whatever the hand desires allows us to tap into a certain shadow power. The normally restrained and proper person is given the opportunity to write randomly and make chaotic marks all over a surface. Many of us will have difficulty at first letting loose because we are so used to controlling our handwriting and graphic markings into conventional forms. I find that truly chaotic graffiti pleases my aesthetic sensibility. The expressiveness of the configurations corresponds to their kinetic abandon.

You might actually consider "practicing" graffiti making as an ex-

pressive discipline. Make a series of paintings over time with the goal of becoming freer in the graffiti-making process. As you develop a sense of abandon in your expressive gestures, you will able to transfer these ways of making marks to other artmaking activities.

If you fear this type of expressive release, remember that there are boundaries to the painting surface that you are using. The surface will accept whatever you do. It becomes a sanctuary, a designated place where you can let go with normally forbidden ways of expression.

I remember a police officer saying to me in the former East Germany, "Das ist verboten" (That is forbidden). I can imagine myself starting a graffiti painting by scribbling those words over and over again, maybe hundreds of times, until I exhaust their repressive power. There is such energy in the words, in the way they were said to me, in my reaction to them.

Explore phrases and words that hold similar positive and negative powers for you. The words are truly "loaded" with energies that you can use as allies in expressive art.

When we play alone with art materials, we are enshrouded in an intimate and quiet relationship with the imagination, which acts as a silent partner. I find that my play with art materials can be likened to creative movement and dance. As I lose myself in the process, I become a medium for creative gestures. Repetition helps me to let go of my inhibitions. Repeating myself curiously helps me to make new and fresh gestures which emerge from the rhythms and patterns of sustained movement. Reverie is induced from repetition.

If you want to experiment with meditative patterns in an orderly way, work on a large sheet of paper and start at the top by making a small gesture in the right or left corner and continue making this mark across the sheet of paper. Make a second line of marks below the first and introduce a slight variation. Continue all the way down the page by making variations on the line above.

You can really lose yourself in creating patterns by making two different line configurations, which are then repeated down, up, or across

the surface of the paper. Endless combinations and repetitions can emerge from your first explorations with designs.

Make designs on flattened slabs of clay by digging into the surface with a stick. Do the reverse by making designs by building up the surface with lines and shapes of clay. Try alternating patterns cut out of the clay with others built onto it.

Patterns can be made by sewing thick threads and yarns onto fabric or by printing shapes across a surface. These different repetitious activities allow the artist to become an agent of the overall design. Virtually any material or object can be used to make patterns. In one of my art workshops, one of the participants worked for two days making varied designs and compositions by printing with a single leaf. She rolled different colors over the leaf with a brayer, and the experience became an extended meditation.

Random expressions with very little repetition introduce another element of aesthetic play. Meandering and wandering lines immerse the artist in expressive gestures which create labyrinths, arabesque designs and other configurations.

Some people are unable to surrender to aimlessness because they fear losing themselves and don't realize that the structure of the art material or the limits of the physical space will always act as a container for our expressions. We generally find that our most seemingly chaotic play with materials reveals an underlying structure because every physical gesture is constituted by movement patterns, what dancers call efforts and shapes. Some movements are bound and tight whereas others are free and open. We never have to fear the absence of structure when we are expressing ourselves in play.

Contour drawings offer the opportunity to combine free movement with the representation of objects and figures. Look at something and allow yourself to draw its form with flowing contour lines. Try to keep your pencil, pen, or brush on the surface as you draw. Imagine yourself touching the contours of the person or thing you are drawing. Be playful and relaxed with the lines and let them go wherever they want and don't worry about faithful likenesses. As you continue to work in this

way, your unique style of drawing will emerge. Study objects carefully and use them as guides but allow your contour lines to have their personalities.

You will find that your expression will improve and become more authentic as you become better at play. Craft will emerge from your extended experimentation and your new thresholds of ability will open doors for discovery. Creativity involves an incessant exchange between play and technical mastery.

AT WORK

Sit with what you already have,
and dream with it in a new way.

THE PRACTICE OF CREATION IS NOT
limited to the artist's studio or writing room. I envision the future
practice of the arts embracing the workplace.

When we view perception as a primary facet of creative expression,
then the scope of practice can include any activity. I am especially
interested in those parts of life where we spend so much time and that
we disassociate from the creative arts. These places will be a future
wellspring for creative transformation. Nothing can approach the
workplace in terms of this unexplored potential.

Imagine consultants coming into an organization to help people
look at their most routine daily actions, movements, conversations,
frustrations, and physical environments as extensions of the creative
process.

Can you conceive of someone asking you, "What does the work-
place give to your creative spirit? How do you exercise the imagination
within this environment? What are the qualities of the space that stim-
ulate you? What can we do to make the place more amenable to cre-
ation? How can the environment help you to do your job better? How
does the energy currently circulate through the space?"

The first thing I say to a fed-up worker, and to myself from time to
time, is, "Imagine life without this place, this job, and the person who

is bugging you. What will you be doing? If you've got a better option, do it. If you stay, what are we going to do to change the situation?"

After fifteen years of being a program director and dean in a graduate school, I had the opportunity to move into a senior professorial position where I was supported in my creative work. For the first time in my life I had ample time and freedom to follow every artistic impulse, and I found that I was missing the things that disturbed me the most during my previous life—the constant interruptions, the pressures of deadlines and crises, the demands of the environment, the teamwork, and the overall process of people paying attention to me in positive and negative ways. These difficulties are the unavoidable ingredients of life in the world.

Prior to leaving the deanship, I complained that people were only engaging me as a role and not as a person, but I soon realized that every aspect of life is a role, a mask, and the key for me is having the freedom to play as many of them as possible. I have learned that work gives me the opportunity to exercise sensibilities that are distinctly different from what I experience with family and close friends. Creating in my studio is very different than creating with a team of people in an organization, and I need these different aspects of practice in order to feel complete and creatively challenged.

When we find ourselves irritated and complaining about work, we might first imagine ourselves living without the sources of our discontents. I have been fortunate enough to have had the opportunity to try out different lifestyles, and I have learned that physical change is not in itself a lasting solution to the soul's discontents. Changes in attitude and perspective are far more satisfying. Therefore, the best practice is the exercise of re-visioning what we take for granted. If I approach the routines of daily work as a creative process, they become my familiar spirits.

The office worker, like the artist, needs repetition as a familiar base that enables something new to spring forth at the right time. When I lose my repetitive structures of daily life, I am thrown into a place without companions and allies. I lose the external structure that carries

me through the day with a sense of purpose. I don't deny that work environments and repetitious actions can be repressive. But we are too quick to polarize our negative reactions into complete denials of the creative value of workplaces. We've established cultural stereotypes of organizations as places of conformity and artistic studios as independent and free. Today we may be seeing the beginning of a global inversion of these attitudes. A return to the medieval collective spirit of creation may be closer than we realize.

If repetition at work is annoying you, try to embrace it mindfully. Fighting against it can be futile because the essential rhythms of biological and physical life require repetition. When we surrender to the repetition, it carries us to a new place. Give the repetition in your work the same aesthetic value as the repetitive art exercises that were described in earlier sections of this book. The creative process utilizes repetitious efforts in both the office and the studio.

At work we can practice the meditation exercise of dreaming with the commonplace activity. As I let go of the need to constantly control my environment, the person who interrupts my thought arouses my ability to shift attention and welcome the unexpected arrival.

When a person interrupts my concentration, I think of the ancient traditions of hospitality that welcome unexpected guests as visitations of the gods. Whatever crosses our paths unexpectedly can be viewed as an infusion of the creative spirit in our lives.

The most routine actions of the work environment can be viewed with fascination—the gestures of moving paper, answering a phone, reading a memorandum. When the meditation teachers emphasize "sitting," they are giving us the essential metaphor of creative and spiritual practice—sit with what you already have and dream with it in a new way.

In addition to exercising the creative imagination by contemplating the workplace in new ways, we can use the energy of the environment as fuel for creation in the arts. At a point in my life when I was frustrated with what I perceived as a split between my job and my desire to paint pictures, I spent a couple of years sketching during meetings,

lectures, and free moments. I then went home and made paintings from the quick studies I had done at work. It was the best therapy I could have ever been given. I was doing something creative with work imagery that I previously saw as alienated from art and imagination. I liked the pictures and exhibited them as "art alchemies." I was taking the situations and feelings that were disturbing me and turning them into gold.

If art is a transformation of daily experience, why not consider moving it into the office? What is it about our culture that insists on separations? A more comprehensive exercise of the creative spirit within the workplace may be profoundly good for productivity and the bottom line. The imagination flourishes through the use of all of its faculties, and languishes in compartmentalization. What appears to be most foreign may in fact have the most to offer the re-visioning of the enterprise.

Creation is a circulation of energy. It is always putting things into new relationships within a continuously interactive process. We promote creativity in work environments by introducing varied sources of energy and letting them find their way to solving a problem.

For years I've imagined what a large company would be like if it provided studios for art, dance, voice, music, and creative writing on the premises. Why not give workers a chance to exercise the creative spirit in the place where many of their tensions and conflicts are located? Imagine the implications of transforming stress at the job instead of taking it home or discharging it somewhere else. Employees do aerobics and other bodily exercises at work, so why not consider extending opportunities for exercising creativity? Creative expression will infuse the workplace with imagination, new perceptions, and different ways of interacting.

I recently went to an art opening where poets recited verse written in response to the paintings. Consider doing this in response to different areas within the workplace. Invite dancers, musicians, and performance artists to prepare works that transform spaces. Ask them to

demonstrate how to improvise in relation to a space, an object, or a situation. Try it yourself.

On the job, creative areas can be perceived as power plants, places where energy is transformed and recirculated back into the system. The individual will feel relief and renewed imagination as a result of creative practice in the workplace, and the overall environment will emit an inspirational aura, continuously charged by the expressive materials.

Rather than hanging only the art of "outside" professionals on its walls, the corporation can feature images "made from within."

As the workplace becomes increasingly high tech, the cultivation of low-tech expressive faculties will enhance the creative ecology and productivity of the environment. But I do not want to overlook how digital communications and tools enhance what we may create from our desktops.

The images on computer screens are a new frontier for the creative imagination. Drawings and photo images can be scanned and sent instantly to many people around the world. New software makes it possible to paint on the screen through the movements and clicks of a mouse. Experiment electronically with all of the exercises for painting and drawing that I have described. The forum for presenting images has been extended to every online screen. The same applies to creative writings. With personal computers, "work" is becoming a very different place with a new generation of opportunities for communication. Workers have liberties to explore and communicate that will continuously reshape our sense of reality and expression. The studio may exist on every desk.

The work environment offers yet another paradox of creative expression. We are overwhelmed with demands and things that have to be done, and we react by longing for more free time to create. We assume that we will be more creative when we are dislodged from the daily regimens that ask so much from us. I find that creativity is generally viewed through the lens of romantic isolation from the world rather than from the more realistic perspective of romantic immersion.

We still see creativity as something that exists exclusively within ourselves rather than within the activity of our environments.

Recent trends in retirement are beginning to correct these notions. As people choose to return to productive and creative work environments even when they are under no pressure for subsistence, we will increasingly realize the important role that these places play within our lives. We need the daily structure and purpose, the camaraderie and social interactions with others, the sense of mutual accomplishment and the knowledge that we are contributing to useful activities that are benefiting others. We begin to see that the workplace is nourishing rather than depleting. It can be a place of creation rather than stifling toil. The workplace gives us a chance to exercise and use our gifts and skills.

I don't think we have begun to collectively shift our attitudes toward viewing the workplace in a more creative way. The changes are taking place subliminally. Because we have so thoroughly separated the place of work from the practice of personal creation in our assumptions about creativity, there is a potential for a major reversal. We have overlooked the community of creation and the imaginative interplay that occurs within groups, and we still continue to think of creativity within the stock type of the individual artist working alone.

I find myself thinking about creativity from the conventional perspective of individual achievement even as I reflect upon how I create together with others at work. I tend to think almost exclusively about what I do within the organization, what I contribute, how I create, and how others incite and fuel my creation.

The workplace becomes a very different place when I imagine myself as an observer of the creative things that others do, as a participant in collective creation that expresses itself like a chorus or a pageant. I begin to view myself as fortunate in being able to participate in the more comprehensive spectacle, the community effort of creation, which energizes me together with my colleagues. We create something together, and there is a deep satisfaction attached to this.

When I have the opportunity and the freedom to choose what I will

do every day of my life, I find myself wanting to be part of the group creation that is achieved through the disciplined effort of the workplace. Like everyone else in my generation, I have thought too literally about work as a job, as a way to make a living, something that I must do in order to survive and support a family. When we have the chance to take the economic necessity away from labor, we discover that we need the workplace for survival of a different kind. We need to be inspired and influenced by others on a regular basis. We need to be part of a collective and creative purpose in order to persist with full vitality.

The workplace is a rich source of stories. Tell tales about your most extraordinary experiences at work. Your most banal moments. Who are the most memorable characters from your childhood jobs? Get together with one or more friends and tell stories about the people you remember from your childhood work experiences.

Who are the strongest and most unusual personalities in your present work environment?

We are so busy working with one another that we rarely take the time to tell stories about the interesting things that happen during the day. Tell a story or brief vignette that describes your present workplace.

Make up a story about yourself at work. Approach yourself as a fictional character, and take liberties in descriptions about events. Feel free to exaggerate and embellish.

Try telling a wish-fulfillment story about yourself in a perfect work environment.

Make up fictional stories about characters who are based upon people you know at work. Tell these stories to others and try writing them down.

The process of creating stories will help you understand the experiences of friends in new ways. If you tell stories from the perspective of a place or an environment, you may find yourself gaining new insights and transformed attitudes about work. Every person is capable of tell-

ing intriguing stories, and it is something we all do in our daily lives without perceiving the process as particularly artistic or creative.

Stories help us to expand our imagination of work. They give us a more complete view of what is happening every day outside the scope of our habitual consciousness. Storytelling ultimately affirms how our work environments are among the richest sources of experience in our lives. They are also the places where we generally fail to exercise the broad spectrum of our creative abilities.

Work is a story that needs retelling. When we find ourselves telling the same stories over and over again about work, we are letting ourselves know that there are important things that we overlook every day. No matter how tedious the job may be, people and circumstances are always changing. There is always a new story waiting to be told about some nuance of our daily experience. We need to make myths from our daily lives and ennoble the things that we typically overlook. Mythologize and make heroes and heroines from the deeds of the people you see every day. Elevate their significance and the value of your work environment, and you will find yourself and your imagination rising with them.

VISION

*In the creative process, one action leads to
another, and the final outcome is shaped by a chain
of expressions that could never be planned in advance.*

Visions are made from the stuff
of everyday life. Françoise Gilot in *Life with Picasso* writes about how
artists draw from their "direct experience of life whatever quality of
vision" they bring to the creative process. She describes how she had
to "break out of the cocoon" in order to create.

The creative spirit makes use of everything that happens to a person.
It sees beyond the limitations of the immediate situation and uses ad-
versity as a source of inspiration. It thrives on challenge. When de-
scribing her performance of Shakespeare, Shelley Winters said that if
something disappointing happened in her life, she would always use it
in her acting. If an actor experiences a painful loss or tragedy, that
setback becomes the basis for envisioning the experience of a character
who is expressing suffering.

In traditional societies, visions are received and not made. They are
bestowed upon persons by the Almighty, often against their intentions.
Those who receive visions must be ready to change and respond to
opportunities that fall upon them. In the shamanic world, visions al-
ways come upon the person from external sources whereas our current
idea of creative inspiration is oriented toward something emerging
from within. In my experience the process of creation involves an in-
terplay between internal and external influences.

We might go in search of visions, but the process of seeking is a preparation for a new way of approaching life. The defining quality of the visionary is a desire to change the world in a positive way. The visionary wants to contribute new life or revive something that has been lost.

My father once said to me that people who are obsessed with success don't really achieve it. He emphasized the importance of doing the best you can with every project without concern for personal gain. When you live in this way and enjoy what you do, the vision of your life takes shape unwatched.

The advice I received from my father suggests that it is good to maintain a certain degree of suspicion in relation to our visions. It is possible to have a pervasive sense of a direction and potential without becoming too obsessed and demanding of yourself. Creative visions can't be forced and willfully achieved.

Have you ever been directed by a vision? How did it take shape? Was it yours alone or was it something that you shared with other people?

Were there times in your life when you wanted to commit your life to a cause or an idea? Did you follow through on your vision? Did you take a risk? Were you reluctant to act? Did you experience stage fright? Have you experienced visionary ideas that were simply entertained and never executed?

Have you realized dreams of what life can be? Are there visions that have gone sour? Visions that have gotten you into trouble?

In my experience there has rarely been an absolute determination that "I should have done this rather than that" because whatever I have done shapes what I am at this particular point of time. I might regret something I did in the past, but some form of life is inevitably born from it, something that would not otherwise exist. This is the way of creation.

A Jesuit who works with art described to me how "God leads through the process of creation. A force catches my attention, and I listen to what attracts me." The vision is what calls, what touches us.

It is an ongoing movement, a process. It moves through us. In order to receive the vision, we learn how to sit, watch, and receive. It wants to be known.

When were you last moved into action in response to a sense of opportunity? Were there risks involved? If you did not act, what was the reason? Fear?

Were you so locked into a particular way of doing things that you did not have the flexibility needed to change directions and do something completely different and new?

The visionary can be perceived as an opportunist, as someone who takes advantage of small openings and turns them into historic events. Major innovations characteristically have humble and accidental beginnings. The opportunistic aspect of creation reacts instinctually to what the photographer Henri Cartier-Bresson called the "decisive moment." The reaction might be as simple as looking and pressing a button or it might involve considerable effort over time.

Creations are like seeds that find their way into tiny chinks in a granite ledge and take root in the smallest deposits of soil.

The vision is a "sense" of what can be, and the visionary has a confidence that it will happen together with a willingness to commit everything to the idea. Visions are a sense of possibility and never rigid scripts. They grow from a person's longing and interactions with the world. The person who serves the vision always lives for something other than the self. Whenever personal gains are paramount, the vision withers.

Carpe diem ("Seize the day") is the guiding maxim of the visionary who instinctively seizes the moment and makes something from it. In the creative process one action leads to another, and the final outcome is shaped by a chain of expressions that could never be planned in advance. It is the process of creating, more than the plan, which shapes outcomes. As I have demonstrated through the exercises presented in this book, I begin the process of creation by making a mark of some kind, and then I build upon it with other expressions.

Visionaries want to be in situations where opportunities are thrust

upon them. They know that the great works of civilization are reactions to dynamic environments. Little significant action takes place in isolation. Everything significant is connected to chance and the surprising arrival of inspirations. Therefore, the creative process flourishes in provocative environments. Creators want to be in situations where they are challenged, where unexpected things are presented to them, and where they must instinctively respond in new ways.

Reflect upon the periods in your life that have been the most productive. Were the outcomes planned or did they emerge unexpectedly?

Meditate upon your school experiences. Did your major learning experiences take shape as a result of a curricular plan or did they lodge themselves between the chinks of experience?

We are also shaped by the experiences of the culture in which we live. What historical moments have inspired you? Are there figures in history who have kindled your ambition? Ponder the creations of others that have fired your ardor. Were there world events or community events that incited you to act in creative and different ways? Are there social or political events that have inspired a personal vision? Have you been insulated from events in the world for long periods of time?

Contemplate your most productive periods. Did you act alone? With others? Were you striving to be creative? How specific were your goals? Do you remember specific incidents that incited your expression? Did you feel that something was calling you to act? Was there a permeating atmosphere of serendipity and happenstance? Did you feel that something other than yourself was making things occur?

Reflect upon your most unproductive times. What forces were directing your actions? Were you striving for something beyond your reach?

No doubt you will see that life is a movement in and out of creative inspiration. The vision must be lost in order to be regained and refashioned. Loss and longing are preconditions of creation.

As you reflect upon your creative achievements, were they preceded by periods of difficulty?

Have there been moments in your life when creative things just seemed to happen in spite of your intentions?

When was the last time you seized an opportunity?

Have your ever been driven by a passionate and all-consuming desire? How recently? If it has been many years since you were smitten by a visionary idea, do you think it will ever happen to you again? Are you amenable to this type of experience?

Ponder the visions that have directed your life. Were they encoded in childhood? Can you see similarities between your current longings and the desires of your childhood?

What has been the most outrageously coincidental achievement of your life? Is there a connection between this and your childhood ambitions?

Is a vision something that you create at a particular time and place, or is it something that you have been living through every phase of your life?

In my experience, visions emerge incrementally from commonplace activities. An artist told me that if she has a picture or image in her mind before she begins, she can't paint it. She can never re-create the image or paint a theme established in advance. She will often paint in response to objects in her environment, but she finds this completely different from painting an image in her mind. The physical presence of the object generates an equally physical response in her gesture.

I have had the same difficulty trying to paint images that originate completely in the mind. I may begin with a mental image, but as I have described in earlier exercises, it takes shape on the paper or canvas in relation to the marks I make and the colors. The vision always emerges through this physical interplay with things.

Adversity and limits can help to generate visions. I create better when working within restricted time frames. I perversely do some of my best paintings at the end of day when the time is limited. If I have a vast and open space, I miss the pressure points that move me into action in an oppositional way. My sense of direction comes from the

push of my environment. I tend to write better when my time is restricted and when I am not able to do it every day.

When I am traveling, I observe how my expression is affected by the new environment. The crowded qualities of a Middle Eastern city or the spaciousness of a Southwestern landscape will invariably affect the compositions of my pictures. The creative artist is highly sensitive to the forces moving through an environment. Everything in the atmosphere contributes to the ecology of the creative process. Therefore, artists have always striven to locate themselves within environments that will stimulate their creativity. D. H. Lawrence exemplifies the artist who travels throughout the world in search of inspiration and artistic subject matter.

Recently I have become more aware of the subtle effects of environments on my artistic expression. My office has a view of the ocean, and during the past summer there were many regattas and sailboats passing within my view. I was very busy working and rarely looked out the window. I would occasionally take a glimpse of the boats and marvel to myself that such a magnificent view absorbed so little of my attention. I was more concerned during the day and the evenings with papers, telephone conversations, and the people with whom I met. In the fall I took a week's vacation and painted every day in my studio. I spontaneously made a series of sailboat paintings without any plans or intentions. The sailboats emerged from my free gestures and explorations on the canvas.

The compositions were filled with numerous boats moving in all directions, and I became aware of how similar they were to the scenes outside my office window that I was perceiving out of the corners of my eyes. The sailboat vision manifested itself in an extensive and successful series of paintings that took shape subliminally in my office during the summer. This experience suggests to me that visions are generated by environments, which project their qualities out to people, who in turn internalize them in conscious and unconscious ways.

Things that we do not do can have a potent effect on our visions, especially those desirable things that we keep at bay or overlook. Freud

was not far off the mark with his insights into how our unfulfilled wishes and unconscious desires influence us from behind the scenes. He understood how visions take shape through unrealized desires. Throughout my childhood I had a longing for water. When I was a teenager I wanted a sailboat but chose to commit myself to other things. I turned my back on the desire for a sailboat as I turned away from the views from my office during the summer, and the vision is still with me. As an artist I realize that the imaginal sailboat is probably more useful to me that the real one.

The inner life is constructed from the images perceived in the physical world. What we see shapes us.

Visions do befall us, as tribal peoples believed, but in my experience they are shaped incrementally through the total range of our life experiences. The vision doesn't simply arrive one day, from above, and without connections to our previous experiences with the world. Just as dreams are shaped by our engagements with the physical world, our visions are directions that emerge from experience.

4

CREATE
WITH WHAT
YOU ALREADY
HAVE

*Since every aspect of an environment expresses
energy that potentially affects other things
and people, there are few boundaries
to the creative ecology.*

BEGINNING
CLOSE TO HOME

*The most accessible way of becoming
more involved with the creative process
is re-visioning what you already do.*

ONE OF THE FIRST STEPS IN THE practice of creating is to identify areas in your life where the artistic consciousness is already at work but not fully appreciated—writing letters to friends, decorating your house, arranging things in your living space, interactions with people at work, managing the flow of paper on your desk, gardening, walking through the neighborhood, cooking, playing a sport, exercising, driving the car. It may be more useful to further your creative practice by beginning with things that you already do.

If you hope to change your creative life by dropping everything you do and starting a new way of creating by studying at a conservatory or an art school, you may not be building on a reliable basis. Everything depends upon the quality of attention you bring to experience. As a way of beginning, I suggest becoming a witness to your life as you live it.

Traditional forums of creative expression will always be the most dependable ways of practice for most people. An evening or weekend creative writing class or dance group, singing in a chorus and taking

continuing education classes at the art school, weekly voice or instrument lessons—such activities introduce a schedule into your life, an external structure that supports your practice.

But we can look closer to home for opportunities for creative practice. In what areas of life do you have special knowledge and expertise? Everybody has something. I try to find the wonders in ordinary and mediocre things. If I can make something creative from my ordinariness, there are few limits to creation.

I have not been painting over the past few months because I have been involved with the daily tasks demanded by my work as a college dean. At a holiday party, a friend began to talk about my paintings. I had not been thinking about them in recent weeks. That night I dreamt that my son, who is an exuberant artist known for splattering paints, was teaching a painting class in a formal living room.

The conversation at the party triggered a dream that embodied the complex of my creative process, my absence from the studio, and my relationship to my son, who will be graduating from college. Everything we do finds its way into our creations. What will my son do with his life? What will I do? The dream was an artwork gathering together the many pieces of my life. All of the different elements feed one another.

Creation is a process that makes use of everything that we experience. There is an unseen creative intelligence at work within each of us that gathers from the broad spectrum of our experience and that does extraordinary things with our most mundane activities.

I repeatedly engage adults who say they have never made art because some person or experience in their early education gave them the impression that they weren't talented. As I help these people to become involved in creative expression, I instinctively try to narrow the gap between what they perceive as artistic activity and what they are immediately capable of doing. As with any form of expression, self-confidence is crucial to artmaking. Through every phase of my work with people in creativity workshops and consultations I challenge the ten-

dency that the average person has to locate art in a distant place, far removed from the daily life of ordinary people.

There are three simple questions we can ask ourselves in order to locate the creative energies of our daily lives. Where are you most engaged at home and at work? What areas of your daily life do you overlook most frequently? What are the things that bother you the most?

Creation is a basic life instinct for all of us, and we do not give enough credit to how its spirit shapes our most everyday actions. Look at the unusual things you do and the purely personal rituals in your daily life—the way you arrange the kitchen counter, your desk, your car, or your tools. There is an aesthetic at work in every placement, a personal style and way of keeping the things that you use every day.

The best way to narrow the gap between your current expressive involvement and your ideas about what art can be is to make significant changes in your conceptions. Most of us are capable of placing preexisting objects in aesthetic configurations. We are always arranging things in our environments with the goal of achieving expressive effects. If you approach what you already do on your desk or in your kitchen from the perspective of artistic expression, you experience yourself as a participant in the creative process as opposed to an onlooker. So much of art involves moving materials that already exist into new relationships with one another. We work together with these substances, whereas most beginners see artmaking as a process where forms and images are fashioned from nothing. The typical beginner feels lost and paralyzed by this all-encompassing sense of nothingness. Standing on the sidelines, we grow increasingly separated from the activity we imagine taking place in a foreign realm. It does not have to be this way.

Areas where you are currently most engaged will help you discover where the creative process is working closest to the surface of your life—the remodeling of your house, the project at work, finding the right lamp for your living room, reading short stories, exercising your body, or hiking in the woods.

Aspects of your life that you overlook offer possibilities for expanding creative perception and activity. Review your day and think about the people that you did not engage, the opportunities for aesthetic contemplation and expression that you did not seize. Each day will offer us far more than we can possibly take on, so I don't want to introduce more things that you feel compelled to do. I simply want to help you realize that there are treasures waiting in neglected areas of life.

All the things in our physical environments are potentially capable of contributing to aesthetic interactions, but their effects will be determined by our ability to engage them. What we see and what we create are determined by what we bring to our relationships with the world.

The greatest opportunities for creative transformation are often lodged in our discontents. Art is an alchemical process that feeds on emotional energy. When we realize that a perfect equilibrium in our lives might not be the best basis for making art, then we can begin to re-vision our stress points. So rather than try to rid your life of tension, consider doing something more creative with it.

Creative transformation of stress gives you the opportunity to move out of the victim role that we often impose on ourselves. Consider writing an ode to the car that is torturing you with its constant needs for repair and its unpredictability. What lessons can the car offer about life? About how you handle stress? About what you do to yourself when faced with disappointments? Can the disturbing thing be the messenger that suggests another way of living?

One of the best ways to access your innate expressive style is to draw in a way that is graphically consistent with the way you write. We cannot get much closer to home in our expression than handwriting. Years ago I observed that my drawings were tight and controlled, whereas my handwriting was bold and free. I realized that in my art I thought too much about what I was doing, whereas I was carefree in my writing. My natural energies of graphic expression were released in handwriting.

Use soft and thick ebony drawing pencils or pens on paper. Begin by

writing nonsense words and configurations in haphazard ways. Identify gestures that please you, and repeat them over and over. As you fall into the rhythm of the movement, amplify it and you will find that the expressions start to look more like artistic gestures than handwriting. Reflect upon the patterns of your movement and the spaces between the lines.

These exercises can be expanded into painting with wide brushes. Write on the painting surface by putting your whole body behind the gesture. What first appears to be writing turns into something else. The goal of these exercises is to get beyond inhibiting self-consciousness by beginning with your most familiar movement patterns.

When you write at work, you are not thinking about what the movements look like. We need to get to a similar place with our expressive gestures. People beginning to paint almost universally think about what the image looks like, and they completely overlook the movements that they need to make it.

When I watch an experienced artist work, there is a sense of abandon and gracefulness in the movements. I am always struck by the quality of the gesture. I see the same fluidity when the average person is painting a wall, washing the car, or polishing a table. In making art we engage these natural movements and use them in a new way.

Try working on a large canvas with big sponges soaked in acrylic paints and apply the colors as if you are working on a wall. Experiment with different-sized rollers and tools used by house painters. Cover a surface with one color of quick-drying paint and then make configurations on top of it with other colors.

Sometimes when painting an artwork we want to slide gracefully, and at other times we have to dig in or move more aggressively. Act as though you are scraping a wall or as if you are sanding an old bureau. Paint as though you are cleaning a window, covering a cake with frosting, scrubbing a counter.

Establish the goal of making a painting with as many different kinds of marks as possible. After you paint new colors on top of thoroughly dried colors, and while the top coat is still wet, use the edges of a

scraper, a putty knife, or a pointed wooden object to make hundreds or thousands of random lines or scratches on the surface. Top coats made with oil based paints will give you more time to make marks than quicker-drying latex or acrylic colors. You might want to just cover one color with another color, something as simple as black over white or vice versa, or you may use many different colors for your under-painting and top coat. You can make endless variations of colors and the appearances of the scratches will surprise you with their different personalities.

I have found this way of painting to be one of the most universally accessible art experiences and a method that enables any person to make an aesthetically stimulating artwork. The greatest value of this technique lies in its inversion of stereotypic attitudes about painting and artmaking. The "I can't paint" defense is taken away. When help-ing people to paint in this way, I give examples from twentieth-century art of important pictures that were made with repetitious and random gestures.

In addition to the use of free gesture and movement, you might experiment with making spirals, concentric circles, and other patterns.

The idea of "scratching" or "scraping" a picture rather than "paint-ing" one might open up new vistas on art for you. The simple and familiar motions of daily life that we all use in our kitchens or work-rooms can be adapted to the creation of artistic imagery.

If you want to become seriously involved in these ways of painting with scratches and scraping motions, I recommend working on Mason-ite, plywood, and other hard surfaces. Firm paper primed with gesso or canvas will tolerate considerable scrapes and scratches, especially if you work with the paper or canvas on a table or other flat and firm surface.

Wooden painting surfaces enable you to really get involved in the scraping and scratching process. You can work with power tools and scrape lines right into the wood, go over the surfaces with power sand-ers, rotors, and the like. When you experiment with these tools, the process of painting approaches the making of sculpture. Two- and

three-dimensional expression come together in the making of a relief characterized by different elevations on the surface of the image. Consider assembling these pieces of wood into sculptural objects.

If you venture into the realm of power tools, keep safety in mind. I always work with manual tools because I am primarily concerned with aesthetic reverie and the direct "feel" of image making, which are not possible with power equipment. However, I see many artists who make fascinating things with power tools within studios that resemble carpentry shops.

Explore the widest range of marks and possibilities for changing the visual and tactile appearances of a surface. Carve, grind, rub, sand, and polish.

We don't realize the important role that elbow grease can have in making art. Creators don't always work with highly refined and delicate strokes that we associate with a medium like watercolor. Raw and rough gestures can be put to good use in the studio.

Reflect on what you do when creating food in the kitchen. There is always a range of gestures from grating, pouring, chopping, pounding, and beating to shaping, trimming, glazing, and careful arranging. The same diversity of gestures goes into the making of art.

Clay offers the opportunity to use many of the tools and gestures associated with culinary creation. You can roll out a big slab of clay into a one-inch-thick surface and make a relief with marks made from kitchen tools. The clay offers a sensuousness and malleability that contrast to the more resistant wooden surface. Each material offers its unique expressive qualities and will elicit different kinds of markings from the artist. It is helpful to work with different media because you will invariably discover something new in one medium that you can use in another.

Covering, printing, and pressing are other motions from daily life that transfer to the creation of artistic imagery. You might experiment with painting over random configurations or patterns made with masking tape which is later removed. Use circles, squares, and sheets of paper to mask and cover parts of a surface as you apply paint.

Paint on shapes made from corrugated cardboard and use them to make monoprints on the surface of the painting. Use pieces of metal, wood, and plastic to make prints. Try to explore many different ways of printing marks on a surface. Use the objects you find in your immediate environment. Investigate different ways of applying pressure. Manual pressing will create a different effect from a more mechanical press. There are many different publications on the making of monoprints that will help you discover the wide range of possibilities offered by this technique.

My goal in this section is the expansion of the range of marks that can be made on a painting surface. By envisioning artworks as fields of "markings" we have significantly increased the range of possibilities beyond the conventional notions of painting of drawing. The artistic image focuses on the significance of marks as things unto themselves rather than approaching marks in a painting or drawing as representations of something else.

The expressions of nature can be especially inspiring and influential if you begin to make art in this way. Ponder the changing configurations made by the sea in the hardened forms of sand below the high tide line. Find other nature markings and reflect upon their aesthetic qualities—lines made by water moving through dirt, ripples and configurations on water made by wind, the shapes of shadows created by light, tracks in snow.

Beginning close to home can involve the simple imitation of nature's ability to make marks in the environment. Emulate nature's motion and its uncontrived purpose. These natural ways of making marks invert the assumption that artfulness is always characterized by willful and crafty action. Although art has room for many ways of creating, the person beginning to create and the experienced creator seeking renewal will find freedom of expression and surprisingly beautiful configurations in the unaffected ways of making marks that we all use in daily life.

CREATING WITH
THE ENVIRONMENT

Spaces are forever acting on us and stimulating
a creative range of expressions.

MOST PEOPLE UNDERSTAND THAT
they are affected by their surroundings. We plan our vacations and
leisure time with the goal of imbibing the salubrious qualities of water,
mountains, and open spaces. We arrange our offices, homes, and
everyday environments in ways that support us practically and emo-
tionally.

Physical environments generate what practitioners of the Chinese
art of feng-shui called *c'hi*, vital energy or breath. C'hi is the animating
principle of all things, including human beings, and the Tao is the
interactive basis of creation, connecting all things to one another.
Landscapes, buildings, interior spaces, furnishings, colors, and artifacts
are in state of constant interaction with one another. Since every aspect
of an environment expresses energy that potentially affects other
things and people, there are few boundaries to the creative ecology.

How do you arrange the spaces in which you live and work? Do you
consciously plan the structure of our environment in order to generate
particular kinds of energies? Or do you arrange things intuitively?

I design an environment like a painter. I put a chair, a rug, a table,
or a picture into a space and this action calls for something that com-
plements its expression. One move is always responding to another.

Spaces are forever acting on us and stimulating a creative range of expressions.

Try walking into different kinds of rooms and watch how you react. What emotions do the spaces elicit?

I have a friend with a large and empty studio where everything but the floor is painted white. All of her paintings are stored away, and the only art you see are the one or two things she is working on at the time. As I walk into the studio, I am struck by its spaciousness, and I compare it to artists' work spaces cluttered with materials, artworks, and miscellaneous things.

On the basis of my many experiences creating with people in a variety of spaces in many different countries, I can't say that there is one particular studio layout that is ideal for creation. Every space has its distinguishing qualities and expressive features.

I realize that some areas are better than others for creating, but over and over again I find that the truly decisive factor is the quality of consciousness that we bring to the space. Successful interactions depend more upon our ability to adjust and compensate to wherever we are in relation to the creative process.

Contemplate how different types of spaces affect you. Do you feel the same in a spacious room with large windows as you do when you are in a dimly lit corner?

Try a spontaneous writing exercise in different kinds of spaces. Write automatically, expressing the stream of sensations that you experience while reflecting on the place. Try this exercise in as many different places as possible—in the attic, the garage, the cellar, the kitchen, the laundry room, a hall, a walk-in closet. Do the same thing in different kinds of spaces—open fields, dense woods, in an opening between large rocks, next to water, in a mall parking lot, in a fast-food restaurant, in the sun, in the shade, in front of a computer screen.

The more you vary the kinds of spaces in these exercises, the more expansive your imagery will become. We create together with our physical environments and don't always appreciate how their qualities contribute to our expression.

The same exercises can be done with body movement and dramatic improvisation, and you will find that each space offers different kinds of influences.

Edward Hopper used to drive in his car for days, hunting for scenes to paint. His automobile was an important ally in his creation. Use your bike or your car and travel in search of places and imagery. In addition to writing or drawing in response to places that appeal to you, try meditating on others chosen randomly, and ones that you don't like. The purpose of the exercise is to stimulate the range of your emotions and expressions.

Contemplate your personal style of creating in reference to places. Do you go through nature searching for subject matter like a hunter-gatherer, or do you cultivate expressions in your studio space like a gardener? Do you combine these modes of creation? How do you care for your creative work space?

Each of us can write a spiritual autobiography by reflecting in detail about our relations with the places where we have lived and the objects we remember. Memories of spaces add yet another dimension to the way they affect expression.

Remember the different places where you have lived. Try writing spontaneously for five to ten minutes, without stopping, about your good and bad memories of places. Don't worry about your sentence structure or the way one thing relates to another. Try to capture the different feelings and images.

Write about places where you would like to return; where you would never go again. Try remembering physical details about the places, colors, and textures. What are the different sensations that places evoke in you now and in the past? Did the place influence your life? If it did affect you, when did this occur? Does it continue to influence you?

Were there places that influenced your creative expression more than others? Are there places from the past that still inspire you?

What are the places in your present life that you might remember in the more distant future.

Just as physical surroundings affect the people who live in them, the overall spaces of individual artworks shape the identity of everything within the composition.

Try making art as though you are constructing a place or arranging things in a room. Watch how the first gestures you make fill the space and call out for something that relates to them.

We don't realize how the making of every artwork, even miniatures, is an arrangement of spaces. Any one of us can move furnishings in a room without inhibition. We can do the same things with forms and colors on a canvas, with words on a page, with movements and sounds in space. Even the most experienced artists can overlook how their expressions are spaces to be arranged. Paintings, poems, stories, dances, sounds, and every form of performance can be viewed as spaces which generate different kinds of energies.

Collage and assemblage are excellent media for the practice of spatial composition. The artworks can be arranged like rooms.

One of the best ways to understand how the overall space of a creative expression affects its parts is to imagine yourself inside the space of the artwork. Choose a painting, collage, sculpture, or some other physical form as the object of your reflection. Select a place within the composition where you would like to locate yourself for a few minutes of contemplation. Change places and observe the differences. Imagine yourself passing through the different areas of the artwork. When you enter the composition, you get a better feel for its energetic patterns. This exercise helps you to experience an artwork as a field of activity, and as it envelops you, there is a heightened sense of "its" expression. You enter the composition the same way you walk onto a beach or enter a cavernous room. The space impacts you with its presence.

Entering the space of the artwork diminishes the egocentrism of habitual ways of looking at things. The meditation helps us get outside of ourselves and into the space of the object we contemplate. It is a strikingly simple way of seeing things better and coming to an understanding of how objects carry expression within themselves.

As I look at a portrait over the fireplace, I see that it is a relatively

faint charcoal drawing on tan paper within a gold frame. I enjoy its serene expression, but I never realized how listless the space is until I imagine myself within it. Yet the portrait has a quiet dignity over the mantel. Maybe we place it there to convey a staid stillness.

On an adjacent wall hangs an expressionist painting with vivid colors and animated forms and textures. As I imagine myself within its space, I have an increased appreciation of its vitality. I notice how we placed it on a wall that needs some life. Without the painting, the wall is colorless in relation to the other parts of the room. It needs something outgoing in order to contribute to the more general expressive interplay of the space.

When space begins and ends with ourselves as points of reference, creative expression is limited. When we look at the energetic fields of objects and paintings as spaces in their own right, we have to subordinate our frames of reference to the expression of the thing that we are contemplating. As we practice this way of looking, the things offer us new ways of experiencing them.

Drawing and painting from nature is the most basic form of creating together with the physical environment. When I contemplate an object or a scene, it acts on me with its expression.

Experiment with drawing from nature by looking carefully at an object. Study its shape, volume, and lines. Look at the way it is situated in relation to its environment. Turn away from the object and try to quickly sketch it from memory. Don't be afraid of making a rough impression. Inaccuracies can be viewed as expressive features. Try to keep your pencil or pen in constant contact with the paper. Don't hesitate.

Study your quick drawing and do another version that builds upon the one you just did. Look at previous drawings as sources for your expression as well as the scene in nature. This use of your own pictures as subject matter and the creation of a succession of pictures depicting the same scene will help you abstract essential forms as compositions.

If you keep making sketches, you will learn how to see the object more completely and you will become more sensitive to its impact on

154 | CREATE WITH WHAT YOU ALREADY HAVE

you. Through experience you become more adept at creating together with other things. Don't expect to "get it" right away. This aspect of expression takes time and patience.

As suggested in the earlier section on distilling, painting from memory helps you avoid excessive entanglement with details. When you fuss with small things, you lose the expression of the whole. Memory assists you in getting to the core of the image. You recall what is essential and significant to you.

Don't be concerned with photographic exactness. The more you paint and the better you become at representation, the more you realize that every picture, no matter how true the likeness, is an interpretation. The great expressionist painters used objects from nature as stimuli and jumping-off points. The object becomes a dance partner. It moves you in particular direction and you respond with your own gesture. Drawing from nature is an ongoing interplay. When you start obsessing about exact likeness, the momentum of the dance is arrested. One partner has dominated the other.

If you make sequential pictures of the same image, you will realize how each response is a fresh interpretation.

Try painting directly from your impressions of an object rather than sketching its form beforehand. I rarely make preparatory sketches because I find that they limit the spontaneity of my gestures.

I am not as free in painting on canvas as I am on paper. My approach to a new canvas is no doubt influenced by the considerable time and labor involved in its preparation. There is a sense that I must put the surface to good use whereas with paper I am more apt to simply throw away a bad start. I unconsciously plan my pictures on canvas in spite of my best intentions to do otherwise. Yet this struggle with the canvas has resulted in the creation of many of my best paintings. I worry when the process of creation gets too facile. I have tried to alleviate the pressure "to make good use" of the canvas by having many different canvas surfaces available at a given time. This allows me to move freely from one to another. There is also the realization that I can always paint over the picture with gesso and begin again.

When painting directly onto canvas, it is helpful to have paints that are in a liquid form. A dry brush will not allow you to make sweeping gestures. Keep your brushes wet and fluid. If you are painting with oil, you can keep the brushes moist with turpentine, linseed oil, or gels.

In addition to looking at an object and turning away to paint, you can also keep your eyes fixed on the object and not look at what your brush is doing.

The purpose of these exercises is the increase of spontaneity. I want to further the interaction between the painter and the object of contemplation. The image that emerges is a third, which has an autonomous life of its own. These exercises are intended to give more expression and vitality to images emanating from your interactions with physical things.

After making preliminary sketches through these exercises, you might want to continue working with the pictures in a more studied and exacting way by checking your gestures against the appearance of the object. Feel free to fix, change, move, and repaint, but be wary of losing the expressive gesture of the whole. We don't realize that it is generally the perception of movement that creates an engaging and pleasing picture.

Colors move as well as lines. They interact with one another and take on new identities in relation to their neighbors.

Artists have historically desired to paint outside in nature because they are affected by the total aura of a place and especially by the light. Go outside and study the way sunlight illuminates the side of a house. Look at shadows and the many shapes created by them.

Try painting outside with a primary emphasis on color. Use forms as the impressionists did, as simple vehicles to convey the energy and vibrations of color and light. Oil paints are more controllable in terms of reworking a picture whereas watercolors force me to respond spontaneously. Each medium carries its special attributes.

Begin by working on a small surface and contemplate the colors in your environment. Before painting with oil paints, mix a variety of colors on a large palette that correspond with the hues of the environ-

ment. Make different shades of the colors. If you want bright effects, mix colors with cadmium yellow and white.

Try to find a simple formal pattern in your environment and use it as the basis for painting color—the corner of a house, a section of fence, a portion of the garden, a street sign, a fire hydrant, a series of tree trunks, the outline of a building or a car. Seek out scenes with clear-cut and simple shadows. Use the shadows to create movement and varied shapes within the composition.

Don't worry about likeness. Just try to capture the overall gestalt of the scene and use it as a staging ground for expressive colors. Monet took the outline of a church and used his brushstrokes and colors to provide the detail.

Let the paint give character to the image, and don't be overly concerned with representing all of the parts. Envision your goal as the expression of color vibrations.

In these exercises the environment acts upon you and influences your expressions. We "imitate" nature's expressive qualities and add something of ourselves through the interplay. Imitation is not approached as "copying." It is viewed as becoming more natural, more akin to nature. We emulate nature's expression which results in the creation of objects that may or may not convey a close likeness to the person, thing, or scene that inspired its creation.

If you desire to work in a more direct way with nature, make artistic configurations with rock, dirt, and other natural things. I have always admired the simple mound constructions of ancient Ireland. If you are in a place with plentiful rock, you might experiment with mound building. I have always wanted to make a series of mounds in an open space, a field or broad lawn. The mounds of hay and the large round or square bails made by farmers in a freshly cut field create some of the most pleasing aesthetic creations I have ever seen. The repetitions of the hay bails or mounds create a rhythmic and linear motion across the broad expanse. A painting of the hay field doesn't "improve" upon the work of the farmers. Art adds another dimension to nature. A

painting of a natural environment expresses an artist's interpretation of the scene.

The makers of these configurations did not set out to create art, yet they fashion some of the most beautiful visual configurations I have ever witnessed. I have similar experiences looking at plowed fields covered with a few inches of snow in winter. The lines of furrows extending for miles create an image that I could never capture in a painting. But I have noticed how my pictures take these repetitious lines and adapt them to the design configurations that can be successfully rendered on a two-dimensional surface.

Flying over farms in the Midwest, I again see how the utilitarian activities of daily life make some of the most aesthetically pleasing constructions created by humans. On a more intentional aesthetic vein, the labyrinthine gardens formed by hedges in English estates are among the most intriguing constructions in the world of landscape architecture. Exposure to places like this, where the human being is literally engulfed in the space, can help us to imagine ourselves entering the spaces of smaller artworks, as I suggested in the previous pages. The artistic imagination is capable of making shifts between these macroscopic and microscopic places.

Reflect upon places where you have been overwhelmed by the beauty of simple environmental constructions. Can you envision ways of expressing qualities of these spaces on a smaller scale?

I realize that the making of mounds or patterns in the earth in your garden will never approximate the sweeping beauty of agrarian landscapes, but you might like to experiment with these smaller formats. In one of my studios a woman made a series of mounds and stick configurations on a beach with readily available stones. She contemplated and photographed the mounds and sticks at different times of day when their appearance and the surrounding environment were altered by the changes in light.

This woman made another environmental construction with cubes of sand that she formed in a container like a child working from a pail on the beach. The cubes of sand were made into a ritual space where

she enacted a performance at sunset. There was a fire in the middle of the space that significantly altered the color and mood of the environment. The next day she took photographs capturing many different perspectives of the construction, and she presented them together with drawings of the sand configurations in a book accompanied by poems and other writings reflecting on the experience.

Moving the studio into nature offers many ways of expanding the range of expression. In my studio workshops we will sometimes create only with natural things found in that particular environment. When we work in this way, there is an inevitable sense of sacredness that comes from direct collaboration with nature and the earth. Because these fleeting and self-effacing creative acts in nature are so clearly separated from the usual goals and expectations of artistic creation, there is an accompanying sense of meditation. We create together with the earth and we become more sensitive to its qualities and expressions.

The deep satisfaction gained from this type of environmental art is related to an absence of possessiveness and self-consciousness. There is no thought given to taking something home with us. The creative act is pursued solely for its own sake within an ephemeral context. The virtues experienced by working directly with nature help us to create in a similar way when we are in the studio.

CHILDHOOD
MEMORIES AND GIFTS

*Everything significant about the soul's ultimate
journey is imprinted in its childhood formation.*

C HILDHOOD IS THE WELLSPRING OF
creative imagination. The autobiographies of artists and scientists
consistently describe how their most productive work springs from an
inquisitive wonder and sense of magic that originates in the early years.
This sensibility is sustained throughout their lives and creation is expe-
rienced as a continual return to the source.

As an artist I have never had a sense of higher states of consciousness
"developing" from less advanced conditions in childhood. It has always
been the other way around for me. The creative spirit sustains the open
and impressionable vision of the early years. It keeps childhood alive,
and the spirit forever returns to childlike wonder as a way of imagining
the world anew.

The renewal of childhood memories and sensibilities furthers the
resources of the creative imagination. The following exercises and
musings are offered as ways of rejuvenation.

Sit and reflect upon the different places where you have lived during
your life. What areas within the houses and yards do you recall? Can
you remember the kitchens, the bathrooms, the doorways. Were there
things about the houses that you didn't like? Did you have a special
place in the yard?

Make a composite sketch in your imagination of the things from each house that you liked the most. Try to remember a significant event that occurred in each house. Were there differences in your connections to the communities and neighbors? Were there places that you did not like?

We can compose autobiographies through memories of houses. Do you remember moving from one home to another? If you moved often, do you remember the details of each change? Were some more significant than others? If you stayed in the same house throughout your life, did you ever long to move?

How are your ways of relating to your present house different from the ways of your parents? How are they the same?

Try telling the story of your childhood through different sensory memories. I recall the rotating blades of my grandfather's push lawnmower, the smell of the grass sticking to the wheels, the rhythmic steel rubbing against steel as he used edging clippers, the static between channels on my grandmother's big wooden radio, the carpet sweeper in the front hall, the sounds of metal taps on the heels of my penny loafers, the revving of the eight-cylinder engine in my mother's 1955 Pontiac station wagon.

Childhood imagination creates intimate relationships with what appear to be insignificant places and objects. Although children have a limited ability to travel alone through the world, they compensate with a special aptitude to journey through the imagination. As Walt Whitman said in *Leaves of Grass*, "the first object he looked upon, that object he became, / And that object became part of him for the day or a certain part of the day, / Or for many years or stretching cycles of years."

The child teaches us how perception is the angel of renewal. A simple piece of wood becomes a ship sailing the sea or a house on a hill. The otherness of the wood becomes the embodiment of the thing living in the child's imagination. The child endows the piece of wood with the inner life of imagination and its desires.

As a four-year-old girl thinks about her grandparents living thou-

sands of miles away, she claims a place in her yard as their house. It is a cozy nook between the five trunks of an old chestnut tree, just big enough for her to enter.

The cluster of tree trunks in the middle of the lawn stimulate her imagining and she bestows upon them the contents of her inner life. There is a merger of physical and psychic spaces.

I played in similar places as a child, special corners and bays in the house, snug closets paneled with wood, wardrobes and old chests. I remember my children being photographed in cardboard boxes, making a house from a refrigerator box, and sitting in a kitchen drawer their mother opened for them, playing with wooden spoons and plastic measuring cups, waving them in the air and dropping them on the floor. I remember sitting in places like that and imagining them to be boats, cars, and planes.

Cozy enclosures offer security and warmth. A safe place is needed to freely imagine, relax, and cast the contents of inner space into the outer world. Simple things, like a plain box or piece of wood, give a vast expanse to the imagination's travel. They hint, suggest, and encourage amplification.

The Freudians see only wombs and the "one-way" desire to return, a possibility that I cannot deny, but my sense of childhood wonder is more oriented to a desire for contact with the external world and its many places and things. The Freudian script takes its power from an inversion of the primal instinct to experience the natural environment.

Do you remember creating places like this in your childhood? Are there places in your home today that resemble the secret or private places of childhood? What is it about childhood that encourages the creation of secret places? Is your ability to imagine and fantasize still intact?

Were there particular places in your childhood where your imagination was most alive? Are there special places where you go today to feel comfortable and safe? To reflect alone? To rejuvenate your emotions?

It is remarkable how forgiving memory is. According to the Kabbalah of Jewish mystical tradition, there is a spark of good in every bad

thing. As I recall the things about my childhood that I disliked the most, they are now full of nostalgia. I used to hate playing alone for days during the summer, but now I look upon those long hours as formative phases of imagination. It was a time to learn how to work and create alone.

There are angels in our discontents.

My worst memories of childhood recall a boy alone in a house where the basic needs were fulfilled but where there was "nothing to do." When I see my own children in a similar state, I sense how their souls and depths are being shaped by the emptiness. Could it be that the thing causing me the most angst was the emerging purpose of my life? In hating isolation I was bonding myself to it. I was learning its depths and opportunities, the beauty of simple wondering. In my pains I was discovering how to fashion something from them, to respect the imagination in stillness, the vast activity in what appeared to be nothing. I was finding my way to contribute to the world.

Everything significant about the soul's ultimate journey is imprinted in its childhood formation.

Revisit your difficult childhood memories with a sense of their formative influence on your life. Do you see connections between childhood difficulties and the things that you like about your life today?

Try keeping a journal of childhood memories. Include photographs of yourself and family members. In addition to writing descriptions of things you remember from your childhood, take liberties and write imaginatively and humorously about the photographs. Make things up. What is the child thinking as he sits in his wagon? Is the lawn party really as pleasant as the smiles in the group photo suggest?

Most of us tend to carry relatively limited scripts of our childhood. Fictionalize the figures in your family photographs. You might discover more emotional truth in your imaginal accounts than the standard stories you tell about your childhood.

Use childhood photos as props for creative writing. Describe the scene, the gestures of bodies, facial expressions, contacts between people, and give voice to the intentions and thoughts of the different char-

acters. I find it much more productive to write in response to a specific scene or an actual object. This keeps the writing tied to the physical world and its particulars, as contrasted to the tendency that many of us have to go off with abstract thoughts and feelings.

Are there things in your house that you have had since childhood?

Do your parents or brothers and sisters keep things from your childhood? Do these things generate memories, stories, and feelings to be expressed?

If your childhood was a difficult time, a chapter in your life that you have closed off or bolted shut, consider reconnecting to the formative powers of childhood imagination. You can access the creative powers of childhood that you may not have fully enjoyed because of the environmental circumstances of your life at that time.

Try imagining the world as you did in your early years. You will find that the child is not lost in an inner chamber of your psyche. It lives close to the surface, ready to appear with the slightest suggestion.

Paint with a child's spontaneity and delight. Accept the child aspect of your psyche as a vital ally in creative expression.

Write poetry by reflecting on a scene, a feeling, or a situation exclusively through images and memories. Allow the images to emerge freely as a child would. Let the images find ways of connecting to one another, and don't worry about their making sense in a logical manner. Just let them flow onto the paper. Afterward you might contemplate how they relate to one another. But don't think too much about them while you are in the process of making them. This is one of the major differences between the creative expression of adults and children. As the Zen teachers say: when you eat, eat; when you walk, walk. When children paint, they paint with all of their being. Adults tend to think too much about what they are doing and ultimately get caught in the restrictions of the controlling mind.

Don't be afraid of appearing childlike as you express yourself. Realize that the notion of the "inner child" may be a defense against childlike aspects that you do not exercise or fear exposing to others. Your

childlike freedom, spontaneity, and forcefulness are the powers you want to reclaim.

Remembering when you used to express yourself freely as a child can be a basis for adult creativity. A man came to create in my studio because he was told at eight by a teacher that he could not draw or paint. Like many adults who have not expressed themselves in the arts since childhood, he picked up where he left off. He remembered the feelings of confidence that he had as a child and his love for making things. He started again by expressing those desires. It took him over twenty years to challenge what the teacher said to him, but he was able to successfully reactivate his interest in the arts.

I have often thought that the strongest cultural inhibition to creative expression is the theory that human beings develop from lower stages to higher ones. We assume that our present cultural epoch is more advanced than more "primitive" ones. We have certainly progressed in terms of technological culture, but this is only one aspect of human expression.

When we compare the artistic expression of the average child in our society to the average adult, there may be an empirical basis for an antidevelopmental psychology. On the basis of imagination and spontaneity it appears that children as a group are more proficient in creative expression. Generally, children from three to six years old express themselves with relative freedom of movement and a forcefulness generally characterized by low levels of self-consciousness.

If we adults are to regain the power to express ourselves freely through the arts, we need to tap into the resources of the childlike and aboriginal aspects of our souls. We never completely grow out of these faculties. They are forever present, ready to be revived and exercised together with the analytic skills that are acquired and refined as the child grows older. Our culture however, is heavily biased toward the latter and has not appreciated how we have regressed from the former intelligences. The spontaneity and freshness of the child's expression is potentially present throughout our lives. It is the basis of creative expression on which our adult skills in the arts are constructed.

As we acquire new skills, we don't have to abandon earlier virtues. The linear and hierarchical bias of developmental psychology assumes that one way of being is replaced with another, more advanced phase. I prefer to think about aging as an enlargement of experience.

Remembering childhood is a way of returning to the source, of reactivating the power of spontaneous and confident creation. The expressive exuberance and imagination of the child never dies or "progresses" to a higher stage of adult development. Childlike spontaneity remains intact in the expression of adult artists where it cooperates with other expressive faculties.

The ability to remember and access the child's ways of expression is not just a matter of tapping into emotional states. I am concerned with reconnecting to the expressive skills of the child, actual techniques for making more satisfying art.

Children's expression takes us back to the basics—playfulness, joy, spontaneity, and imagination. But there is also a fundamental technical aptitude that we lose as adults which is the ability to portray complex subject matter through essential forms. In this respect children are adept abstract artists. The child represents a sailboat with a simple triangle adhered to a rectangular hull with a straight line. Young children paint their shapes freely and without obsession. Their rudimentary forms are characterized by free graphic movement and color. They use colors that please them rather than ones that match the appearance of the object being represented. These innate proclivities create livelier and more imaginative paintings. Colors, forms, and compositions are selected for their sensory appeal and their expressiveness. This sensate orientation is what we must "remember" in order to paint more freely.

The artist Milton Avery was one of the masters of this formal simplification in the art world. Look at his paintings and those of Paul Klee for inspiration. They will help you get back to the basics.

Rather than creating an exact likeness of an object or scene, the young child creates forms that suggest its appearance. There is a mental space or gap, an intermediate zone, between the actual thing repre-

sented and the pictorial form. The gap between the two realms is an opening to the imagination. When the artistic image presents a literal and exact likeness, the gap is narrowed and sometimes eliminated. Imagination requires an open and undefined space between things.

Try making pictures of things that you see with the most basic forms possible.

Young children are busy thinking while they paint, but they usually do not labor over what they do. In order to reconnect to these ways of painting, try representing houses, animals, human figures, and landscapes quickly and with a sense of abandon.

Randomly select colors with the goal of creating a dynamic overall effect rather than a "realistic" likeness. Using large brushes will encourage you to be more concerned with broad areas of paint rather than fussy and exact lines.

As you apply shapes and lines, approach the composition as a dance between all of the different gestures. Don't get too involved with a single area of the painting. Stay focused on it as a field of interacting characters. Every gesture is important. As I suggested earlier, getting caught up in one area can result in the loss the overall rhythm and expression of the whole. Keep the image of the dance as your guide to painting. Can you imagine the effect on a dance performance if you stop the overall movement through space and focus exclusively on what you are doing with your right foot? Like a dance, the painting of a picture is an activity that dynamically utilizes the entire space of a performance area. Imagine the canvas or paper as a stage to be filled with expressive action.

If you see something you don't like, let it be. I find that bothersome areas of a painting are often vital to the comprehensive movement and harmony of the image. I have to keep reminding myself that the detail might be incorrect when I look at it as an entity unto itself, but within the whole composition it may make an important contribution.

When I paint a figure or object from life, I have learned to simplify its basic form rather than strive for an exact replication of its many details. Paradoxically, this simplification often creates a more lifelike

appearance because the gap between the shape of the pictorial image and the figure that it represents elicits a response from the viewer which fills in and completes the perception of a particular thing. If I pay great attention to literal detail, the viewer is more apt to perceive the picture exclusively as a two-dimensional representation.

I repeatedly discover that overinvolvement in details "stops the process" of my expression. I try to keep moving and working on the overall surface of the canvas. If I spend too long in one area, it begins to lose its connections to the overall composition. Details and exact likenesses are "sacrificed" for the sake of the holistic movement and impact of the pictorial image. This is the hardest thing to express to a beginning adult painter who easily gets stuck in a particular detail and loses the sense of the picture's total expressive movement.

Children have a beguiling ability to paint with a sensitivity to the whole image. Some say that this is because the child does not "know" so much about details and that the child's mind is not cluttered with memories, experiences, and expectations. I do not think this is so. Young minds can be surprisingly full of ideas. I think that since the young child does not have the fine motor skills needed to render detailed representations, concerns for exactness are less likely to interrupt the expressive gestalt of a picture.

Expressive adult art makes use of the gross motor gestures that we find in children's art. The skilled artist combines these free and sweeping strokes with the ability to work precisely. The beginning adult painter, and the typical adolescent artist eager to leave childhood behind, tend to be overly concerned with precision, not realizing that this is only one aspect of a successful expression.

Attention to details is essential to any artwork so long as we stay attuned to the overall context in which they are located. I try to keep one eye on the detail and the other on the expression of the whole configuration. In a successful painting the precise rendering of details must fit in with the expressive gestalt of the image. This applies to every facet of creation.

When making a painting I begin with rough and free gestures that

will suggest the direction I will take in shaping the final image. When a painting is completed quickly and successfully, it is usually because I work in a way that is close to what a young child will do when making a picture. The first exploratory gestures give me a sense of what the image can be, and I try to paint it freely without getting caught in one area of the painting.

In keeping with my earlier comparison of painting to dance, I attempt to keep the entire surface of the painting alive with movements and colors. I hold the emerging image of the picture in my mind's eye, but I simultaneously focus on the whole in a "blurred" way without concentrating too much on parts. I feel the painting kinesthetically and never approach it as a static visual image.

I believe that children paint in this way. It is pleasurable and dynamic. The exact rendering of parts is of less concern than the spontaneous creation of the whole. The same thing applies to making a successful speech or giving a performance. The actor must generate a movement and expressive energy which enable the details to emanate from the thrust of the whole. Whenever I begin a painting, a lecture, or a performance, the spontaneity and quality of the first gestures lay the energetic foundation for the ensuing composition.

Beginning painters can apply these principles by starting their pictures with broad brushstrokes. I encourage beginners to leave the small brushes at home during our first sessions. I give them different sizes of house-painting brushes and tell them that these tools suggest that the surface is to be covered freely with paint, color and gesture. Young children work in this way. They complete pictures quickly and they are not apt to use small and fussy brushstrokes. Painting a figure or a scene briskly with large brushes forces the artist to deal with the complete image rather than fussing with details. This is the way young children work.

A woman in one of my studios used printmaking brayers to begin her paintings. The large gestures of the composition and the figures within it where laid out with the free movements of the rubber rollers and she built upon them with her later brushstrokes and careful appli-

cations of color. The basis of the painting was fluid motion. She used the gross motor gestures that we see in the paintings of young children together with the precise techniques of the adult artist.

When making paintings according to the kinesthetic and "blurred" process that I described, don't be afraid to leave out details. As with the images of young children, you will discover that the success of the image results from its comprehensive expression which cannot be experienced until the painting is completed. While you are working, it is easy to get caught in the act of looking at parts as though they are self-contained and finished sections, which they are not and cannot be if the overall image is to succeed. The parts and details must always defer to the expression of the whole, a principle that young children innately display when painting.

I found it helpful as a beginning painter to paint figures and shapes with a bright light behind them. Their details were imperceivable and I could only see the shadowed contours and shapes. This helped me to see the form as a single shape rather than thousands of details. I try to apply this sense of the overall contour to any figure that I draw. I always begin by making the complete shape with quick gestures and I find that slight distortions and imperfections give the image an expressive advantage. We can learn from Picasso and Matisse how deviations from an exact likeness give a drawing or painting its unique character. The deviation creates the gap which opens to the imaginal realm.

Young children create these gaps naturally and elegantly. We adults are so captured by details that we leave few gaps as we diligently fill every empty space. We've got to know exactly what we're doing as we do it and what it ultimately means and what value it will have when it's completed. Consequently, our minds become cluttered and we miss opportunities to create undefined and suggestive spaces that invite responses from the viewer's imagination.

Every adult wishing to paint expressive pictures might consider visiting a kindergarten where children paint freely on easels with large brushes and tempera paint. Watch the children and imitate them, trusting that you will find a way to incorporate these abiding gestures of childhood with the concerns and skills of your adult life.

5

PRACTICE

A complicated expressive gesture cannot be broken down into a lesson plan. It can only be learned through practice and repetition, with the goal of reaching a point when it happens instinctively.

ACTING AND NOT ACTING

The process of creation is a force moving through us,
and only through practice do we learn
how to cooperate with it.

WHEN I PLAYED COMPETITIVE GOLF
as a child and asked my father for advice, he'd say, "Practice." He
demonstrated the proper grip and a few other essentials but that was
the extent of our instructional conversation.

He told me to carefully watch people play, good players and bad
ones. "Watch what they do," he said, "and then go practice."

When my son wanted to learn how to paint, I told him the same
thing without making conscious connections to my father's advice. I
gave him paints, canvas, demonstrated the basic principles of opera-
tion, and told him to start working.

"Paint," I said. "If you paint constantly, your style will emerge as
well as the pictures."

I told him to look at pictures he liked and pictures he didn't like and
to paint freely, and to avoid being overly concerned with the result.
"They'll get better," I said, "as you keep doing them."

A complicated expressive gesture cannot be broken down into a les-
son plan. It can only be learned through practice and repetition, with
the goal of reaching a point when it happens instinctively. Creation is

a complex process that cannot be reduced to analytic steps. The skilled artist is the one who is always responding and compensating for the changing winds of the creative process. Nothing is ever the same. Conditions are infinitely variable. Each engagement presents a new challenge and that is the defining quality of creative practice. Mechanical instruction and step-by-step guides to the perfect brushstroke avoid the basic conditions of the process.

In my experience with creation, satisfying results correlate with the ability to stick to the discipline of practice. If I can stay engaged with a project, creative illuminations will appear through a natural unfolding of the process. The work needs time to mature, gestate, and draw new things to itself.

While he played the piano, Duke Ellington said, "I'm not playing; I'm dreaming." It is like the Islamic mystics who quote the Koranic saying, "It is not you who throws the dart when you throw it." Creativity is a force moving through us, and only through practice do we learn how to cooperate with it. The "process" is like a muscle. It needs to be exercised in order to function effortlessly.

My father tells me, "If you practice properly, your body will know what to do. You can't direct it with your mind. The mind needs to relax and let the body act."

Practice enables us to act and not act at the same time.

BECOMING A STRANGER

When I become a stranger,
I am eclipsed by the expressiveness of the
new environment and touched by it.

ARTISTS ENCOURAGE US TO MAKE
the familiar unfamiliar. During the Italian Renaissance Marsilio Ficino
said, "The soul always ponders new and unacknowledged things." I
find it helpful to imagine myself as a stranger in my most familiar
haunts. Blanche DuBois in *A Streetcar Named Desire* described how she
always depended on "the kindness of strangers." I feel this way about
the generosity of places and things.

Because I travel frequently, I have opportunities to walk through
unfamiliar neighborhoods. I look with foreign eyes at how people cul-
tivate their habitats and how the places influence those who reside in
them. As a stranger I feel a heightened sensitivity to what places con-
vey. I am keenly attuned to their qualities. Maybe their spirits receive
something from the kindness of my attentions. I wonder why it is that
we are apt to be less open to the spirits and graces of our regular
surroundings. What is it that makes a place boring for one person and
fascinating for another? The more foreign I become in my most habit-
ual surroundings, the less likely I am to fall into my insensitive ways
because I am more aware of the things around me. Kindness extends
from giving attention to "their" conditions and not mine.

Walking through unfamiliar cities always helps me see home with

more imagination. When I am in a new city, the sky becomes my familiar spirit whereas I am more apt to take it for granted at home.

Try looking at doorways, gates, and other passageways symbolically. As you walk down a street, consider the different types of entrances you see. What do they say to you about the spirits of the place and the soul? What rites do you imagine people experiencing as they pass through the openings. What qualities connect the passageways in one house to those of its neighbors'? What characteristics distinguish homes from one another?

Take this foreign perspective and apply it to your own household. Imagine yourself walking through it as a stranger who is looking at things "for the first time."

What do you feel at the different points of passage?

Look at your fireplace, bed, closets, picture frames, and dressers symbolically. What things give the stranger a sense of the people who live in the space? What areas convey intimacy?

Are there ceremonial places in the home?

Are there chairs that look like seats of the soul?

Where is the imagination most alive?

Are there places that you find more inviting than others? If you habitually sit in particular places, consider why you do this. Are there aesthetic qualities that please you? Is it a matter of proximity and convenience? Could there be symbolic attractions to certain positions at the table?

How can we bring more imagination to the way we perceive the world? As a child I imagined myself as a foreigner or a person from another era. I also imagined life from the perspective of the place itself. I wondered what it would be like to be relatively timeless and to experience so many changes? I imagined the place without any buildings or roads. I thought about how different the architecture was in my New England home two hundred years ago. I went further back in time to what it would be like as a native person living in the same place. I identified with the rocks, which stayed relatively constant through it all.

While walking through the Santa Monica Mall I experienced it as a new temple of the world's peoples and their displays. I was waiting for a friend, so I sat for an hour and witnessed the extraordinary presentations of ordinary people.

Sometimes, when I am walking through strange cities and neighborhoods, I feel as though I am a spirit, intensely connected through my senses and thoughts but foreign because I originate from a different part of the world.

Travel to distant places helps me experience my spiritual being, linked to the earth and yet separate. I have the same feelings at home, but the separateness is not so intense. As a meditation I try to feel more like a stranger in my daily routines. Detachment paradoxically makes me more present. Distance and intimacy are partners that need one another. What is most foreign carries within itself the potential for intimacy because we are typically sensitive to the subtle nuances of its expression.

The people with whom we live are often the ones whose presence arouses the least reaction from us. Although we are intimately accustomed to their expressions, we tend to be less aware of them. This unconsciousness often accounts for the ease of coexistence, but it has its shadow in a lack of appreciation. The same thing happens with our relationships with art materials.

If you constantly paint with thick, opaque applications of oil colors, experiment with wet media like watercolor and ink, where the medium flows. When you return to your oils, you will have a different sense of their qualities.

Try approaching your creative expression in diverse ways. If you usually paint on canvas, work on paper or panels. Shift from coarse to smooth surfaces or vice-versa. Keep changing. As the nineteenth-century painter William Morris Hunt said, try "anything to keep you from a 'way' of doing things."

We learn from continual practice, but exercises need variety in order to solicit new responses. This is why we seek out novel experiences with people, places, materials, and ideas. When I become a stranger, I

am eclipsed by the expressiveness of the new environment and touched by it. The experience adds a fresh infusion to my creative chemistry.

Artists constantly talk about the need to establish a distance from their expressions in order to see them. The same thing applies to our relationships to family, jobs, and communities. In keeping with Immanuel Kant's notion of "aesthetic disinterest," it can be useful to emotionally detach oneself from a creative project or familiar situation in order to see it with as little bias as possible.

We can be disinterested and passionately interested at the same time. One perspective does not cancel out the other. I can simultaneously love the place where I live while trying to stand back and look dispassionately at the significance of what is happening in my day-to-day life. The same thing applies to looking at artworks.

Becoming a stranger in the presence of our most familiar and intimate expressions is especially useful in conflictual situations. Strife and emotional tensions are often expressions of an inability to let go of a rigid frame of reference. Conflict is the agent of change.

Try looking at the conflict as though you are a complete stranger to its forces. Approach the elements of the problem as if they are a chapter in Jonathan Swift's *Gulliver's Travels*. Imagine yourself explaining the problem to a person with a completely different worldview.

Stepping outside the conflict for a moment can be extremely useful in expanding your understanding of the problem. But also realize that many people shape their identities through uncompromising positions and a reluctance to open to different ways of looking at their experience.

The way of the stranger is fluid and creative. It is nonauthoritarian and humble. It embraces change and it is based on a belief that there is an intelligence operating within the creative process that may be wiser than a single person's point of view.

I find it helpful to look at my paintings as though I had never seen them before. I imagine them being painted by another artist. By stepping outside my usual relationship with them, I am able to look at them more completely as things unto themselves. We artists tend to

get overly attached to our creations. We look at them as extensions of ourselves, and in many ways they are. But this familiarity can inhibit seeing their unique qualities.

Creative expression is closely associated with distancing ourselves from habitual ways of doing things. Habit is by definition more and more of the same. In the next section I will extol the benefits of repetition, but there are two sides to every artistic coin. In the creative process repetition is paired with change. The two forces are partners that complement one another.

Painting a familiar image with your eyes closed may be a useful way to make the habitual act foreign and strange. The finished image may generate new graphic techniques and subtle or dramatic changes in rendering customary material.

I just completed a studio workshop where a woman's normal painting hand was bound by a large cast. She covered the cast in plastic and used it as a paperweight to hold down the painting surface while she worked vigorously with her other hand. She compensated for the loss of control with an intensity of gesture and a boldness in her compositional design.

This exercise of painting with the nondominant hand is a well-known technique for facilitating new expression. As I work without my usual controls and dexterity, there is a renewed appreciation for expressive gestures. If I work robustly , I discover a more primal and raw way of making gestures. When I make gentle and deliberate strokes with my nondominant hand, there is a distinctly different quality to my gestures. It feels as though another person is making the picture because each hand has its distinct personality when I paint. Perhaps ambidextrous people can maintain a continuity of quality with each hand, but most of us will find the nondominant hand to be a less technically proficient agent of expression. The loss of one faculty stimulates us to find another to take its place.

These handicapping conditions can be a boon for creative expression. Imagine your nondominant hand as a child artist, as a naive beginner who can begin painting in a completely different way. Don't be

frustrated with your lack of control and the loss of your usual equilibrium. Each hand will generate its unique qualities to your work. The nondominant hand will offer a simplicity that is lost as we become more proficient and controlled. Work with both hands together. Explore their partnership and the different qualities they offer to your expression.

Hold your brushes and pencils in unfamiliar ways and you will find that they introduce new qualities to your gestures. Work from all angles of a painting—from the bottom, top, sides, and corners. As you shift your viewing perspective, there is a completely different field of visual forces influencing your expression.

All of these attempts to see and to act differently collaborate with the continuities of your expressive style and interest. The familiar and unfamiliar are forever shaping one another.

REPETITION

One artwork is the inspiration for another.

How many times have we heard the ten-year-old child say to the teacher, "I can't think of anything to draw."

Compare this situation to a group of three- and four-year-olds who universally immerse themselves in the process of making pictures with markers or painting at easels.

What accounts for this difference?

The young children aren't thinking about what they are going to do. They simply act with the materials, and they relate to them sensuously rather than mentally. This is not to say that there is an absence of intelligent thought in the free manipulation of material substances. The senses think together with the brain as interdependent participants in a creative ecology. When one faculty, such as the reasoning mind, starts to dominate the other intelligences, the creative interplay is arrested. Yet we still hold to the notion that creation comes from individual minds working in isolation.

As I described at the beginning of this book, ideas and mental images work together with gestures and materials in every phase of the creative process. Young children have lots of ideas about what they want to paint, but they are more accepting of what art materials do when combined with natural gestures.

Watch four-year-olds painting on easels with bold strokes and col-

ors. One of their greatest gifts is the innate ability to know when to stop. Their pictures are rarely fussy and overworked, tendencies that extend from an overactive and insecure mind. The pleasure of the children is palpable and reflected in the lively and spontaneous pictures.

The four-year-old is sensuously attracted to the paints and the large blank surface and they begin to work as a reflex action to the possibilities suggested by the materials. The medium and things of the physical world carry suggestions for creative action.

The young child paints kinesthetically, as a bodily expression, whereas many ten-year-olds respond conceptually. They have already accepted the notion that creative ideas exclusively originate within the human brain. As they grow more aware of their thinking, self-consciousness sets in, and they progressively separate from the earlier *participation mystique* with the physical world. The developmental psychologists have it backward when they view the young child as egocentric.

Imagination gathers together all of a person's faculties into creative action. So it is no wonder the ten-year-old who tries to mentally plan a picture is likely to get stuck. Yet thoughts and memories are always important stimulants for creation. I remember my son drawing a complicated picture of a red tugboat with an airport and city in the distance. The nature of the scene called for varied activities and images—planes flying and taking off, trucks, helicopters, hangers, city skyscrapers, construction crews working on top of buildings, birds in the sky. The tugboat in the foreground set off a chain reaction of work-related images and ideas. He had flown on airplanes from Boston's Logan Airport, which is on the water and right next to the city. He was painting both from his experience and from his imagination of the world. Ideas and memory images participated in the creative experience. They issue from a process that has been described as aesthetic play or meditation. As the person becomes immersed in a particular activity or situation, the composition emanates in a way that makes use of whatever resources can be applied to the task. Young children do

this naturally, because they have not yet learned to be distracted by plans and expectations.

Imaginative expressions will often start with the simple repetition of a familiar theme, like a child's drawing of a boat, airplane, or house, and then the relatively constant way of beginning is embellished through the imaginative construction of the composition. The child might draw the same boat over and over again, but every time its environment will be different, and the boat itself will change. The repeated image emanates different qualities every time it is made.

Accomplished adult painters get down on themselves for painting the same themes over and over again. I try to draw their attention to how each painting is different and I encourage them to look positively at the recurring figures as familiar spirits with whom they have a long and creative relationship.

I say, "These are the figures of your psychic landscape, so why reject them?"

The recurring image is the person's channel or river through which the creative stream flows constantly to new places. It is the place from where the rivers run.

Picasso wasn't worried about repeatedly painting minotaurs or the same faces on his figures. Yet beginning painters set themselves the task of inventing something completely new in each picture. A series of paintings expressing different aspects and moods of the same subject matter lets the process flow from one image to another.

The familiar image regenerates itself with each new creation. All of the different starting points ultimately take us to the same wellspring which can never be exhausted. If we are able to open ourselves to a process of free play in our artistic expression, the same beginning will generate endless varieties in our compositions. We learn from drumming and percussive music how the repetition of a familiar rhythm generates new variations that flow effortlessly from the sustaining source.

The Bible says: "All the rivers run into the sea; yet the sea is not full; unto the place from whence the rivers come, thither they return

again" (Ecclesiastes 1:7). And what is the source, the place from each all of the creative streams flow? If we follow the suggestion of Ecclesiastes, then every channel of creation returns again to the place from which it came. Nietzsche referred to this process as the eternal recurrence of the same. I personally experience the urge to create as a desire to return to this source over and over again. The creative instinct moves like a river and my desire for involvement is unending.

When I am inspired by looking at one of my creations or something created by someone else, the expressive result is the stimulus for yet another cycle of creation. The source is not hidden and lodged in a distant place. It is before me all of the time. One thing is always growing from another. This is why we paint from nature as well as imagination; why we write about our experiences and make music from familiar sounds; why I surround myself with the creations of other people which inspire my own expression.

The source is life. I am moved by an event, a person, a problem, a memory, a scene, a pattern, a gesture, someone else's creation, or any other thing, and I respond to its charge with my own emotional expression. Creation is a response to life that gives something back to the source.

One artwork is the inspiration for another. The Beatles were inspired by 1950s American rock 'n' roll artists like Little Richard, Fats Domino, Elvis Presley, Jerry Lee Lewis, and Buddy Holly. They described how they never would have become involved in music if it weren't for their love of these artists' recordings. Paul McCartney said they imitated Little Richard. "We loved him so much," and through impersonating his music "our own voice would emerge."

I approach imitation as a meditation on the qualities of an inspirational artwork. As I admire the expressions of another, I internalize them and build my own style from them. As with the Beatles, I contemplate books, paintings, poems, and performances that I emulate. I want to keep "good company" because the things in the immediate environment affect my expression.

Rather than literally copying the expressive products of another art-

ist, I meditate on the essential elements or archetypes that appear through their art. The mature styles of artists emerge through an integration of individual mannerisms and interests with the source, the movements of the creative process which is the river of Ecclesiates that continually flows and returns to the same place, casting forth an endless variation of offspring as it interacts with the artist.

As I contemplate the work of another artist, a fusion takes place. The gestures become part of me and I put my personal spin on them.

Creation is constantly playing different variations on themes and restating basic truths. The more we work at originality, the more we return to the same fundamentals which are renewed in each historical period by those who express them in appealing and striking ways. Original statements keep returning to origins but in a style that is authentic to the person making the expression. The source can never be copied because it doesn't exist anywhere in a fixed form. It can only be interpreted.

The assumption that creativity always involves the invention of something new may be one of the most prevailing obstacles to creative expression. In my teaching I emphasize authentic and sincere expression rather than invention. If we liberate our personal and often idiosyncratic styles, we will create with individuality and vitality. The pressure to invent invariably generates superficial and overly conceptual ideas.

Try approaching creation with attitudes of repetition rather than invention. When we stop trying to make something new, we see how each expression invariably distinguishes itself from the ones before it.

Look at these repetitions as your creative routines or your rituals of preparation. Approach them as ways of establishing your creative rhythm, as a method for gathering inspirations and ideas.

I find it useful to approach expression as an ongoing statement and restatement of what already exists. Originality is too abstract for me. It suggests making something from nothing. Even God in Genesis makes one thing from another.

Plumb the depths of your most habitual acts. They are your familiar spirits.

What do you do over and over again? Can you observe differences in each expression?

Try walking from one place to another in a room and notice how each repetition is distinguished from the one before it. There is constant movement in human expression and in every new action something emerges that we did not know before.

I have made paintings of the same subject repeatedly and I am intrigued with the distinct differences. This also applies to creative writing, music, and dance. Everything is in motion. Even the most stationary objects will generate variations every time a person sets out to interpret them through an expressive medium.

Make a drawing, painting, or clay figure in response to an existing art object, one that you made or a piece created by another artist, and then make yet another in response to the one you just completed. Keep making artworks in response to the ones immediately preceding them. Watch how one grows from the other and generates a sequence of variations both subtle and overt.

Do the same thing with creative writings, body movements, and vocal improvisations.

Every subtle variation affects us and emanates into a new expression whose origins can never be traced to a simple pattern of cause and effect. Each expression spawns another, and this is why artists naturally work in series.

The source is a fertile movement that bears new forms from itself, and the origins of the movement cannot be identified.

As creators we can do many things to both advance and inhibit the motion. The process of creation is an ongoing practice of interaction between ourselves, the materials of expression, our audiences, and the movement source which is always changing and inviting contact in different ways. Nothing is ever exhausted or definitively explored within the creative process. The same object engages us in endless variations day after day.

Repetitious expressions may not be as automatic and unchanging as we first think. We might be anesthetized to their subtle variations and changes, unable to see how nothing is ever the same.

We tend to flee from repetition with fear that it will absorb our spirits. And consequently, many of us jump about sporadically without giving an activity the time to reveal the subtle gifts of spiritual practice. We learn from the practice of sitting meditation that when we endeavor to cease physical activity, we paradoxically expand our sensitivity to the movements of the body and the environment.

Don't be afraid to do the same thing repeatedly. The practice will reveal that creation pervades everything. The creative process corresponds to Buddhist meditations on impermanence and spaciousness. Nothing can ever be repeated in an absolute sense. There are always nuances that go unnoticed when we see our lives as monotonous drudgery.

Sit in a chair and extend your right arm in front of you and move it slowly from right to left. Repeat the movement over and over again. Watch how you contemplate differences in speed, the feel of the air, the visual impressions. As I continue to move in this way, I become increasing aware of returning the arm from the ending point on the left to the beginning on the right. I grow irritated with the idea of right and left, beginning and end, and the movement becomes seamless and continuous without a particular orientation in space. I begin to experience myself as the agent of the movement, and I get up from my chair and move with my entire body.

The most elemental motions lead to other expressions unless our meditation is focused on containment and the restriction of movement. Every perspective has its value, and its way of moving toward and away from the source.

When I began to paint seriously I was intrigued with the paintings of Josef Albers and the way he repeated the same simple, geometric compositions with different color combinations in each picture. The unchanging formal configurations were strikingly different because of the interactions among the colors. Albers approached color as the most

relative aspect of the visual arts. His work shows how what looks at first like repetition is actually a series of changes. The forms stayed the same but the colors changed.

A color can never be viewed in isolation from its context and neighboring influences. I analogize this relativity to other aspects of life. Many things change in relation to the fluctuations of environment whereas other conditions stay the same. Albers said that learning how colors change helps us learn about life as well as color.

Reflect upon your personal qualities that can be likened to color and light. Also consider your more "formal" qualities that are less apt to change in relation to the flux of their environments. How do these different aspects of yourself relate to one another? What is your dominant character? Do you oscillate among the different aspects?

When we start to paint, we are often more focused on the making of forms. Experiment with Albers's method and do a series of pictures using the same forms with different colors. When we relax the pressure to create forms and compositions, we can begin to play with the effects of color.

A constant impulse toward variation distinguishes nature from mechanization. Try making a series of drawing of the same object and if you move freely, you will see that each one is distinctly different.

The process of taking photographic portraits reveals the extraordinary variety in what would at first appear to be the same image. Put a 36-exposure role of slide film in a 35 mm camera and quickly use the whole roll to take pictures of another person's face while talking to the person. You might want to make slight variations in the angle of your shot and the distance for aesthetic variety. When you have the slides processed, project them onto a screen and watch for the subtle and distinct variations in each image. If you want to continue with this exercise by taking portrait photographs of two of more people, you will see the variations increase in proportion to the number of people involved.

Art activities focused on repetition tend to increase our awareness of variation. I have also found that repetitive expressions tend to liberate

me from the self-imposed pressure to be "creative" and "innovative." As I stick to the task of repetition I discover how the creative process varies itself. It is like staying with a chant, repeated movement, or rhythm that takes us into a trance state.

The creative process is a bottomless reservoir of expressions. As we try to do the same thing over and over again, we realize that exact replication is not the way of human expression.

GOING ON TO
THE NEXT ONE

The creative spirit demands persistence.

THE WAY OF CREATION IS A PRACTICE that lives each instant as fully as possible, lets go, and moves on to the next engagement. When examining the lives of creative people there is always sustained desire and a vision into the future.

The sense that every day is a new opportunity runs through the history of creative transformation beginning with Heraclitus's declarations that the sun rises anew each day, and that we never step into the same brook more than once.

The creative spirit is attuned to the most essential rhythms and flow of nature. Daily practice is the antidote to depression. When I am depressed, the sinking of energy helps me to see that I am a microcosm within the total expression of nature. My personal initiative rises and falls like the sun.

Fixation on negative performances is a primary obstacle to creation. How many times have we heard athletes say to one another, "Let it go."

If I can't let it go, it possesses me. I am better at this in art than I am in sport, but my worst difficulties in letting go of inept performances are my most convincing teachers. The failure becomes an overriding force in my life unless I go out and try again.

The creative spirit will always have its good days and bad ones. This inconsistency is an essence of the process, which moves according to its inherent chemistry and not my expectations. In my experience, it is excessive self-consciousness which turns this natural condition into a major inhibition.

I was reading through *The Iliad* during one of my difficult periods and I was buoyed by the rises and falls of fortune that permeate the book. Gains and setbacks occurred with a rhythmic consistency with everything depending on the whims of the gods. Victory and defeat were determined by whether or not they were with you on a particular day. The bounds of fate were absolute, with Zeus never taking a single side.

Homer wrote, "So long as gods were afar from mortal men, so long waxed the Achaians glorious." The Homeric discovery continues in contemporary epics as revealed by the film *Star Wars*, where the primary salutation is "May the force be with you." And this greeting is a modification of the familiar "God be with you."

It is not I alone who paint the picture when I paint it, or write the page when I write it. Some days this force propels me, and on others it does not. Athletes and artists know this dynamic intimately. The spirit comes and goes.

Success in any endeavor that involves the ups and downs of the creative spirit demands persistence as recommended by Homer in *The Iliad* when he says, "for an enduring soul have the Fates given unto men." We cast ourselves into the competition, or the studio, with the realization that we may or may not have it that day. As Agamemnon declares, "What could I do? It is God who accomplisheth all."

So I am asked, "What is the essential quality that carries us through difficult times?"

In my experience it has been acceptance tied to a faith that the weather will change. Through it all I have to keep "showing up."

In my painting studios I constantly see people going through extended periods when nothing seems right. It can be excruciating, like being forsaken in torment. But I have learned that there is always a

purpose working its way through the difficulties. Invariably, the block-age generates a new dimension of expression if we can stay with the process. I try to let the bad days go while accepting their place in my expression. The creative process knows the way, and I have to trust that it will take me and my environment where we need to go.

After a devastating performance in which my father also partici-pated, I asked him, "How do you deal with the pain of this?"

He replied, "Go on to the next one."

I have never received more poignant advice on working with the creative process. Persist or perish, as the medieval motto suggests.

Giving up is also part of the process. Surrendering. Quitting the chase. There comes a time when I have to accept the inevitable and let go. But there is always the new day or the next step into the brook invoked by Heraclitus.

In a strange way, the negative performances invariably deepen the process if we can stick to the discipline.

Going on to the next one is the basis of artistic expression. Even after our most successful creations there is the challenge of the next one. We don't realize how the most successful artists may suffer more than we realize in relation to expectations about what will come next. They might fear that the gift is gone, that the muse has deserted them, that the inspiration will not be there when they return to the studio. They are typically never satisfied with yesterday's success.

In what areas of you life have you been most successful in letting disappointments go? Where have you had the most difficulty?

Can you recall bitter defeats that helped to shape future achieve-ments? Are there areas of your life that have been arrested because of setbacks? Can you identify pockets of unrealized creative potential that can be reactivated?

As you practice the creative process in any discipline, try to remem-ber that disappointments are inevitable. They are major elements of the process which somehow contribute to the overall energetics of cre-ative expression. There has to be an interplay between highs and lows if we are to access the most transformative chemistry of creation.

CRITICISM

*Sooner or later every creator realizes that
"getting it right" is the heart of the work.*

IN THE LITERATURE ON CREATIVITY
there is ongoing opposition between process and product, and writers
tend to support one or the other. I've always been oriented to both. As
a process-oriented type, I see the products of creation as offspring and
resting places during the journey. Expression is forever moving and
going on to new forms, but this does not have to negate the objects
created along the way. The process of making art is inseparable from
its products.

Those who promote the values of spontaneous and passionate ex-
pression have a tendency to belittle the products of the work. What
inhibits creation is the way people approach the products.

The process needs the objects of expression as sources of action. It
really is absurd to insist that the creative process is something to be
pursued without concerns for them. Images made by other artists and
images made by ourselves parent the new images we make. Art is an
ongoing sequence of influences.

As I create in any medium, there is a critic who accompanies each
phase of the process. I embrace the critic as a companion, a necessary
aspect of creative expression, an element of expression that calls for "a
little more of this," "less of that," "not that at all," or "you'd better
start all over again." In order to improve, the process has to be able to
look at itself and make adjustments.

I sense the critic in my hands and eyes as I paint, in my body when I dance, in the voice when I sing, in the text as I write. The internal critic is a way of sensing the experience as it unfolds.

Attempts to dismiss the critic completely are misguided, and they overlook how self-criticism is a perfecting force within artistic expression. Sooner or later every creator realizes that craft and "getting it right" are the heart of the work.

Those who celebrate process over product have a tendency to confuse the critical aspect of the process with the judge who stands apart from the work and passes judgment. All too often the judge is not a party to the process and enters the scene with a set of standards that do not grow from the work, in contrast to the critic who is enmeshed in the process.

When I look at someone else's work, I see myself primarily as a witness. I might describe what I see or express what intrigues me, but I am wary of passing judgment. I realize that every creator has an active critic and I offer my observations as yet another perspective, another point of view that will hopefully contribute to the artist's appreciation of the expression. When I am painting or writing, I actively seek out responses from others. All too often I cannot see what I am doing, or I need another person's perspective to validate or challenge my inner critic. In these situations I don't want people to hold back on their opinions. If they can't stand something, I want to hear it.

I have artist friends who never show their work to others while they are creating. They find comments distracting, and their friends have to wait until the work is completed in order to experience it.

We've all had experiences in our lives with harsh judgments. I don't want to encourage this way of responding to others, but no doubt each of us has benefited from hearing what we don't want to hear at key points in our lives. It is intriguing how it can be just as difficult to hear criticism of the things we make as it is to receive critical comments about ourselves. Perhaps it is sometimes even more difficult to hear people's criticisms of our creative expressions. I remember my first studio session with Theodoros Stamos at the Art Students League of

New York. I brought in a painting, hoping that it would show my potential ability, and Stamos said loudly in front of the class, "That's horrible. Too fussy. You've got to learn how to paint freely."

I could have walked out, but I decided to trust the teacher and learn his way of painting. In a brief look at my adolescent picture, he identified a problem with my expression that I still encounter. Ultimately the criticism had a major positive impact on me. It came at just the right time, like a surprising slap, or more accurately a whack, from a Zen stick. The criticism said to me, "Art is serious business, kid. If you're going to work in my studio, you're going to have to listen to what I have to say and receive what I have to give you. You're not going anywhere painting like that." I listened and I've been painting ever since. The criticism was a rite of passage. I had to change completely if I was to commit my life to art.

As a teacher, I don't come on quite as strongly as Stamos did because I've found that the average person needs support. In my experience the critic works better in a relaxed and confident environment, so I try to articulate the positive aspects of every expression as a basis for continuation. It is an unabashedly Pollyanna approach, looking for sparks of vitality and originality in a person's artistic expression and ways of building on them. We start with what we have and welcome the critic as one of the participants in a process of unfolding.

Gertrude Stein, who was celebrated for her support of many of the twentieth century's most influential painters, described how she told artists what was good about their paintings. She felt that this encouraged them to keep searching for their "special gifts." Stein noted how the bad qualities of the pictures disappeared without her saying anything about them. If you don't give something attention, it tends to recede.

Sports psychologists similarly focus on the good thoughts. They encourage the athletes to vision positive outcomes. Negative images generate negative results.

But there are also serious problems connected to withholding honest criticism. Many of us are afraid of criticizing others because we fear

that they will dislike us. In supervisory and teaching roles we owe it to people to be frank because otherwise our dislikes will leak out indirectly. In keeping with the Gertrude Stein approach, a good technique for supervision, teaching, and leadership is the consistent presentation of what a person or organization wants to achieve. We will then be encouraged to evaluate our actions according to these goals. Leaders have to get beyond doing things just to please people. Popularity may not penetrate as deeply as respect.

Reflect on your personal history with criticism. Were there times in your life when you stopped creating because of another person's judgments of your work?

How strong is your inner critic? Do you shut yourself down with negative judgments?

In what areas of your life is your inner critic a natural and productive partner in what you do?

Where are you most sensitive to criticism? Why?

In what areas are you most open to criticism?

I want criticism during the process of creation, or when I am preparing a performance. Criticism is more difficult to receive once the work is completed because the judgments aren't part of the formative process. However, when we look at our creative expression as a lifelong process, the painful judgments of completed creations inevitably make contributions to the total body of our work. With the passage of time, we view our experiences differently.

I have a colleague who has given me painful criticism on many occasions. My instinctive response is to get hurt and angry at him, but when I reflect on the situation, I see that he is telling me things that annoy him, and others may tend to withhold these things. I realize that he is close enough to me to criticize me, and our relationship continues, perhaps strengthened by the criticism. If I step out of my personal feelings, I see that he is trying to improve a situation, and ultimately help me to perform better. I have to be aware of things that he is telling me.

As the athletes say, "No pain, no gain." Yet sensitivity to people's

feelings is also part of the process of giving honest feedback. Harsh and hurtful criticism can become sadistic, or masochistic when we do it to ourselves. When I reflect on many of my best teachers, I see how they practice the art of oblique and subtle criticism. Part of my learning process is refining the ability to hear messages which may be couched in humor, tenderness, or a positive statement such as those given by Gertrude Stein.

Many of us find that giving criticism may involve considerable risk. We fear that people will react in the wrong way, or perhaps they will turn against us. The best environment for criticism involves ongoing dialogue to ensure accurate and fair communication. It is quite common to hear something other than what the critic is trying to say. We might have to go back and forth to make sure the intent of the comment is clearly understood. Because we fear criticism, there is a common tendency to exaggerate and distort what a person is trying to tell us.

John Humphrey Noyes, who initiated nineteenth-century experiments in communal living, said: "Without the lubrication of love, criticism works more mischief and distress than it does good." In his 1876 publication *Mutual Criticism*, Noyes lays out the essentials for giving and receiving criticism: respect, sincerity, patience, "right spirit," the absence of condemnation and combativeness, no "unloading" of enmition, the overriding goal of releasing a person's potential, and the sacrifice of self to the truth.

During the encounter-group era of the 1970s we discovered how damaging criticism can be when it is given in order to release the emotions of the critic or as a means of personal empowerment and control. The effective critic genuinely cares for the person or situation being evaluated. There is an overriding and sincere concern for improvement. The most useful criticism occurs in an environment where people feel safe with one another, where there is common respect and purpose, and the realization that there will be ongoing support during the process of change and experimentation with new ways of acting. The creative environment is a place where mistakes are accepted as

"part of the process" and where they are perceived as opportunities for learning. As I say to people wanting to paint, "You cannot be afraid to make mistakes. They are inevitable and they will help you to paint better. You are apt to remember them and avoid them the next time."

Distance may be needed in order to open to criticism and to hear what someone is trying to say to me. But the most effective criticism is immediately connected to the event being reviewed. There tends to be nothing more damaging and confusing than pent-up criticism that has no direct context. We profess to be criticizing one thing, but it really something else that is the source of our complaints. When this happens, it is truly the person who is being criticized rather than a particular action or expression. I keep telling my psychotherapy graduate students, "You've got to call it when it is happening or wait until it happens again."

When we are insecure about our expressions or when we really don't want to change the way we do something, we are less receptive to criticism. As Shakespeare writes in *Much Ado about Nothing*, "Happy are they that hear their detractions, and can put them to mending." We have all confronted situations where we know there is no possibility of change and where criticism is futile. A Native American healer once said to me, "I cannot help a person unless they first ask for help. They have to acknowledge that something needs to be changed."

Timing is one of the most important and subtle features of effective criticism. Constant carping and incessant negativity build antagonism and resistance whereas the deftly timed comment can be transformative. The sensitive critic moves when there is an opening, a need, a sense of receptivity, and perhaps a desire for insight into a problem.

Can you recall moments when you desired critical help from others? Compare these situations to moments when you were resistive to criticism. What accounts for the differences in your experiences? Reflect on your history of giving criticism to others, to yourself? Has timing been an important issue?

Even though people may want criticism within educational situa-

tions, most have a difficult time receiving it. And all of us have met
people who just can't listen to criticism of any kind.

Have there been periods in your life when you could not accept
criticism? If so, reflect upon what your world was like then.

What changes have you experienced that make it is easier to take
criticism now? Or were you better at taking criticism at earlier times
in your life?

When you have difficulty listening to a person's criticism of some-
thing that you do, try to see your point of view as one of many perspec-
tives on the situation. Rather than jumping to the defense, try to
approach the critical position as an ally that arrives to help you im-
prove. As you open to other ways of looking at the condition, you
become increasingly flexible in relation to your own opinion. It be-
comes easier to let it go, since you are not rigidly tied to it.

Attempt to be unattached to opinions or ideas. It's always difficult
to maintain a flexible outlook on experience. Each of us sees the world
through ingrained attitudes and biases. There is a stubborn aspect in
all of us that resists change, and sometimes obstinate persistence can
be a saving virtue. There is no single way of responding to every situa-
tion. There are times when I have been misled by the criticisms of
others. Ultimately each of us has to trust our own inner critic and its
vision. Civilization and culture will be severely threatened if individu-
als are not willing to stay committed to unpopular ideas that challenge
dominant ideologies.

In the practice of creative expression, we typically shape our per-
sonal visions through a critique of things that we don't like. I have
discovered that my discontents have been among my most productive
allies in creation. They call out for another way of experiencing life.

The artistic medium carries a critical voice within itself—the missed
note, the rhythmic lapse, the area within the painting that won't con-
nect to the movement of the whole. As I said earlier, there is something
within the artwork that desires to get it right. This reality underscores
how those who urge us to think only about process and not products,

negate one of the most essential forces within the process. The expression innately strives to perfect itself.

In perfecting the critical eye and ear realize that you are cooperating with the expressive material. Work together as partners. Let it tell you what it needs, what it can do, what it cannot accept. The most sophisticated and sensitive critic exists somewhere between you and the art materials, within the interplay of the creative process.

What does the expression say to you as you make it?

Does the stone speak to you as you arrange it in your garden? Do the stones that you have already placed call out for particular shapes and textures in the ones that you consider adding?

As you make small random marks with a pencil on a piece of paper, observe the way you cover the surface and build an overall configuration. I usually develop a drawing by relating marks to one another in terms of proximity. I don't make one mark in the far left and then make the next one in the far right, then go back to the left, and so forth. The marks have an innate way of gathering together, building on one another and forming shapes. As a shape is forming, the empty space calls for attention.

I might also begin by making marks in the center and building a shape which progressively covers the entire surface. As I make what appear to be totally haphazard marks on a surface, there is something in my movement that suggests the placement, pressure, length, and thickness of the next gesture. There is an intuitive critic that tells me when to stop in one area and when to move on to another, when to leave a line alone and when to keep fiddling with it. The process of making art is a mode of critical thinking that is kinesthetic, tactile, and visual. Decisions are "part of the process" and imbued in every gesture and its relationship to what went before it and what will ensue.

The critical judgments of the creator tend to more improvisational than strategic. The process is an impromptu performance in which the creator receives direction from the material. Critical thinking in the arts is always a process of "sensing" what needs to be done. Excessive self-consciousness and premeditation are the major obstacles to this

type of intuitive thought which requires relaxation, reverie, and the ability to let the expressive gestures lead the way. The mind collaborates as a reflective participant. Our usual cognitive ways are inverted in the creative process and this is what beginners find so difficult.

Physical materials inform the actions of the creative process, which I often experience as a "responding" as well as an initiating intelligence. When you carve the block of wood in your studio, does it tell you what it wants to say? I imagine the materials of expression having voices and the artist's skill involves a sensitivity to their communications. Every gesture that I make on a canvas or a piece of paper suggests the ones that will follow. Aesthetic thought proceeds according to principles of intuitive shaping and elaborative emanation.

In my studio workshops I find that the playful construction of sculptures and artifacts with sticks, stones, wire, twine, and other natural materials highlight these intuitive modes of critical thinking. The physical materials are so thoroughly themselves that we have to find ways of making them into something new while maintaining their existing qualities. The process of making things with these materials is incremental. As I shape two or more things into a relationship with one another, they invite additions. Materials are attached to one another, and gravity plays a major role in the aesthetic placements and decisions. Visual and spatial factors such as symmetry and asymmetry, balance and tension, participate in the process of artistic problem-solving.

Determinations as to whether or not a configuration "looks right" are highly individual. The artistic critic does not proceed according to universal laws that can be passed on to people through step-by-step instruction. This variation and freedom are what beginners often find most difficult.

Experienced artists as well as beginners can often be confused by criticism that takes the form of judgment. It may be difficult for me to look at my work from the perspective of the person who is criticizing it. I find that a detailed description of what is going on within an artwork can sometimes be much more helpful than another person's judg-

ment. The most useful and informative critique may be the phenomenological one in which great care is given to articulating what is experienced in the artwork.

What do you see, hear, feel, and imagine as you contemplate an artistic expression? As I go through this process with one or more people, I always experience the object of reflection in a more comprehensive way.

One of the most common practical problems artists have is the decision as to when to stop working on a painting, sculpture, story, poem, or dance. Many times I have taken a painting too far and overworked it, losing the bold spontaneity of an earlier phase of the process. The same applies to poetry, performance, and every other expressive discipline.

The decision as to when to stop is always going to be tied to the particular conditions of an artwork. In my experience the finished painting or drawing reaches a state of maximum movement and expression. All of the parts and colors move together. There is nothing that obstructs their motion. Eugène Delacroix described how he was "seized" by the "magical accord" that takes place within a painting.

The finished painting or drawing reaches out or, as John Dewey said, "strikes" the viewer. I try to leave things fluid, and I have learned how easy it is to overwork a painting and arrest its free movement and "striking power" with stiffness or excessive effort. Therefore, I tend to stop as soon as the picture is able to stand on its own and as soon as it suggests the first sense of completeness. The lessons of doing too much are constantly informing my decision as to when to stop. It's like eating, drinking, or any other biological activity. We "sense" when to stop, and through practice we are able to make this judgment instinctively, and we all do it differently.

After watching a performance that went on and on, a poet friend who was sitting next to me whispered, "It's too much, overbearing, and inconsiderate of the audience. You've got to leave people hungry."

Reflect on those times in your life where you simply overdid something.

Recall other instances where your timing was perfect.

In my experience bad timing and poor decision making have usually been tied to impatience, anxiety, or distraction. I jump too quickly or I miss the chance to engage an opportunity. Emotional states are major sources of errors in aesthetic judgment. This is why training in the creative process is closely tied to personal sensitivity and emotional awareness: because the artist's aesthetic judgment depends upon these affective sensibilities.

If we envision critical sensibility as existing somewhere between ourselves and the objects of our expression, we realize that the decision as to when to stop is not to be made by the creator alone. We make these judgments together with our expressions. Perceptual acuity becomes a major element of aesthetic training. We tend to think of creators primarily as initiators, not realizing that their craft relies as much on the ability to respond sensitively to the environment.

I liken my work in every expressive medium to couples dancing. There is a force or space between my partner and me that inspires and directs the dance which envelops both of us.

Reflect upon your good and bad experiences with couples dancing. How do your dance experiences compare to your more general life experience? Try new ways of relating to partners and the dance. If you always lead, try following, and vice versa. How do you approach your work with expressive materials? Do you instinctively lead or follow? I have found that it is useful to do both during the creative act. The sensitive dance has a natural way of bringing itself to a stopping point. The same thing happens when you work with paint, stone, or the environment.

Creative decisions arrive like a bird alighting for an instant outside a window. The opportunity can be easily missed, but when we are attuned to our expressive work and its inherent movement, there is a certainty that characterizes the moment of decision. Everything within the painting, the text, or the garden has found its resting place. There is a sense that the work of a few hours, or years, has come to completion. We don't feel that we are making the decision. The expression tells us that it is complete. There is a sense of stillness, a satisfaction among the participants, that will be disrupted if we do anything more.

WONDER BEFORE THE OBJECT

Looking is a creative discipline in its own right.

One of the most pervasive fears connected to creative expression is the apprehension of self-revelation. People ask, "What is this expression saying about me that I don't want other people to know?"

I counter this self-consciousness by saying, "What does it say about itself?"

People have a hard time separating what they make, and show, from who they are.

Interpreters have viewed artistic images as if they were EKG screens or DNA tests revealing the psychic data that artists carry within themselves. The idea of self-revelation through art is a consequence of looking at artworks as though they are printouts to be decoded by a particular theory of behavior.

I am more interested in what creative expressions reveal about themselves. When I look at a painting or a movement or when listening to sounds, I attune myself to their unique statements. I watch for the movement in the painting, the animation of colors and forms. When I observe a dance, I am intrigued by the shapes of the movement and the way dancers connect to one another and to the space. The life force is conveyed by these expressive properties.

In my work with creative arts therapy I have urged people to open themselves to these expressive qualities and their medicines rather than try to "figure them out" according to a scheme of interpretation that overlooks perceptual energies. Every expressive configuration carries spirits of some kind, and their impact depends upon our ability to receive them. When we look at artistic expressions exclusively in terms of what they say about artists, we miss the primacy of their communication.

When engaging an artistic expression, I try to view it as a thing unto itself. In creative arts therapy I find that the inclination to see paintings as "parts" of ourselves needs to be complemented by an appreciation of their autonomy.

When people insist that their pictures are parts of themselves, I cannot deny their feeling and I don't care to get caught in a dualistic insistence that they are not. I will leave these ultimate determinations to metaphysics. I am more concerned with the nuances and styles of approach and how attitudes effect relationships and creativity.

Connections between the expression and the person who made it cannot be denied. I feel that the basic desire to see creations as parts of ourselves is a potentially creative link between the person and the world. The problems of egocentrism can be avoided by viewing personal creations as offspring. Like children, the creations are both intimately related to their parents and distinctly themselves. This approach acknowledges how expressions bear traces of their makers and have close ties to their psychic lives while maintaining autonomy.

Do we look at children and only ask, "What are they revealing about their parents?"

Creations of the imagination carry imprints of their makers, but they also bear the features of the environment in which they were made and the materials of their fabrication. They may spring to life during a moment's reflection when we are engaged with something wholly other than ourselves and they may carry only the stylistic qualities of our expression. Every creation is an alloy of some kind that embodies

the forces of its formation. As in dreams, there are always some subtle infusions from the material world.

Richard Ellmann, who wrote biographies of James Joyce, William Butler Yeats, and Oscar Wilde, said that creative expressions are not virgin births. As much as I oppose the way psychology has reduced creative expressions to its theories about people, I have to agree with Ellmann. Everything that we make carries marks of our contact with it, and exploration of these connections is no doubt inspired by a desire to deepen our appreciation of the creative process. But when it comes to relationships with the things we make, the most significant engagement involves the way in which the creations shape us.

When we shift our focus away from the artist as the prime mover and onto the objects of creation, we see how they affect the sensibilities of those who make them, contemplate them, or live in their company. By increasing our sense of wonder as we stand before an object, ourselves effaced, we magnify its impact on us. We become more attuned to the way our relationships to objects change and how they may generate different effects as we continue our contact with them.

How do you approach the fruits of your creative labor? Are you so attached that it is difficult to leave them or pass them on to another person, or do you let them go like a fine meal?

Try different ways of perceiving the things you make. Look at them as icons, familiar spirits, shamanic helpers, ritual objects.

How do you view the things you make at work? Do you perceive these creations differently from artifacts made in your studio or in the privacy of your home? Are the memos that we write, the telephone calls we make, the reports we author, and the meetings we attend completely separate from the creative process?

Do you see yourself in your expressions?

There are so many different ways of looking at whatever you make. You might view your creations intimately as parts of yourself, or see them as complete strangers.

The key to this free play of interpretation is the realization that each perspective brings a different kind of relationship. There is no single

and absolute way of explaining the bonds between an artist and a creation. Each way of looking brings something different. The Freudians sexualize images just as Jungians are more apt to spiritualize and mythologize them.

There is a creative basis to every interpretation, which is ultimately an attempt to access the life-giving properties of expression, which cannot necessarily be transmitted through concepts. The interpretation of art can be approached more as a meditation than as an explanatory exercise.

When we meditate on an image, we step outside the realm of what it says and what it means. We begin to experience objects in their material nature, and paradoxically this way of looking brings a corresponding sense of their spiritual beings. The spiritual and material expressions of objects are intimately connected. Colors, forms, and textures generate energies that are received by the eyes. Our more intellectual attempts to understand objects take us into a world of concepts, which distance us from the material and spiritual existence of the thing before us and our relationship to it.

Sufi mystics in the Middle Ages meditated on flowers in order to experience their angelic natures. They believed that every material thing has an angelic or spiritual counterpart that can be accessed through interpretive reflection. This way of looking at things opens the viewer to spiritual infusions and medicines. It is a form of loving contemplation that dissolves self-consciousness and limited views of reality. Everything in our environment has something to offer to the creative and spiritual interplay.

Contemplate your creations like a Sufi meditating on flowers in the garden. Begin reflecting on a picture by entering its world. Watch the colors and forms interacting with one another. How does your eye move through the picture? Are there areas that immediately attract your attention? Why?

Look at other details of the picture that you have not contemplated before. As you spend time reflecting on the picture, you may realize

that you have never looked carefully at its visual details even though you made the image.

Every picture is a field of visual energy, but we tend to look exclusively in terms of literal meanings. We feel an urge to translate the graphic expression into a psychological story. Pictures do generate narratives, even when they are composed purely of textures, colors, and shapes. When there is ambiguity in the composition, this condition tends to stimulate the imagination and the desire to make a personal connection of some kind. Therefore, strive to refrain from attributing a specific meaning when you reflect on an image.

See if you can experience the picture as an energetic field. In the earlier section "Moving between Worlds" I described ways of responding to paintings and visual artworks with movement and vocal improvisations. When watching another person engage their art in this way, I am always amazed at how the process of physical expression furthers the perception of a physical image. Words make their contributions, but they tend to shut down the energetic emanations of a visual image whereas movements and sounds open up the sensory channels. We see more and experience the image in a more complete sensory engagement.

Contemplate images with the attitude of withholding judgments or explanations of any kind. The interpretation of art can be approached as a tantric discipline that reflects upon visual qualities. Why is it that we feel the need to respond to visual communications verbally? Is the reluctance to become involved in visual contemplation a defense against the unknown, the process of meditation, and purely sensual experience?

When I reflect upon an image, I open myself to its presence and its many different qualities. I view it as a whole and I examine its details. My eyes move from one section to another as I look in terms of color and texture as well as forms, shapes, and lines. I let go of my personal frame of reference and open myself to the world expressed by the image.

Look with wonder and imagination and the images you create will

usher you into a new perspective on sensory experience in every aspect of your life. The perception of art is as essential to the creative process as the making of images. Looking is a creative discipline in its own right which links one creative act to another.

A contemplative way of looking does not seek answers and meanings. It desires visual experience for its own sake. There is an ongoing sense of wonder and delight before the things of the physical world.

When we think of artmaking as a process that is unconcerned with objects, there is a loss of the potentially intimate relationship between ourselves and our creations. Because art instruction has historically overemphasized the final products of creation, there has been an equally one-sided embrace of a purely sensate activity when working with materials. Difficulties arise from single-mindedness and the dominance of one aspect of creation. We need all of the potential players in the creative process—ourselves, the environment, the materials we use, other people, and the things we make. The contemplation of imagery underscores the intimate ties we have to things that emanate from expression. The images we make have the ability to guide, console, and inspire.

The meditational interpretation of art reveals how important objects are within a comprehensive approach to the creative process. I find that it is important to return again and again to an art object with the realization that our relationship is in constant flux.

One of the best ways to appreciate the mysteries and endless resources of artistic images is to select a painting or other creation that you made and use it as a meditational object over an extended period of time. Practice sitting meditation before the same image and gaze into it every day as if you are looking at it for the first time. You will find that it is capable of being an endless reservoir for contemplation. As you return to the image over and over again, you will begin to appreciate how fixed interpretations and meanings restrict its ability to act upon you in new ways. Focus on energetic patterns, shapes, lines, colors, and visual movement.

Ask yourself what the object says about itself. What does it offer to

your life? As your relationship with the object becomes more contemplative, and if you once saw it as part of yourself, you might meditate on yourself as part of its expression. How are you an extension of its life?

Looking and imagining are vital elements of meditation practice. Contemplate the different aesthetic "spirits" conveyed by art objects. How capable are you of receiving them? As you reflect continuously on the same object over an extended period of time, it will help you appreciate how any experience can be engaged as a source of aesthetic wonder. Everything depends upon your attitude and your commitment to the creative imagination. But don't place too many demands on yourself. Realize that you are not the total river of creation. You are in the river, in the process, and it will carry you where you need to go.